世界の美しい　欧文活字見本帳

世界歐文活字300年經典

350件絕版工藝珍藏，
令人目眩神迷的歐文字型美學

www.kazuipress.com

嘉瑞工房
コレクション

KAZUIPRESS

嘉瑞工房　著　　曾國榕　譯

前言

15 世紀下半葉，金屬活字的發明促成活版印刷的興起，從此散播到世界各地，並在極短的 40 年間成為了全球主要的印刷方式。在照相排版與平版印刷的技術取代活版印刷之前，整個歐文活字字型的歷史就是印刷文字的歷史。眾所皆知現在是電腦數位字型的全盛時代，相較於金屬活字，只要擁有個人電腦與相關知識、技術，任何人都可以用更簡單的方式製作數位字型，然後放上平台販售、讓用戶購買與使用。但是，環顧周遭生活，雖然以金屬活字印刷的印刷品已幾乎絕跡，但我們所使用的許多字型可是誕生於金屬活字時代的骨董呢！儘管數位時代也誕生了許多非常獨特且優秀的字型，不過 Garamond 或是 Helvetica 等字體在現代還是被我們廣泛地使用著。

出版這本書的目的，並非只是為了滿足懷舊的趣味，書中有許多時至今日仍是相當實用的絕妙設計，相當值得作為排版時的參考工具書，從中感受前人排版時所花的工夫與精巧之美，並運用於自己的創作中。

本書是從敝社蒐集的眾多樣本宣傳冊中，精挑細選出的優秀之作。這些作品引起我們的興趣的原因，不僅僅由於它們是金屬活字印刷的成品，還因為其使用的字型或排版樣式都具有時代的獨特魅力。

最初，活字鑄字廠所製作的樣本及文宣品等，是專門提供給印刷業者，可說是印刷領域專業人士彼此間的交流為目的所製作。不過，後來為了將字體的優秀之處傳達給平面設計師的用戶們了解，開始委託一流的藝術總監來監修，成品也就越來越精美了。

展現每一套字體排版時的最佳狀態，以及多款字型混排時的創意巧思與平衡感的拿捏，這些對於我們的排版工作來說，是多麼有幫助的範例啊！優良的排版、字型的組合……等，不但是創意的寶庫，就算以純欣賞的角度來看也是充滿樂趣的。不過，書中的某些範例，在今日的設計師眼中，也許會覺得有些字體略帶老氣，或是感到有些版型有點俗氣。此外，書中收錄的部分字體可能也沒有數位字型的版本。但是，我們的用意並非讓大家模仿這些範例，而是希望各位從中汲取創意的靈感，或想像一下同樣的版面若替換成現有的數位字型將會呈現怎樣的成果。

無論是現代感的、或是復古風的等等，若懂得善加運用不同的字型，就能表現出相當多樣的風貌。不要總是套用相同的字型與排版樣式，試著相信自己的感性，更加自由且大膽地運用字型吧。這本書絕對可以助你一臂之力。

我們將書中的樣本手冊大致劃分成一些不同的系統，但並未列出每個範例的具體年代或是鑄造廠等資料，此外，因鑄造廠的名稱以及字體名稱會因不同國家而有些許的差異，故目前的呈現方式大致參考了 1970 年出版的《The Encyclopaedia of Type Faces》一書。不過，因為活字字型的販售年份也如同現在的數位字型一樣，往往是間隔數年陸續推出而非一次發表所有的字型家族款式，所以無法確定詳細的發行年份，閱讀時請做為參考就好。還有，雖然附上了簡單的解說或觀賞時的重點導引，不過還是希望讀者們好好以自己的視角欣賞及觀察，自己的心得才是最重要的收穫。

嘉瑞工房

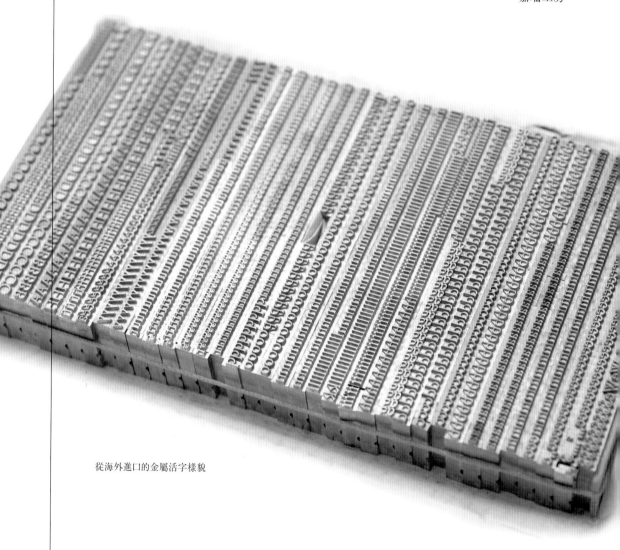

從海外進口的金屬活字樣貌

目次

作品說明附上的鑄字廠名稱，是製作該樣本書的鑄字廠，年份為樣本書的製作年份。書中的字體名稱會使用英文，而鑄字廠與人名會譯為中文（首次出現時會標注英文名稱）。

名詞解釋（譯注）

字型（英：Font／日：フォント）
具有共通樣式且符合同樣尺寸規格，內含文字、符號、數字等字符，字數齊全可供排版使用的產品。例：鉛字字型、數位字型

字體（英：Typeface／日：書体）
意指文字的風格，視覺上能將其造型歸屬於某種特定的類別或賦予專門的命名。例：楷體、明體、黑體是中文的三大印刷字體；Caslon 是由威廉・卡斯隆一世（William Caslon）所設計的字體；一種字體可能同時有好幾套不同廠商生產的版本、或是不同尺寸及樣式的字型。

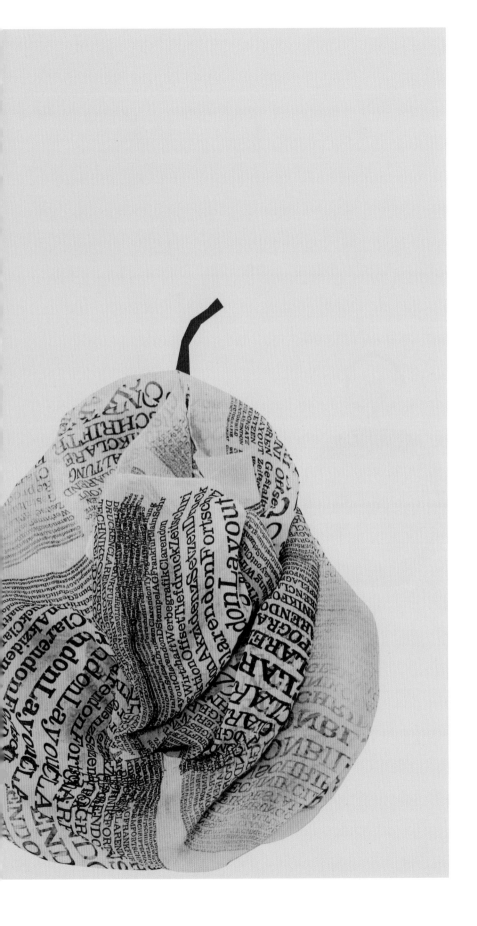

透過設計範例來欣賞活字字型

デザイン事例とともに見る活字書体

07

玩心滿溢的排版

為了推銷 Clarendon 而製作的手冊。把 Clarendon 初
期較為粗糙的感受重新整修後，為了賦予觀者新鮮的
印象，運用了充滿玩心的手法來排版與構圖。

斯坦普爾 (D. Stempel AG) 鑄字廠（德國） 1970 年代　298×210mm

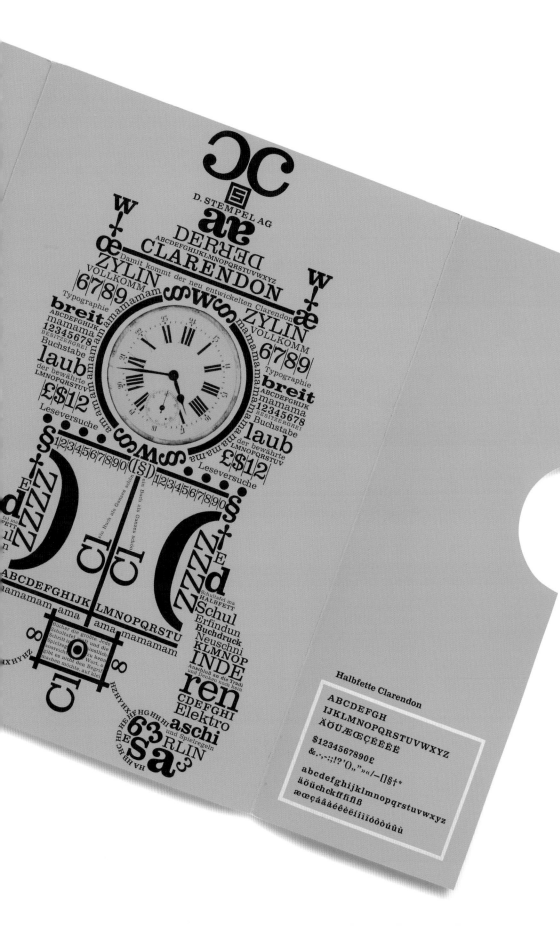

Halbfette Clarendon

ABCDEFGH
IJKLMNOPQRSTUVWXYZ
ÄÖÜÆŒÇÉÈËÈ
$1234567890£
&.,-:;!?'(),"»«/–[]§†*
abcdefghijklmnopqrstuvwxyz
äöüchckfffiflß
æœçáâàéêèëïîìíóôòúûù

以草書體表現音色

草書體的折頁型錄。這種典型銅板雕刻風格的草書體，常被用於傳達優雅印象的邀請卡之類的印刷品上。在這個設計範例中，是用來表現喇叭高亢洪亮的音色。

史帝文森・布雷克 (Stephenson Blake & Co. Ltd.) 鑄字廠 (英國) 1970 年代 202×128mm

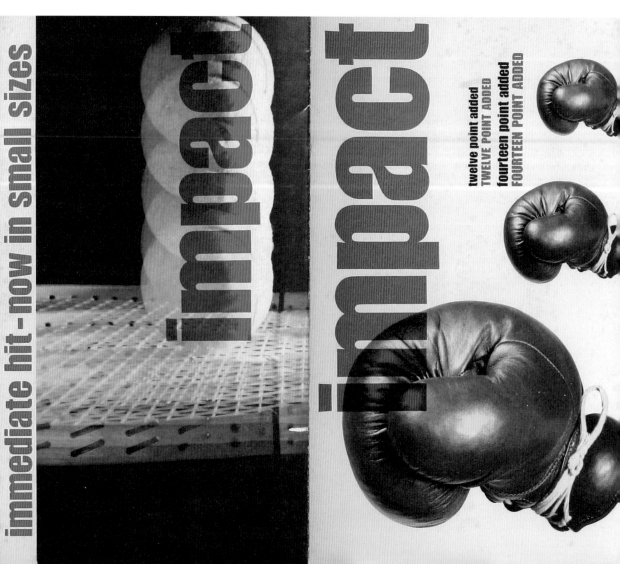

將 Impact 如其名般地營造出衝擊的效果

Impact 的折頁型錄。字如其名般,是會帶來衝擊性印象的字體。考慮到放大使用時的效果,J 與 r 都設計了兩種造型,而 & 符號的高度與英文小寫字母相同。視覺上用拳擊手套還有網球的特效,以象徵性的手法傳達出「衝擊」的印象。

史帝文森·布雷克鑄字廠(英國) 右:1960 年代
258×204mm 下:1965 年左右 205×128mm

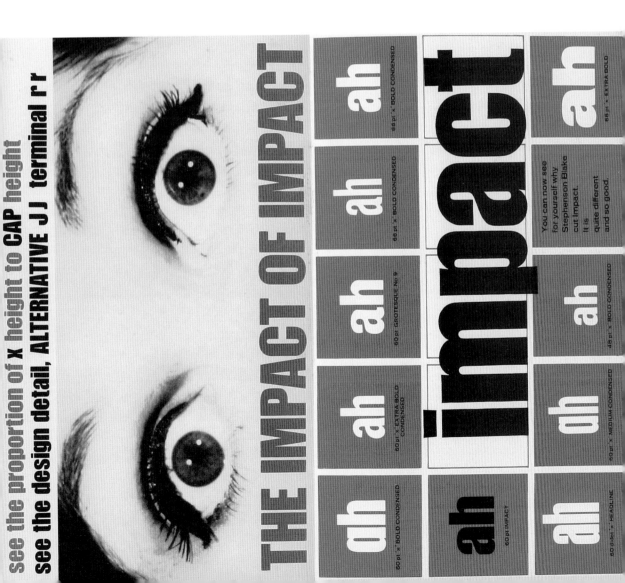

將字型家族以星形展示

不僅介紹 Helvetica 各款字型家族，也能當作活字尺寸大小的樣本，是兼具兩種用途的文宣品。斯坦普爾鑄字廠除了提供印刷業的專業人士更多排版方法，也為了讓一般平面設計師們對於字型家族的多樣性感到驚艷，而特別製作了這個文宣。當時的活字字型鑄字廠會策畫這類的推銷用文宣品，並在自家鑄字廠內部進行印刷。

斯坦普爾鑄字廠（德國） 1970 年代　185×160mm

Condensed Sans Serifs 5

ABCDEFGHIJKLM
1234567890£$
abcdefghijklmnopqr

ABCDEFGHIJKLMNOPQRST
1234567890£$,.:;-!?'([
abcdefghijklmnopqrstuvwxyz

ABCDEFGHIJKLMNOPQRSTUVWXY
ZÆŒ& 1234567890£ ,.:;-!?'([
abcdefghijklmnopqrstuvwxyzfifflflffifl

ABCDEFGHIJKLMNOPQRSTUVWXYZÆŒ
1234567890£$ -!?'([
abcdefghijklmnopqrstuvwxyzfifflflffifl

ABCDEFGHIJKLMNOPQRSTUVWXYZÆ& ,.:;-!?'([
abcdefghijklmnopqrstuvwxyzæœfiffflffifl 1234567890£$

ABCDEFGHIJKLMNOPQRSTUVWXYZ
ÆŒ& 1234567890£$ -!?'([
abcdefghijklmnopqrstuvwxyz

ABCDEFGHIJKLMNOPQRSTUVWXYZ&1234567890£$
abcdefghijklmnopqrstuvwxyz

Condensed Sans Serifs 6

ABCDEabcdef

FGHIJKLghijklmn

MNOPQRSTUVWXYZ&1
opqrstuvwxyz234567

ABCDEFGHIJKLMNOPQRSTU
abcdefghijklmnopqrstuvw

ABCDEFGHIJKLMNOPQRSTUVWXYZ
abcdefghijklmnopqrstuvwxyz ,.:;-!?

ABCDEFGHIJKLMNOPQRSTUVWXYZ& ,.:;-!?'([
abcdefghijklmnopqrstuvwxyz1234567890£$

ABCDEFGHIJKLMNOPQRSTUVWXYZÆŒ&1234567890£$
abcdefghijklmnopqrstuvwxyzæœ ,.:;-!?'([abcdefghijkl

For smaller sizes see Condensed Sans Serifs 7

Condensed Sans Serifs 12

ABCDEFGabcdefg

HIJKLMNOPhijklmnop

QRSTUVWXYZ&1234567890
qrstuvwxyzæœfiffflffifl,.:;-!?'

30 Point Large Face
ABCDEFGHIJKLMNOPQRSTUVWXY
abcdefghijklmnopqrstuvwxyz&

30 Point Small Face
ABCDEFGHIJKLMNOPQRSTUVWXYZ
abcdefghijklmnopqrstuvwxyzfiffflffifl

ABCDEFGHIJKLMNOPQRSTUVWXYZÆŒ&
abcdefghijklmnopqrstuvwxyzæœ1234£

For smaller sizes see Condensed Sans Serifs 7

**Stephenson Blake sans have the pleasing difference
to catch the eye
in to-day's dead sea waters of geometric sans**

Condensed Sans Serifs 7

ABCDabcdef

EFGHIJghijklm

KLMNOPQRSTUVZ
nopqrstuvwxyzfiff

ABCDEFGHIJKLMNOPQR
abcdefghijklmnopqrstu

ABCDEFGHIJKLMNOPQRSTUW
abcdefghijklmnopqrstuvwxyz

ABCDEFGHIJKLMNOPQRSTUVWXYZ
abcdefghijklmnopqrstuvwxyzfifflffifl

ABCDEFGHIJKLMNOPQRSTUVWXYZ& 123
abcdefghijklmnopqrstuvwxyzfifflffifl abc

ABCDEFGHIJKLMNOPQRSTUVWXYZ& ,.:;-!?'([
abcdefghijklmnopqrstuvwxyzfiffflffifl 12345678

ABCDEFGHIJKLMNOPQRSTUVWXYZÆŒ& ,.:;-!?'([
abcdefghijklmnopqrstuvwxyzæœfiffflffifl 1234567890£$

ABCDEFGHIJKLMNOPQRSTUVWX
abcdefghijklmnopqrstuvwxyz&

ABCDEFGHIJKLMNOPQRSTUVWXYZÆ
abcdefghijklmnopqrstuvwxyzæœ

Grotesque 9

ABCabcd

DEFGHIJKL
efghijkmn

MNOPQRSTUV
opqrstuvwxy

WXYZ&1234567
abcdefghijklmn

ABCDEFGHIJKLMN!
abcdefghijklmnop

OPQRSTUVWXYZ& .;-!?
qrstuvwxyz 1234567

ABCDEFGHIJKLMNOPQRSTU
abcdefghijklmnopqrstuvw

ABCDEFGHIJKLMNOPQRSTUVWXYZ
abcdefghijklmnopqrstuvwxyz .;-?

ABCDEFGHIJKLMNOPQRSTUVWXYZÆŒ&,.:;-!?
abcdefghijklmnopqrstuvwxyzæœ123456789

ABCDEFGHIJKLMNOPQRSTUVWXYZ&1234567890£$
abcdefghijklmnopqrstuvwxyzæœ,.:;-!?'abcdefghijklm

ABCDEFGHIJKLMNOPQRSTUVWXYZÆŒ&1234567890£$ABCDE
abcdefghijklmnopqrstuvwxyzæœ,.:;-!?'abcdefghijklmnopqr

Grotesque 9 italic

ABCabcd

DEFGHJKL
efghijkmn

MNOPQRSTU!
opqrstuvwxz

VWXYZ&1234
abcdefghijklno

ABCDEFGHIJKLM!
abcdefghijklmnop

NOPQRSTUVWXYZ&?
qrstuvwxyz1234567

ABCDEFGHIJKLMNOPQRST
abcdefghijklmnopqrstuvw

ABCDEFGHIJKLMNOPQRSTUVWXYZ
abcdefghijklmnopqrstuvwxyz,.:;-?

ABCDEFGHIJKLMNOPQRSTUVWXYZ&,.:;-!?'
abcdefghijklmnopqrstuvwxyz1234567890£

ABCDEFGHIJKLMNOPQRSTUVWXYZ&1234567890£$
abcdefghijklmnopqrstuvwxyz,.:;-!?'abcdefghijklmno

ABCDEFGHIJKLMNOPQRSTUV
abcdefghijklmnopqrstuvwxyz

字型與圖案的協調感 1

19 世紀的字型折頁型錄，是型態上較為古早的無襯線體 (Grotesque sans-serif)。背景選用魚的木刻版畫，應該是為了營造類似 19 世紀木口木版畫的氛圍。

史帝文森·布雷克鑄字廠 (英國) 1960–1970 年代
204×127mm

字型與圖案的協調感 2

現代無襯線體 (Modern sans-serif) Granby 的折頁型錄。以鏟子的形狀來表現字型家族的不同字重。可以稍加留意不同尺寸與字重間，有些 i 與 j 點的形狀會有不同的造型，但其實之所以會將點設計成菱形的原因，是為了與倫敦地下鐵的專用字體所搭配的設計。順帶一提的是當時倫敦的地下鐵字型並沒有細字重的款式。(譯注：倫敦地下鐵的專用字體為 Johnston)

史帝文森·布雷克鑄字廠 (英國) 1960 年代
216×127mm

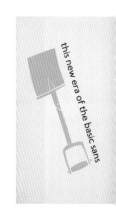

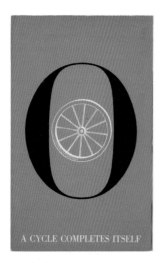

A CYCLE COMPLETES ITSELF

字型與圖案的協調感 3

Old Style No. 5、Cheltenham 與 Bodoni 的折頁型錄。將三種字體與圖案或是照片作搭配，展現字母 O 形狀上的差異。Old Style No.5 是屬於 Caslon 風格的字體。Cheltenham 曾是席捲世界的流行字體，當年擁有最多的字型家族，被稱為「20 世紀的字體」。

斯坦普爾鑄字廠（德國） 1960 年代 201×126mm

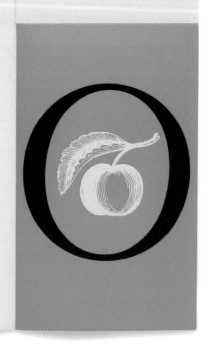

藍與紅的對比

Lectura 的折頁型錄。原始版本是阿姆斯特丹鑄字廠 (Typefoundry Amsterdam) 所設計的。將字體以顏色進行區分再針對形狀上的特徵加以解說。

斯坦普爾鑄字廠（德國） 1970 年代　212x76mm

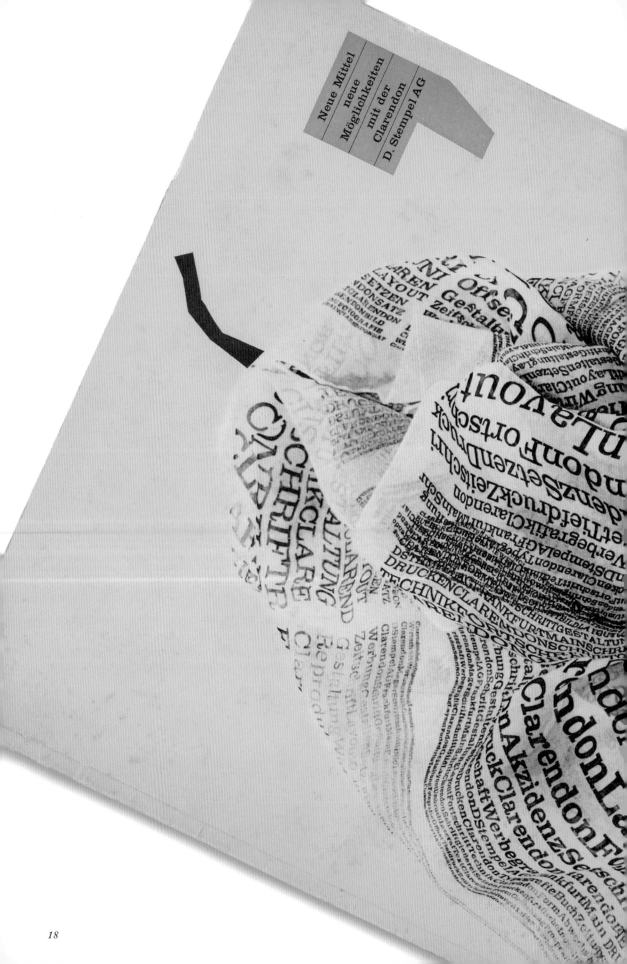

CLA REN DON

Den neuen
wachte Interesse
an der Clarendon ist
gute Gründe: für die
Werbung und Akzidenz,
für Drucke informativen
Charakters besteht eine
starke Nachfrage nach
Schriften mit solider,
sachlich klarer, unver-
brauchter Form, wie
sie die Clarendon
darstellt.

Sechs Garnituren stehen bereits
zur Verfügung:

Clarendou
mager halbfett
kräftig fett
breitfett schmalmager

Viele
Überlegungen
und Versuche
geben
einer neuen
Druckschrift
voraus.
Die endgültige
Form
wächst
langsam
und reift
mit der
Zeit.

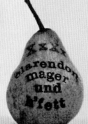

出乎意料的立體表現

在封面上以西洋梨呈現 Clarendon 字體的樣本冊。出乎意料地將文字以立體的方式呈現。在封面的逗號裡排入文句是斯坦普爾鑄字廠慣用的手法。

斯坦普爾鑄字廠（德國） 1960 年代 303×243mm

Immer wieder…

Quengeleien und Querelen zwischen Mutter und Tochter, Vater und Tochter. Generationsprobleme. Den kritischen Blick über den Brillenrand hat sie von der Mama. Denn sie hat eigene Ansichten und Meinungen. Die Persönlichkeit will sich bilden. Praktisch: an den Freunden, Lehrern, Kollegen, theoretisch: an Büchern und Zeitschriften. Sie liest Quorum (und das heißt: Beschlußfähigkeit - und das macht: beschlußfähig). Quorum ist die quicklebendige Zeitschrift der jungen Generation. In den nächsten drei Heften kommen Eltern, Erzieher, Ausbilder auf der einen und die Vertreter der jungen Generation auf der anderen Seite zu Wort. Sie sagen, begründen und belegen die aktuellen Probleme zwischen den Generationen. Frei und offen, kurzweilig und spannend sind diese Berichte, Gespräche, Gedanken. Was dort steht, geht uns alle an. Quintessenz: Quorum lesen.

Quorum
die Zeitschrift der jungen Generation.

Gaston-Antiqua und Kursiv

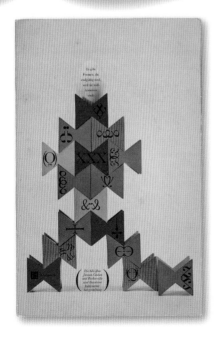

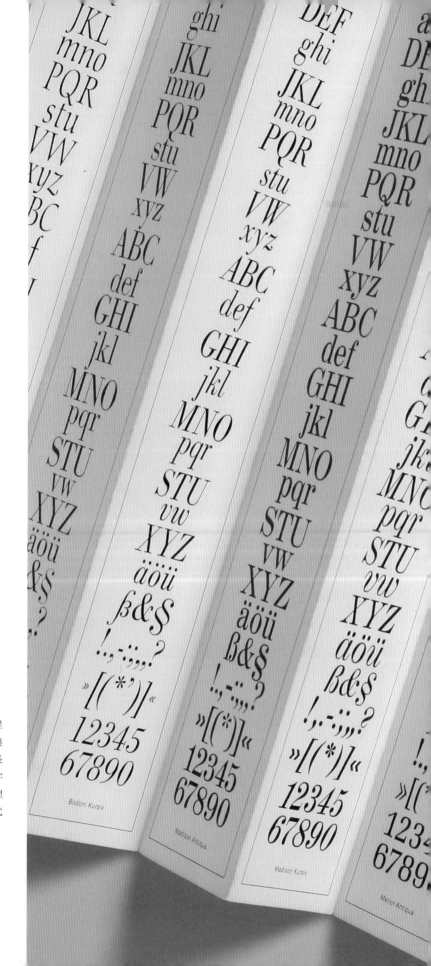

讓文字的形狀差異一目瞭然

以蛇腹折法製作的字型樣本，僅僅呈現羅馬體（Roman type）風格的字體與其附屬的義大利體（Italic type）。細長的欄位編排，讓觀者更好比較不同字體彼此之間字形上的差異。此樣本裡將 Optima 歸類為羅馬體（譯注：現代多半將 Optima 歸類為無襯線體）。

斯坦普爾鑄字廠（德國）1970 年代　297×54mm

abc DEF ghi JKL mno PQR stu VW xyz ABC def GHI jkl MNO pqr STU vw XYZ äöü ß&§ !.,-:;.? »[(*')]« 12345 67890

abc DEF ghi JKL mno PQR stu VW xyz ABC def GHI jkl MNO pqr STU vw XYZ äöü ß&§ !.,-:;.? »[(*')]« 12345 67890

abc DEF ghi JKL mno PQR stu VW xyz ABC def GHI jkl MNO pqr STU vw XYZ äöü ß&§ !.,-:;.? »[(*')]«12345

abc DEF ghi JKL mno PQR stu VW xyz ABC def GHI jkl MNO pqr STU vw XYZ äöü ß&§ !.,-:;.? »[(*')]«

abc DEF ghi JKL mno PQR stu VW xyz ABC def GHI jkl MNO pqr STU vw XYZ

Mellor Kursiv

Antiquaschriften

haben sich
organisch entwickelt.
Sie sind
unaufdringliche
Mittler des Wortes
und schaffen mit
kultivierten Formen
klare Verbindungen
zwischen Druckwort
und Leser.

Antiquaschriften

Verbinden
unvergängliche
Schönheit mit Klarheit
Zweckmäßigkeit.
Sie sind bezaubernd
und erweisen
ihre Gültigkeit heute
in zunehmendem
Maße in allen
Sachbereichen.

Antiquaschriften

Der Zeilen
und Stile, die zum

CONGRESS HALL

BERLIN

A landmark of modern architecture, Congress Hall in Berlin stands as a monument of international good will. Designed by the American architect, H. H. Stubbins, and accepted by Berliners in their typically big-city fashion, Congress Hall has earned the sobriquet of "our oyster" or "the big jaw". The reference is to the upswept design of the roof, as well as to the thousands who come from all over the world to hold their multi-lingual meetings and trade conventions beneath that distinctive roof.

下了許多工夫的活字樣本冊

工夫をこらした活字パンフレット

25

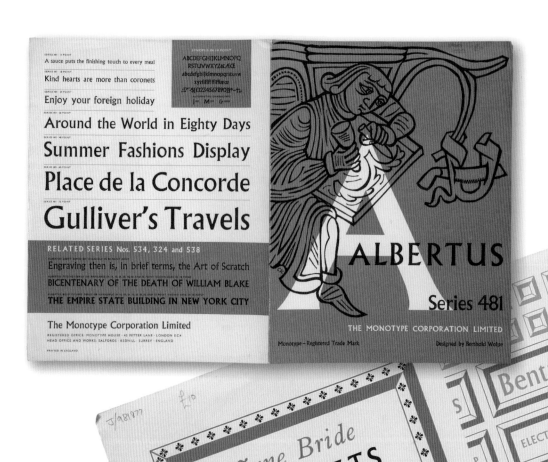

古典的標題用字體

Albertus 的折頁樣本。Albertus 誕生於現
代無襯線體的全盛時期,是特別為了重現
古典風味而被設計出的標題用字體。一開
始僅製作了大寫字母,但由於受到相當好
評,才又追加設計出小寫字母。被廣泛用
於書本標題、廣告、包裝等,也被倫敦市
官方用在街道、房屋的名牌上。

蒙納 (The Monotype Corporation Ltd.) 公司 (英國)
約1960 年代　286×222mm

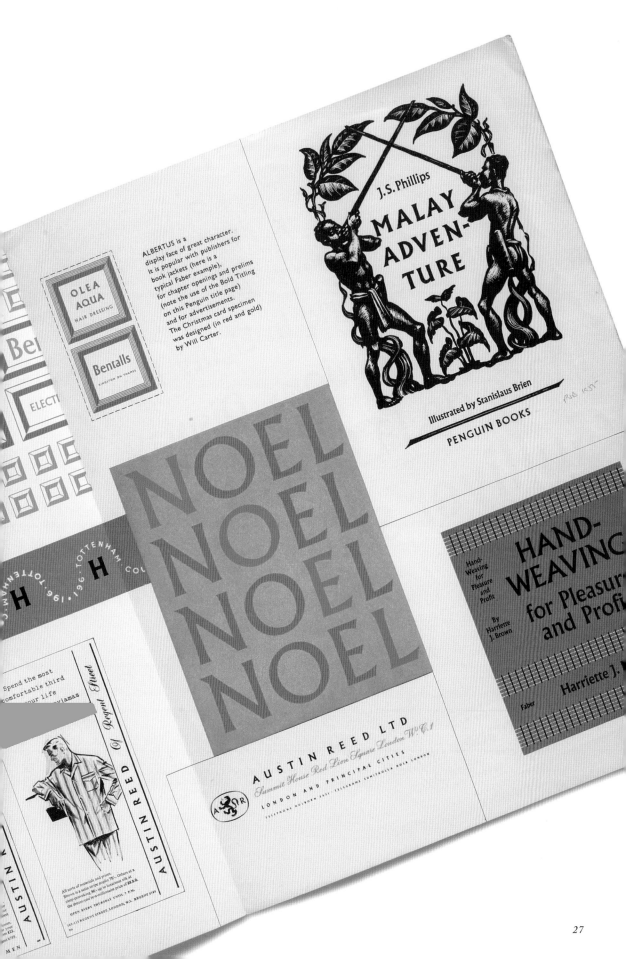

ALBERTUS is a display face of great character. It is popular with publishers for book jackets (here is a typical Faber example), for chapter openings and prelims (note the use of the Bold Titling on this Penguin title page) and for advertisements. The Christmas card specimen was designed (in red and gold) by Will Carter.

OLEA
AQUA
HAIR DRESSING

Bentalls
KINGSTON ON THAMES

J. S. Phillips

MALAY
ADVEN-
TURE

Illustrated by Stanislaus Brien

PENGUIN BOOKS

NOEL
NOEL
NOEL
NOEL
NOEL

HAND-
WEAVING
for Pleasur
and Profi

Hand-
Weaving
for
Pleasure
and
Profit

By
Harriette
J. Brown

Harriette J.

Faber

Spend the most
comfortable third
of your life

AUSTIN REED LTD
Summit House Red Lion Square London W.C.1
LONDON AND PRINCIPAL CITIES

Chocolats
de la
Reine Eugénie

16, Cour de la Grande Chaumière
CONFISEUR

Spécialité de Papillotes et Dragées de Cérémonie

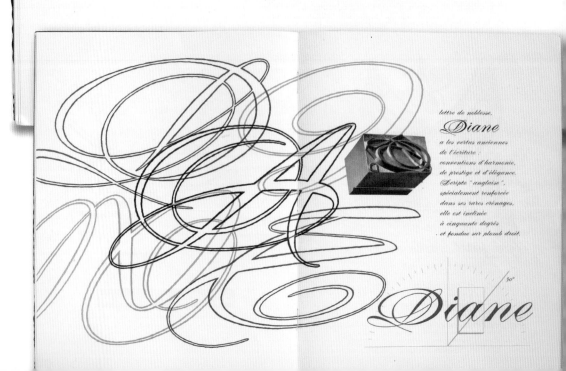

lettre de noblesse.

Diane

*a les vertus anciennes
de l'écriture :
conventions d'harmonie,
de prestige et d'élégance.
Scripte "anglaise",
spécialement renforcée
dans ses rares crénages,
elle est inclinée
à cinquante degrés
et fondue sur plomb droit.*

Diane

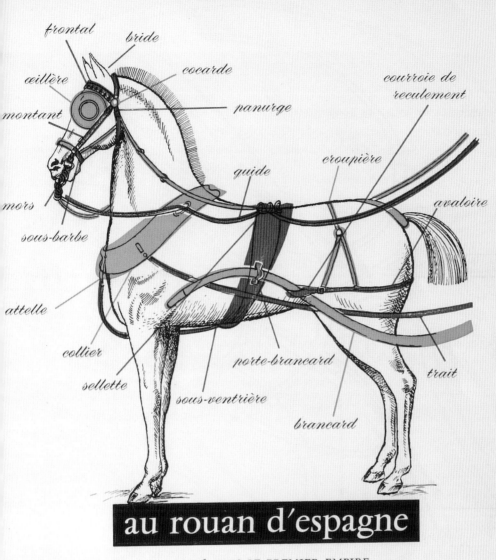

frontal · **bride** · **cocarde** · **courroie de reculement** · **œillère** · **panurge** · **montant** · **croupière** · **guide** · **avaloire** · **mors** · **sous-barbe** · **attelle** · **collier** · **porte-brancard** · **trait** · **sellette** · **sous-ventrière** · **brancard**

au rouan d'espagne

FONDÉ SOUS LE PREMIER EMPIRE

Ancien Fournisseur du Chevalier d'Orsay et de Milord l'Arsouille

86 rue de Fontenoy à Saint-Cloud

華麗且高級的印象

Diane Script 被稱作是最端莊且正式的歐文體系草寫字體。不僅適合用在邀請卡,也可運用在高級化妝品之類的包裝或是品牌 LOGO 上。想要挑選一款羅馬體與如此華麗的草書體搭配是一件相當困難的事,不過相同活字鑄造廠的一款名為 Vendôme 的羅馬體,兩者一起使用時的融合感就非常好。範例中,這兩款字體在尺寸大小的選擇上與在版面上的字數多寡等,都刻意營造出劇烈的對比,充分發揮彼此的搭配效果。

　　Diane Script 不像一般的草書體金屬活字被鑄造成具有傾斜角度的金屬字身,而是鑄成金屬長方體的樣式。由於大寫字母的字形樣貌複雜到辨認上有些困難,所以在金屬字面上會標記以供辨別用的文字(如左頁鉛字上的「D」)。另外樣本裡也提供了關於斜體角度的解說。

奧利夫 (Fonderie Olive) 鑄字廠 (法國) 1970 年代　280×224mm

用相同風格的字體營造整體感

Palatino、Michelangelo、Sistina 等 的 樣 本 冊。使用了 Palatino 的字型家族（羅馬體、義大利體、義大利體及曲飾文字〔swash〕、小型大寫字母〔small caps〕）構成版面。並搭配同樣風格的 Michelangelo 或 Sistina 作為標題字體，不但表現上更為豐富，也營造出整體感。示範了以字型家族構成版面時的一個良好提案。

斯坦普爾鑄字廠（德國） 1970 年代 301×214mm

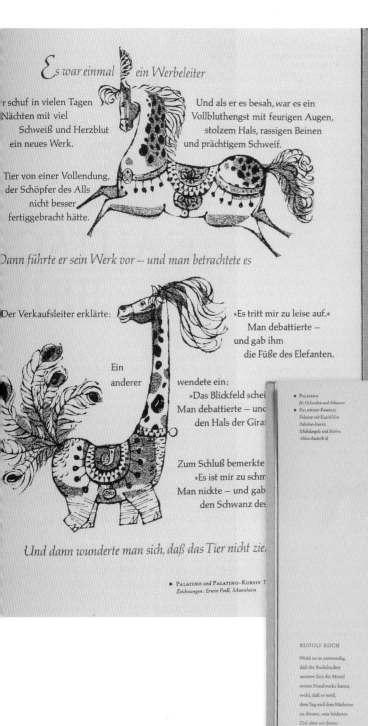

\mathcal{E}s war einmal ein Werbeleiter

r schuf in vielen Tagen
Nächten mit viel
Schweiß und Herzblut
ein neues Werk.

Und als er es besah, war es ein
Vollbluthengst mit feurigen Augen,
stolzem Hals, rassigen Beinen
und prächtigem Schweif.

Tier von einer Vollendung,
der Schöpfer des Alls
nicht besser
fertiggebracht hätte.

Dann führte er sein Werk vor – und man betrachtete es

Der Verkaufsleiter erklärte:

Ein
anderer

»Es tritt mir zu leise auf.«
Man debattierte –
und gab ihm
die Füße des Elefanten.

wendete ein:
»Das Blickfeld schei
Man debattierte – und
den Hals der Giraf

Zum Schluß bemerkte
»Es ist mir zu schm
Man nickte – und gab
den Schwanz des

Und dann wunderte man sich, daß das Tier nicht zie

• PALATINO *und* PALATINO-KURSIV T
Zeichnungen: Erwin Poell, Mannheim

• PALATINO
für Urkunden und Adressen
• PALATINO-FAMILIE
*Palatino mit Kapitälchen
Palatino-Kursiv
Michelangelo und Sistina
Aldus-Buchschrift*

Pakkt an!

Laßt se
bis trie

GAUTSCH
BRIEF

Von C
Jeder
zu wi

H
nach .
der H
erhal
verlie
Kraff
geno

RUDOLF KOCH

Wohl ist es notwendig,
daß der Buchdrucker
unserer Zeit die Mittel
seines Handwerks kennt,
wohl, daß er weiß,
dem Tag und dem Nächsten
zu dienen, sein höchstes
Ziel aber sei dieses:
Jeden Gegenstand, der
aus seinen Händen
kommt, zu einem Sinnbild
des Unendlichen zu
machen dadurch, daß er
ihn schön macht.

GAUTSCHMEISTER	*Arthur Wetzig*
ERSTER PACKER	*Leonhard Th. Keller*
ZWEITER PACKER	*Gustav Stenger*
SCHWAMMHALTER	*Heinrich Egenolf*
ZEUGEN	*Günther Schön*
ORT UND TAG	*Mainz, den 21. 6. 1954*

22

23

相當舒服的平衡感

使用美國制的點號系統 (American Point) 並以英語編排的樣本書。下圖中的標題是拿帶有曲飾線的字母 (swash letter) 跟 Palatino Italic 一起組合使用。文章的開頭使用了小型大寫字母，內文則是羅馬體。頁面、文字尺寸、寬鬆的行距等設定令人感到相當舒服。右頁是 Sapphire 與 Optima 的廣告樣本。裝飾風格的 Sapphire 與沉穩感覺的 Optima 兩者搭配起來，在色彩或大小上都呈現絕妙的平衡感。頁面的布局與擺位、框線 (border)、裝飾花樣，還有行距的平衡感都令人相當舒服。

斯坦普爾鑄字廠 (德國)　1960 年代　297×210mm

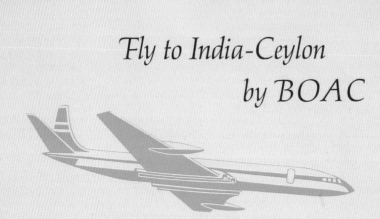

Fly to India-Ceylon
by BOAC

ONCE SURRENDER to the fascinations of these two great countries of the East and you'll want to return again and again. For here are some of the world's masterpieces of art and architecture—the magnificent heritage of centuries-old cultures and traditions. Scattered throughout the vast expanse of India and in the Northern plains of Ceylon are the fabulous palaces and temples of bygone days—some seemingly untouched by time, others whose splendour in ruin is even more beautiful and impressive. In contrast to this background of antiquity stand the great modern cities—New Delhi, Bombay, Calcutta, Madras, Colombo . . . with their fine public buildings, busy thoroughfares, luxury hotels and prosperous business houses—symbols of the industrial and economic development which is taking place in these historic countries. Courteous, charming and friendly, the peoples of India and Ceylon welcome you to their hospitable shores, happy to entertain you, proud to share your enthusiasm for the delights of their lovely lands.

British Overseas Airways Corporation

RAMON
MONTEVERDE

Comercio al por mayor en tabaco

Fábricas de cigarrillos

Fincas de tabaco

Recomendamos

el uso de los cigarrillos

de esta casa

ANTONIO CONZARES
CADIZ

Herbst und Winter Moden 1966

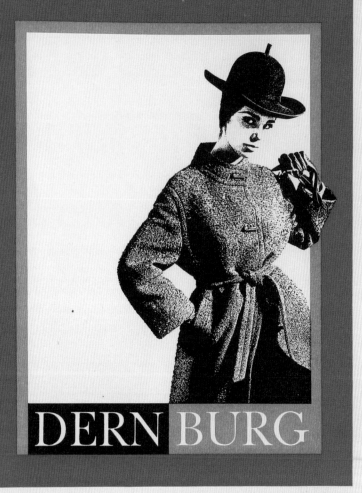

DERN BURG

Motiv des Firmenzeichens beherrscht die Titelseite des Kataloges (oben), auf dessen Innenseiten (unten) sich die Modelle, durch den Umschlag als zum Haus gehörig nzeichnet, nun freier bewegen können.

Modell **MINDORO**

Sehr sportlich, sehr kleidsam — ein extravagantes Modell der neuen Winterkollektion, für Dernburg exklusiv entworfen von dem bekannten New Yorker Meistercouturier Edward Sax.

Modell **MANITOBA**

Ein molliger Mantel aus Kanada-Tweed ist der passende Anzug für den winterlichen Spaziergänger. Dieses großzügig geschneiderte Modell in Indischrot, Klinkerbraun oder Torontogrün hat das heuer so beliebte elegant saloppe Flair.

Vous avez soif de…
Le jus de fruits est là,
toujours prêt à être servi!
our votre teint, pour votre
anté, pour votre silhouette,
buvez régulièrement de

us de fruits naturel

*Facile à conserver, à transporter, à utiliser,
le jus de fruits naturel en boîtes de 13 cl 5 ou
55 cl, vous offre la plus riche sélection de
fruits d'origine récoltés à la meilleure époque:
orange, ananas, pamplemousse, tomate, abricot.
Dix boîtes de 13 cl 5 représentent
en moyenne le jus de trente oranges
ou de vingt pamplemousses,
si vous deviez les
presser vous-même*

Hierbij hebben wij de eer u mede te delen dat onze procuratie-
houder, de heer S. Kuhfuss, na vijfentwintig jaar zijn beste krachten
aan onze vennootschap te hebben gewijd, zich om gezondheidsredenen
genoodzaakt heeft gezien zijn werkzaamheden neer te leggen.

Tevens maken wij van deze gelegenheid gebruik u te berichten,
dat wij met ingang van 1 januari 1965 bijzondere procuratie hebben
verleend aan de heer B. Achsen, voordien chef van ons kantoor Basel.
Hiermede is de aan de heer Kuhfuss verleende volmacht vervallen.
Overeenkomstig artikel 2a van onze Statuten wordt de vennoot-
schap verbonden door twee directeuren of door een directeur en een
procuratiehouder.

De heer Achsen zal tekenen

Y. B. Achsen

Biedermayer & Co.
Zürich

HORNPIPES · REELS · SCOTTISHES · POLKAS · WALTZES

TUNE BOOK

PRINTED FOR THE NORTHI...

Baskerville 與 Bembo 的使用範例

雖然 Baskerville 是書籍排版專用的字體,但
其實也頗適合用於廣告、書籍裝幀等等的場
合。右下圖則是使用 Bembo 字體排版的效
果。這些樣本展示了一些不錯的使用範例,擴
展了以往所認知的字體使用範圍與可能性。

左頁:斯坦普爾鑄字廠 (德國) 1960 年代 300×213mm
右頁:恩斯赫德 (Jon. Enschedé & Zonen) 鑄字廠 (荷蘭)
1970 年代 287×141mm

Sluit
donkerte
buiten
&
haal
gezelligheid
binnen
met

LUX *armaturen*

MADE IN ITALY

*Uitgevoerd in

blank metaal en

gekleurd glas*

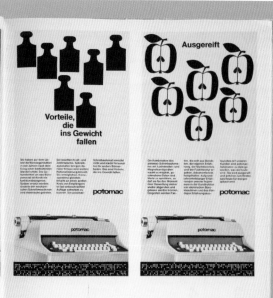

A landmark of modern architecture, Congress Hall in Berlin stands as a monument of international good will. Designed by the American architect, H. H. Stubbins, and accepted by Berliners in their typically big-city fashion, Congress Hall has earned the sobriquet of "our oyster" or "the big jaw". The reference is to the upswept design of the roof, as well as to the thousands who come from all over the world to hold their multi-lingual meetings and trade conventions beneath that distinctive roof.

以無襯線體做出柔軟的排版

Helvetica 的排版範例。如左上所示，依據圖案與標題擺放方式不同，儘管內文的版型都相同，但給人的印象就會相當不一樣。在日本，使用無襯線體時幾乎都是將文章排成頭尾左右切齊（justified text）的矩形排版；但其實歐美的作法通常是行頭靠左對齊（flush left）而右邊行尾不對齊（ragged right）的方式，詞距與行距的平衡感也令人感到非常舒服。如本頁右上一般，使用框線之類的裝飾活字，以簡潔的幾何圖案（墨水瓶與蘋果）取代插圖，也能充分發揮良好的效果。化妝品的廣告，也很自然地使用置中的對齊方式，讓原本堅硬感的無襯線體營造出柔軟的排版效果。

斯坦普爾鑄字廠（德國） 1960 年代 301×213mm

helvetica
helvetica
helvetica
helvetica

Satzanwendungen und Druckbeispiele

BUILDING CONSTRUCTION TUITION GRANTS

Tuition grants in Building Construction Technology are available to eligible high school graduates at the North American Institute. Classes begin in September, 1964.

Associate in Science Degrees are awarded upon successful completion of this two-year curriculum, designed to develop skilled personnel for management opportunities in the vast building construction industry.

These management opportunities include such jobs as junior field engineer, estimator, expediter, quantity surveyor, construction executive, and even general building contractor.

DELIVER US FROM GHOULIES AND GHOSTIES AND LONG-LEGGITY BEASTIES AND THINGS THAT GO BUMP IN THE NIGHT

NO ADMITTANCE EVER

VACATION 1964 ALL DEPARTMENTS CLOSED FROM JUNE 26 TO JULY 13

各式各樣的頭條標題

Headline 的樣本型錄。Headline、Headline Open 是廣告專用的字型，是為了盡可能地讓行距能縮到最窄的情況下使用而設計的字體。雖然通常被用在頭條標題，但若與中空 (open face) 的字型款式或其他的字體作搭配，加上尺寸大大小小所組合出的不同平衡感，可以藉此創造出全新的可能性。

路德維希與梅耶 (Ludwig & Mayer GmbH) 鑄字廠 (德國) 1960 年代 245×174mm

...r courses for the advanced student

CHINESE

...or for the visitor to foreign countries

FRENCH

...and guidance of native instructors

GERMAN

each course: $ 35.00

ITALIAN

...epartment: university on the green

RUSSIAN

south mountain, colorado

SPANISH

HEAD**LINE**

is available in a complete range of sizes

from 20 to 72 point ...

the accompanying HEADLINE OPEN

from 20 to 60 point.

...LL ARE WELCOME
...LL ARE WELCOME

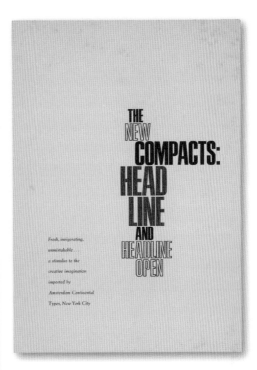

THE NEW COMPACTS: HEAD LINE AND HEADLINE OPEN

Fresh, invigorating, unmistakable ... a stimulus to the creative imagination imported by Amsterdam Continental Types, New York City

The Graphic Signs Called Letters Are So Co
20

The Graphic Signs Called Letters Are
24

The Graphic Signs Called Letter
28

The Graphic Signs Called
36

The Graphic Signs
48

The Graphic Si
60

abcd efgh iiklm nopqr stuvw xyz gjpqy

HEADLINE OPEN
with lowercases

[L+M] Ludwig & Mayer Type Foundry, Frankfurt, West Germany

travel with ○○○○○

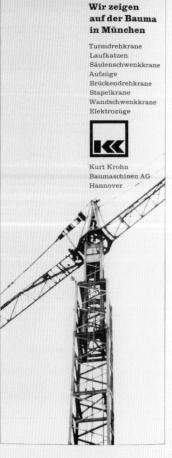

**Wir zeigen
auf der Bauma
in München**

Turmdrehkrane
Laufkatzen
Säulenschwenkkrane
Aufzüge
Brückendrehkrane
Stapelkrane
Wandschwenkkrane
Elektrozüge

**Kurt Krohn
Baumaschinen AG
Hannover**

**Auf der
Bauma 1965**

führen wir Ihnen
unsere Baumaschinen
in Betrieb vor.
Besuchen Sie uns.

**Kurt Krohn
Baumaschinen AG
Hannover**

Fachzeitschriften-Inserate zeigen besondere Ereignisse an, die den
tiellen Kundenkreis mit dem Hersteller zusammenbringen. Die inter-
en Bildausschnitte wirken wie Signale, welche auf die Kurzinfor-
n aufmerksam machen. Die treffliche Beziehung von Bild und Schrift
enbar.

拓展豐富的字型家族

Clarendon 的型錄。將 18–19 世紀時被設計出
的 Clarendon，重新設計成更具現代感的新版
本。與舊版相比，加大字母寬度後的新版本不
僅帶來了一股全新的視覺感受，也更加充實了
字型家族的款式豐富性。拿來排像是注解、圖
說等文章時，能讓讀者留下特別深刻的印象。
若善加運用豐富的字型家族，就能創造出更多
不同的版面表現。

斯坦普爾鑄字廠（德國） 1960–1970 年代 　左：299×213mm
上、右：220×211mm

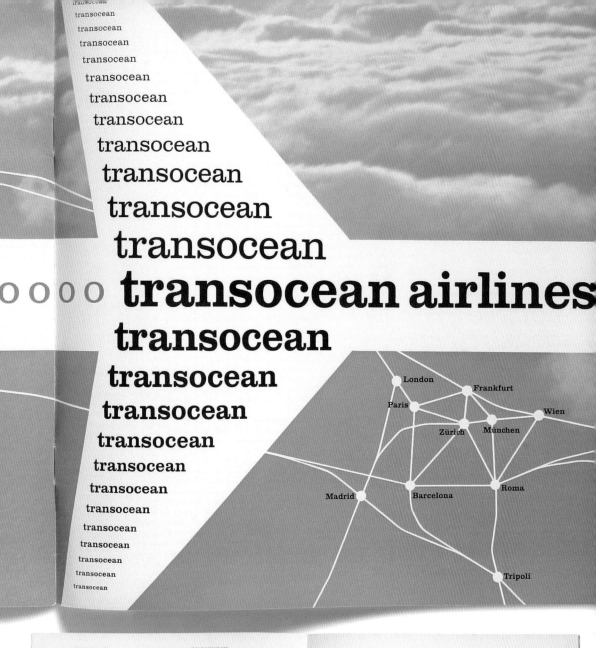

transocean airlines

London · Frankfurt · Paris · Wien · Zürich · München · Madrid · Barcelona · Roma · Tripoli

Leading comparison

10 pt i.1 regular solid
The instruments below were assembled by the Parisian collector Jacques Kugel. The gilded brass box in the center, made in Germany in the sixteenth century, is a multiple-faced sundial. Its top is a sundial with a compass, and its sides are other sundials, for use at different latitudes. The box held the three richly ornamented smaller boxes in the picture. Above the sundial is a multipurpose instrument called an astronomical compendium, fashioned from gilded and silvered brass. It was probably made by Christopher Schissler, of Augsburg, around 1600. The ivory tablet sundial, inlaid with silver, was made by CHARLES BLOUD, OF DIEPPE, AROUND

10 pt i.1 regular 1 point leaded
The instruments below were assembled by the Parisian collector Jacques Kugel. The gilded brass box in the center, made in Germany in the sixteenth century, is a multiple-faced sundial. Its top is a sundial with a compass, and its sides are other sundials, for use at different latitudes. The box held the three richly ornamented smaller boxes in the picture. Above the sundial is a multipurpose instrument called an astronomical compendium, fashioned from gilded and silvered brass. It was probably made by Christopher Schissler, of Augsburg, around 1600. The ivory tablet sundial, inlaid with silver, was made by CHARLES BLOUD, OF DIEPPE, AROUND

10 pt i.1 regular 2 point leaded
The instruments below were assembled by the Parisian collector Jacques Kugel. The gilded brass box in the center, made in Germany in the sixteenth century, is a multiple-faced sundial. Its top is a sundial with a compass, and its sides are other sundials, for use at different latitudes. The box held the three richly ornamented smaller boxes in the picture. Above the sundial is a multipurpose instrument called an astronomical compendium, fashioned from gilded and silvered brass. It was probably made by Christopher Schissler, of Augsburg, around 1600. The ivory tablet sundial, inlaid with silver, was made by CHARLES BLOUD, OF DIEPPE, AROUND

10 pt i.1 semi-bold solid
The instruments below were assembled by the Parisian collector Jacques Kugel. The gilded brass box in the center, made in Germany in the sixteenth century, is a multiple-faced sundial. Its top is a sundial with a compass, and its sides are other sundials, for use at different latitudes. The box held the three richly ornamented smaller boxes in the picture. Above the sundial is a multipurpose instrument called an astronomical compendium, fashioned from gilded and silvered brass. It was probably made by Christopher Schissler, of Augsburg, around 1600. The ivory tablet sundial, inlaid with silver, was made by CHARLES BLOUD, OF DIEPPE, AROUND

10 pt i.1 semi-bold 1 point leaded
The instruments below were assembled by the Parisian collector Jacques Kugel. The gilded brass box in the center, made in Germany in the sixteenth century, is a multiple-faced sundial. Its top is a sundial with a compass, and its sides are other sundials, for use at different latitudes. The box held the three richly ornamented smaller boxes in the picture. Above the sundial is a multipurpose instrument called an astronomical compendium, fashioned from gilded and silvered brass. It was probably made by Christopher Schissler, of Augsburg, around 1600. The ivory tablet sundial, inlaid with silver, was made by CHARLES BLOUD, OF DIEPPE, AROUND

10 pt i.1 semi-bold 2 point leaded
The instruments below were assembled by the Parisian collector Jacques Kugel. The gilded brass box in the center, made in Germany in the sixteenth century, is a multiple-faced sundial. Its top is a sundial with a compass, and its sides are other sundials, for use at different latitudes. The box held the three richly ornamented smaller boxes in the picture. Above the sundial is a multipurpose instrument called an astronomical compendium, fashioned from gilded and silvered brass. It was probably made by Christopher Schissler, of Augsburg, around 1600. The ivory tablet sundial, inlaid with silver, was made by CHARLES BLOUD, OF DIEPPE, AROUND

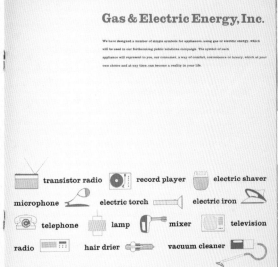

Gas & Electric Energy, Inc.

We have designed a number of simple symbols for appliances, using gas or electric energy, which will be used in our forthcoming public relations campaign. The symbol of each appliance will represent to you, our consumer, a way of comfort, convenience or luxury, which at your own choice and at any time, can become a reality in your life.

transistor radio · record player · electric shaver
microphone · electric torch · electric iron
telephone · lamp · mixer · television
radio · hair drier · vacuum cleaner

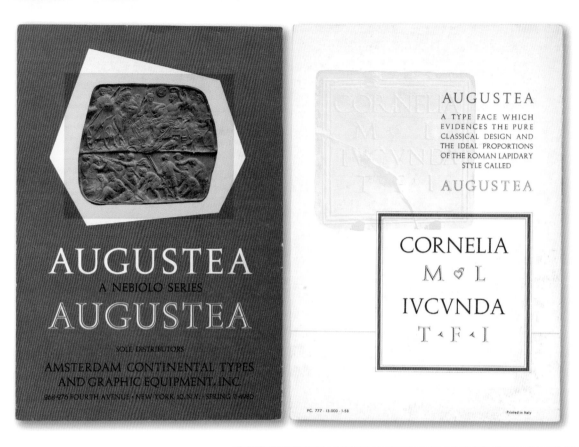

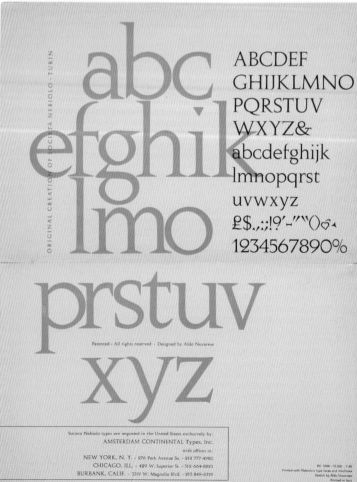

傳達出歷史與傳統印象的字體

上圖中的 Augustea Roman、Augustea Roman
Inline，由於是復刻古代羅馬石碑上的字體，
因此只有大寫字母的設計。此外，像是句點、
逗號跟間隔號等等的點都呈三角形。右圖是
為了內文排版專用而設計的 Nova Augustea，
字母造型設計上也深受羅馬碑文影響，因此
能賦予讀者歷史與傳統的印象。

內比歐羅 (Societa Nebiolo) 鑄字廠 (義大利) 1960 年代
上：245×172mm　右：340×245mm

nova Augustea

The upper case Latin letterform was perfected during the Age of Augustus, the lower case not until the Renaissance. The former was derived from ancient Greek and Phoenician symbols, the latter from humanistic and Carolingian scripts. Combining these two styles into a single, consistent type face was a difficult assignment for the early type designers, who worked in Italy. The type styles which they developed for use on their hand presses were not all equally successful. Designing lower case letters equal to the classical Roman capitals was the task undertaken by the Nebiolo Typefoundry, when it sought to complete the renowned AUGUSTEA family, inspired by the forms of the ancient stonecutters' letters.

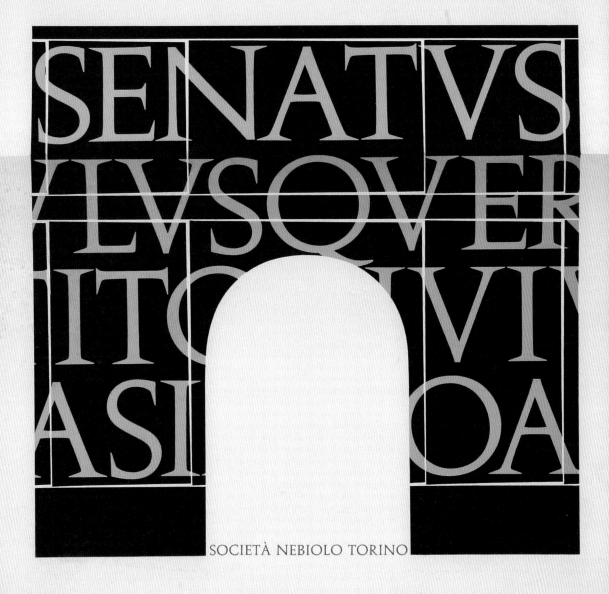

SOCIETÀ NEBIOLO TORINO

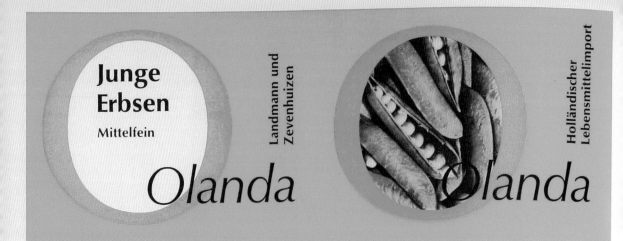

Junge
Erbsen

Mittelfein

Olanda

Landmann und
Zevenhuizen

Holländischer
Lebensmittelimport

Olanda

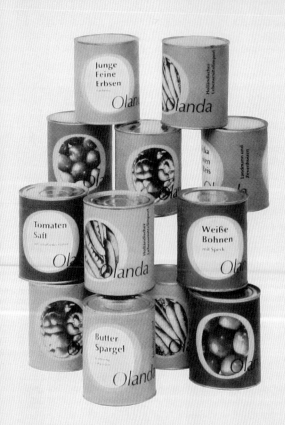

Für den größten Teil der Konsumgüter ist das Gesicht der Packung, das den Hersteller ausweist, zum Garanten für die Güte des Inhalts geworden. Der Kunde muß dem verpackten Erzeugnis vertrauen, weil er es beim Kauf nicht prüfen kann. So kommt der richtig und gut gekennzeichneten Warenpackung eine bedeutende werbliche Aufgabe zu, der die Packung nur genügen kann, wenn sie genug optische Intensität besitzt und schnell und ausreichend darüber informiert, was die Ware betrifft und ihren Hersteller. Das große O und die Wortmarke als immer wiederkehrende Merkzeichen sind ein einprägsames grafisches Motiv, das die Firma Olanda auch auf der Packung repräsentiert.

Oben: Ein Standardetikett für Dosen.

Links: Wiedergabe von Dosen mit verschiedenem Inhalt. Mit dem Bildmotiv und der Warenbezeichnung ist jeweils die Grundfarbe geändert; sie ist werbepsychologisch dem Inhalt entsprechend angepaßt: z.B. Erbsen - grün, Pflaumen - blau, Tomatensaft - rot usw.

Wer Werbung bis zur letzten Konsequenz betreibt, findet immer neue Werbeträger: Fabrik- und Geschäftsfronten, die Innenausstattung der Verkaufsräume, Messestände, Werbegeschenke und das rollende Material des Unternehmens. Besonders wirksam ist die Beschriftung bei Lastzügen und Lieferwagen durch die überraschende Präsentation auf Autobahnen, Landstraßen und im Stadtverkehr.

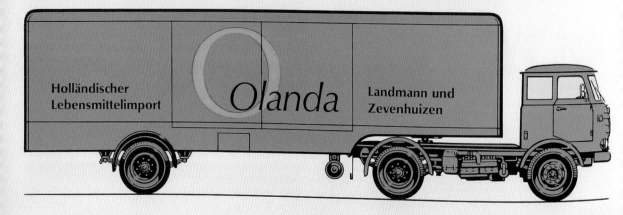

Holländischer
Lebensmittelimport

Olanda

Landmann und
Zevenhuizen

珍貴的無襯線羅馬體

赫爾曼‧察普夫 (Hermann Zapf) 所設計的 Optima 是一套用途非常廣的字體。風格分類上是屬於羅馬體而不是無襯線體，所以拿來排內文也能讓人輕鬆閱讀。也很常被運用於廣告上。

斯坦普爾鑄字廠 (德國) 1960 年代　左：299×213mm　下：220×211mm

Optima® ®

Regular
Italic
Medium
Semi Bold
Black

The Optima type family in five weights, designed by Hermann Zapf, takes a special place as a link between Roman and Sans Serif in contemporary type creation. Its crisp and smart style unites the clarity and expressiveness of classistic forms with the simplicity and the mechanical efficiency of the linear sans-serif designs. There are advantages in this synthesis which make the design as suitable for book and catalogue composition as for display typography. These were responsible for Optima's world-wide success and its recent extensive usage in fine typography in the U.S.A. The first three weights, Regular, Italic and Semi Bold, appeared in the U.S.A. in the year 1960. Now, two more weights have been developed which considerably increase the application range of the type family. The new weights are in the first place a valuable complement with respect to Optima application on coated stocks and in offset and gravure printing. With this purpose in mind, the strokes of the Medium in comparison with the Regular and those of the Black in comparison with the Semi Bold were notably enforced. The smaller sizes of the five Optima weights are also available with identical image in Linotype matrices. This further extends the scope of Optima's practical application suitability. Optima, in its many forms, will now meet the widely diversified typographic requirements of the Graphic Arts Industry.

D. Stempel AG Typefoundry Frankfurt am Main

Optima-Antiqua

ABCDEFGHIJKLMNOPQR
STUVWXYZ &.,-:;!?'()/ $ 1234567890
abcdefghijklmnopqrstuvwxyz fffifl

Optima® Medium

The basic character in a type design is determined by the uniform design characteristics of all letters in the alphabet. However, this alone does not determine the standard of the type face and the quality of composition set with it. The appearance is something complex which forms itself out of many details, like form, proportion, ductus, rhythm etc. If everything harmonizes, the total result will be more than the sum of its components. The only reliable basis for the design of a type is a positive FEELING FOR FORM AND STYLE. IN ORDER TO

The basic character in a type design is determined by the uniform design characteristics of all letters in the alphabet. However, this alone does not determine the standard of the type face and the quality of composition set with it. The appearance is something complex which forms itself out of many details, like form, proportion, ductus, rhythm etc. If everything harmonizes, the total result will be more than the sum of its components. The only reliable basis for the design of a type is a positive FEELING FOR FORM AND STYLE. IN ORDER TO

The basic character in a type design is determined by the uniform design characteristics of all letters in the alphabet. However, this alone does not determine the standard of the type face and the quality of composition set with it. The appearance is something complex which forms itself out of many details, like form, proportion, ductus, rhythm etc. If everything harmonizes, the total result will be more than the sum of its components. The only reliable basis for the design of a type is a positive FEELING FOR FORM AND STYLE. IN ORDER TO

The basic character in a type design is determined by the uniform design characteristics of all letters in the alphabet. However, this alone does not determine the standard of the type face and the quality of composition set with it. The appearance is something complex which forms itself out of many details, like form, proportion, ductus, rhythm etc. If everything harmonizes, the total result will be more than the sum of its components. The only reliable basis for the design of a type is a positive FEELING FOR FORM AND STYLE. IN ORDER TO

The basic character in a type design is determined by the uniform design characteristics of all letters in the alphabet. However, this alone does not determine the standard of the type face and the quality of composition set with it. The appearance is something complex which forms itself out of many details, like form, proportion, ductus, rhythm etc. If everything harmonizes, the total result will be more than the sum of its components. The only reliable basis for the design of a type is a positive FEELING FOR FORM AND STYLE. IN ORDER TO

The basic character in a type design is determined by the uniform design characteristics of all letters in the alphabet. However, this alone does not determine the standard of the type face and the quality of composition set with it. The appearance is something COMPLEX WHICH FORMS ITSELF OUT OF MANY DETAILS, LI

Report on the Commerce and Manufactures of Canada

National Institute of Industrial Psychology

Geometrical Composition and Design

Pyramids and Temples of Gizeh

Madison Square Garden

British Thermal Units

MECHANICS OF VIBRATION

Melior Bold Condensed

Melior

An original type design by Hermann Zapf

能改變版面印象的羅馬體

Melior 也是赫爾曼．察普夫
以羽毛筆寫出的字體為發想
所設計出的活字字型。當作
型錄等等的內文字體不但很
好閱讀，而且相較於一般常
見的羅馬體所排出的感覺，
更能賦予讀者截然不同的版
面印象。

斯坦普爾鑄字廠（德國） 1960 年代
270×190mm

pens pressure pins ballpoint pens slide rules curve rul

rubber erasers copying pencils rectangles drawing rul

four-color pencils rulers pencils all kinds of writing lea

scales fountain pens calculating disks shorthand penc

goniometers sketch pencils

Wherever fractions of seconds count...

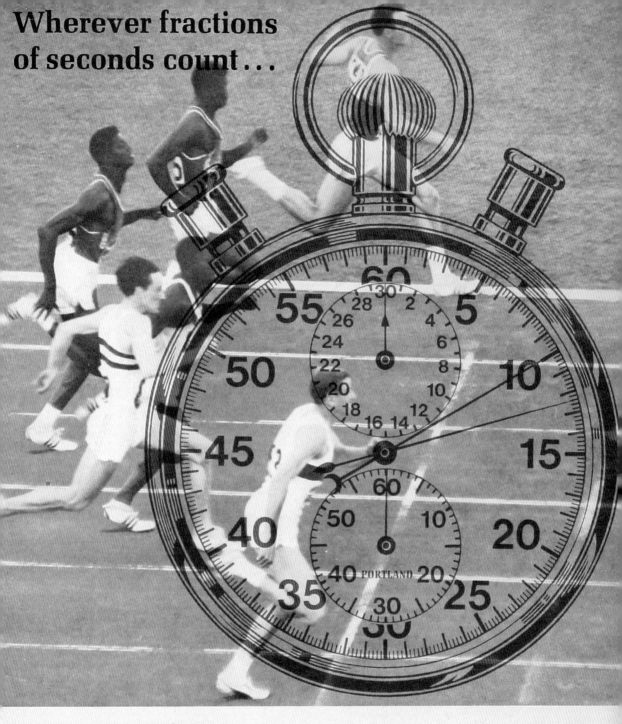

The fastest runner of the world spurts in vain if he is not accompanied by incorruptible clockwork. From start to finish — fractions of seconds decide — it pursues him step by step. It stops him faster, more precisely than he is able to stop himself.

Portland Inc. Precision Watch Manufacturers

507 North Street Springfield, Mass.

Societa Nebiolo

BGFM

Sammeln Sie unsere Kleinpropaganda, sie gibt Ihnen wertvolle Anregungen

Gedruckt auf Zerkall-Bütten der Papierfabrik Zerkall Renker & Söhne, Zerkall über Düren/Rhld.

ELISABETH

*E*LISABETH FRIEDLANDER, die Künstlerin, die diese Schrift entwarf, kommt aus einer strengen Schule. Ihr Lehrer war E.R.Weiß, und die Antiqua *Elisabeth* verleugnet diese Herkunft nicht. Das ungewöhnlich schöne Bild dieser Schrift dürfte nicht zuletzt auf dem reizvollen Kontrast beruhen, der durch die Bindung zarter Schriftzüge an ein festes Formgesetz entstand. Die *Elisabeth* gehört zu den Schriften, die dem Buchdrucker für den Satz von Qualitätsdrucksachen zur Verfügung stehen.

BAUERSCHE GIESSEREI FRANKFURT AM MAIN W13

ELISABETH-ANTIQUA	ELISABETH-KURSIV
Verzeichnis historischer Denkmäler und Bauten in Frankfurt am Main	Ein Umstand schöner Bücher aus der Produktion deutscher Verlagshäuser
Scipios Feldzug beendet die glanzvolle Geschichte Karthagos	Neue Literaturhinweise für alle Freunde der bildenden Kunst
Luftkurorte und Gasthäuser in südlichen Schwarzwald	Vollstümliches Schrifttum des neunzehnten Jahrhunderts
Umsonst suchen Narren in Klugen nach Verstand	Erlebnisse eines Autors und der Einfluß auf sein Werk
Musarion oder die Philosophie der Grazien	Das zeitgenössische Romanschaffen in Schweden
Bildherstellung für jede Druckmethode	Subskriptionspreise im Inlandsbuchhandel
Entwicklung der ägyptischen Kunst	Lebensalter und Erfolgsperioden Kafkas
Römische Kirchenbaumeister	Sonderexemplar für Bibliophile
Plastik von Michelangelo	Reformen des Verlagsrechts
Kindheitserinnerung	Bestseller aus Amerika
Stromlinienform	Neuerscheinungen
Bücherschatz	Fachzeitschrift

...zart
...7, D-Dur
...Viola, Baß
...ei Hörner, KV 205
...rgo Allegro Menuetto I
Adagio Menuetto II
Finale Presto

Anton Bruckner
Sinfonie Nr. 1, c-Moll
Sätze: I. Allegro II. Adagio
III. Scherzo IV. Finale,
bewegt, feurig

...ngelbert Scholl

...Richard Riemann,
...oline und Viola

如同女性般優雅的字體

左圖的 Diotima 是赫爾曼·察普夫的妻子古德龍·察普夫·馮·哈塞（Gudrun Zapf-von Hesse）所設計的。右圖的 Elizabeth 是埃米爾·魏斯（Emil Weiss）的弟子伊麗莎白·弗里德蘭德（Elizabeth Friedlande）所設計，這兩套出自女性字體設計師之手的字體，也如同女性一般具有纖細優雅的氣質，很適合用在以女性為客群的刊物或印刷品上。

左：斯坦普爾鑄字廠（德國） 1960 年代 210×99mm
右：鮑爾（Bauersche Giesserei）鑄字廠（德國）
1960 年代 97×216mm

宣揚自家公司 Garamond 的正統性

勒德洛 (Ludlow) 鑄字廠所製作的 Garamond 樣本冊，以排版來說是相當高水準的範例。此外，這樣本的獨特之處在於附上傳承自克洛德・加拉蒙 (Claude Garamond) 於 1952 年製作的字型樣本 (參見翻開的樣本冊左頁)，藉此誇耀自家公司旗下 Garamond 字型的正統性。

勒德洛鑄字廠 (美國) 1930 年代 306×222mm

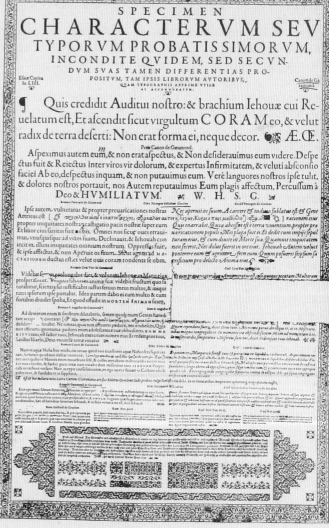

THE BERNER SPECIMEN BROADSIDE OF 1592

THE GARAMOND TYPEFACE

In spite of Garamond's far reaching influence upon all type design since his time, there is but little that is definitely known of the origin of the letter forms that gave him fame. Hence it has come to pass that the present-day typefaces known by his name are not derived from a type by Garamond himself, but from a face cut long after his death by another and less skillful hand. This later face, however, had acquired the fame of being cut by Garamond, and for that reason it deserves the attention of typographers.

In 1611, Jean Jannon, a printer and also a typefounder who had been trained in the famous Estienne establishment, left Paris to take a position as printer to a Calvinist academy at Sedan. Here he had difficulty in procuring materials for his work and therefore undertook, between 1615 and 1621, the cutting of a series of types for his own use. In 1621 he issued a specimen book showing his types, and in an introduction to this book he made it clear that the types shown were of his own creation. In 1642 the Protestant city of Sedan came into the power of Cardinal Richelieu, and Jannon's punches and matrices, at least in part, were taken for the use of the Cardinal. For in that same year, while the famous prelate lay on his deathbed, there appeared from the recently created Imprimerie Royale a book, *Les Principaux Poincts de la Foy Catholique*, of which Richelieu was the author, printed in three sizes (approximately 18, 24, and 36 point) of a type that was unquestionably cast from matrices struck with Jannon's punches.

After the printing of this book, no further use was made of the type, which was quite daringly sophisticated and "modern" for its day. But the punches and matrices remained in the possession of the institution which continued to be the national

52–55 頁選自恩斯赫德鑄字廠的樣本冊內頁（與 35 頁相同）。

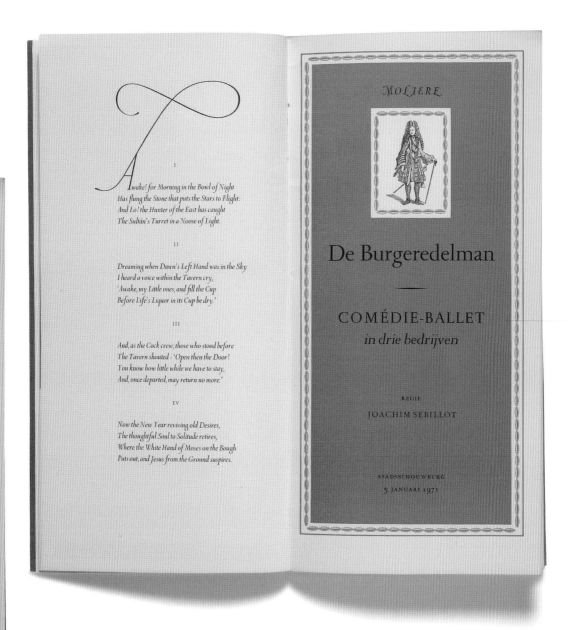

I

Awake! for Morning in the Bowl of Night
Has flung the Stone that puts the Stars to Flight:
And Lo! the Hunter of the East has caught
The Sultán's Turret in a Noose of Light.

II

Dreaming when Dawn's Left Hand was in the Sky
I heard a voice within the Tavern cry,
'Awake, my Little ones, and fill the Cup
Before Life's Liquor in its Cup be dry.'

III

And, as the Cock crew, those who stood before
The Tavern shouted - 'Open then the Door!
You know how little while we have to stay,
And, once departed, may return no more.'

IV

Now the New Year reviving old Desires,
The thoughtful Soul to Solitude retires,
Where the White Hand of Moses on the Bough
Puts out, and Jesus from the Ground suspires.

MOLIERE

De Burgeredelman

—

COMÉDIE-BALLET
in drie bedrijven

REGIE
JOACHIM SEBILLOT

STADSSCHOUWBURG
5 JANUARI 1971

帶有手寫優雅筆畫線條的義大利體排版。呈現義大利體的優良內文排版範例，以及高品味的標題頁。值得注意的點是義大利體排版時的字距，其實會比日本人所習慣的感覺還要來得擁擠些。

Romulus 與 Romulus Open Caps 的排版樣本（一部分是 Cancelleresca Bastarda 字體）。文章欄位的輪廓，是以羅馬體與義大利體交叉擺放且變換色彩的排版設計。

Lutetia 的排版樣本。左圖是書本標題頁，使用尺寸較大的字時用了大寫與小寫字母來排版；不過小尺寸的字時只用了大寫字母來排。此外，較寬鬆的字距設定減弱了視覺上的強度，字距與詞距兩者的關係經營的十分巧妙。下圖中 Lutetia Open 空心字體的文字間距與花朵圖案，搭配起來的協調感非常優美。內文字盡可能的挑選小尺寸的字型來排，上下則用較大尺寸的字型夾著文章形成凝聚感。木版畫（船的插圖）與文章之間特意安排了較大的留白，讓兩者不僅取得空間上的平衡感，同時又保有各自的獨立性。義大利體的部分，技巧純熟地運用了曲飾字母。

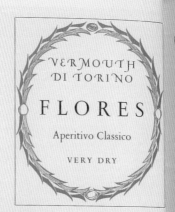

VERMOUTH
DI TORINO

FLORES

Aperitivo Classico

VERY DRY

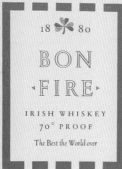

18 ✲ 80

BON
FIRE

IRISH WHISKEY
70° PROOF
The Best the World over

DEUTSCHER SEKT
SUPERIEUR
AUSLESE

Spezial
Dry

GARANTIERT FLASCHENGÄRUNG

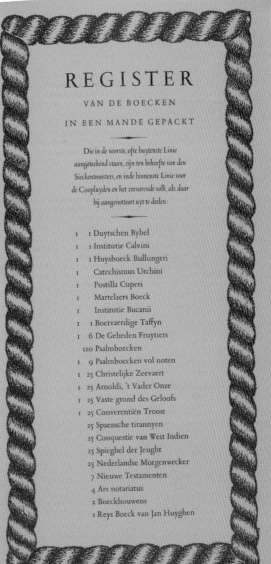

REGISTER

VAN DE BOECKEN

IN EEN MANDE GEPACKT

Die in de voorste, ofte buytenste Linie
aangeteekend staan, zijn ten behoefte van den
Sieckentroosters, en inde binnenste Linie voor
de Coopluyden en het zeevarende volk, als daar
bij aangenotteert uyt te deelen:

I 1 Duytschen Bybel
I 1 Institutie Calvini
I 1 Huysboeck Bullungeri
I Catechismus Urchini
I Postilla Cuperi
I Martelaers Boeck
I Institutie Bucanii
I 1 Boetvaerdige Taffyn
I 6 De Gebeden Fruytiers
120 Psalmboecken
I 9 Psalmboecken vol noten
I 25 Christelijke Zeevaert
I 25 Arnoldi, 't Vader Onze
I 25 Vaste grond des Geloofs
I 25 Converentiën Troost
 25 Spaensche tirannyen
 25 Conquestie van West Indien
 25 Spieghel der Jeught
 25 Nederlandse Morgenwecker
 7 Nieuwe Testamenten
 4 Ars notariatus
 2 Boeckhouwens
 1 Reys Boeck van Jan Huyghen

左頁是 Romanée 作為書本標題頁的排版範例，大寫字母的字距非常用心安排。值得加以留意的是右頁中的義大利體，小寫字母 f 的底部帶有襯線，而且整體具有垂直感，是十分罕見且特殊的義大利體。

Syntax 字型家族的排版範例

文字線條末梢的傾斜切角是其特徵所
在，也是其他無襯線字體所沒有的造
型細節。範例中有效地活用了字型家族
的許多版本。

斯坦普爾鑄字廠 (德國) 1970 年代　222×212mm

Beispiel dieser Seite:
Syntax Antiqua mager 20 p

Verwendete Schriften:
Syntax Antiqua extrafett
Syntax Antiqua mager
Madison Kursiv

Luft- und klimatechnische Anlagen werden bei Bauplanungen leicht als notwendiges Übel oder üble Notwendigkeit angesehen. Es kommt oft zu Entscheidungen mit halbem Herzen, denen später die Reue folgt. Deshalb »THINK BIG«. Nachträgliche Einsichten und Wünsche sind schwierig und kostenraubend. Ziehen Sie schon bei den ersten Überlegungen unsere Planungsspezialisten zu Rate. Ihre Erfahrung in der Klimatechnik hat sich schon in vielen Fällen bewährt.

Lesungen der Volkshochschule

*Alle Veranstaltungen finden donnerstags in der Aula
der Städtischen Realschule Karlshafen, Goetheplatz statt*

Gis Körner	**Tramp-Romanze**
Henny Stiker	**Hochhaus**
Rainer Zoltan	**Spiegelgeschichte des McPorridge**
Pery Standop	**Gedichte**
Cris Leffholz	**Hülsenbusch und kleine Schweiz**
Jan Dobson	**Sturmhöhe**

Eurostile

A new type expressing, through its
novel design, the dynamic style of our age

Eurostile

Eurostile

Eurostile

Eurostile

A NEBIOLO TYPE SERIES

直線與圓角的無襯線體

無襯線體基本上是以直線和圓形構成，
不過 1952 年時創造出一款以直線和圓
角所構成，只有大寫字母的無襯線體
Microgramma。再過十年後，具有相同造
型發想且包含小寫字母的 Eurostile 問世
了。手冊上選了 e 和 o 兩個字母，來展現
其字型家族成員不同的風貌。

內比歐羅字廠（義大利） 1960 年代 342×245mm

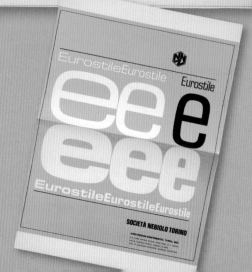

JOH. ENSCHE

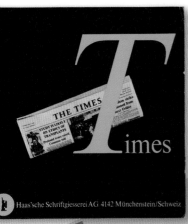

用 Times 展現時髦的效果

作為報章排版上相當實用的 Times，也可以用來呈現非常具有質感與格調的版面。

上：哈斯（Haas'sche schriftgiesserei AG）鑄字廠（瑞士）
1960 年代　223×212mm
下：恩斯赫德鑄字廠（與 35 頁相同）

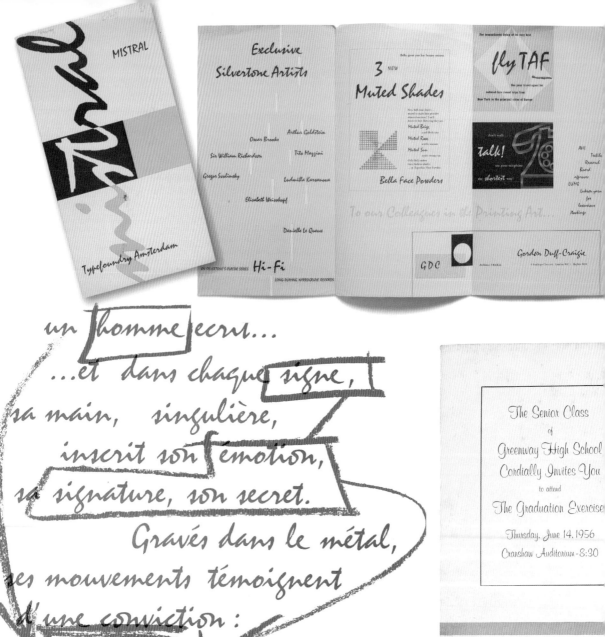

un *homme* ecrit...

...et dans chaque *signe*,

sa main, singulière,

inscrit son *emotion*,

sa signature, son secret.

Gravés dans le métal,

ses mouvements témoignent

d'une conviction :

les *Scriptes* sont orateurs,

ils appellent

en marge des textes.

Leur timbre est celui

de la *publicité*.

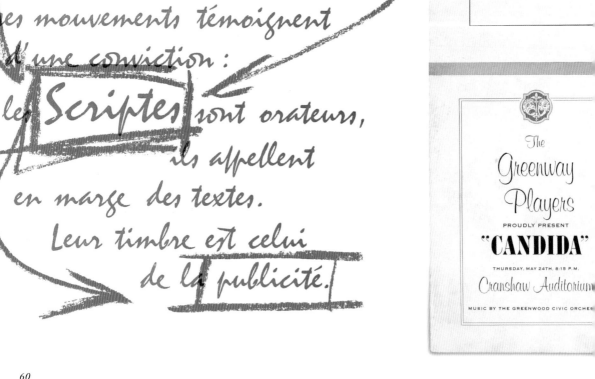

毛筆書寫風格的 Mistral

出自法國奧利夫鑄字廠的 Mistral 字體折頁傳單（左頁）。Mistral 是會讓人聯想到毛筆書法的字體，常被用於商品標誌等設計上。跟帶有尖銳感的字體一起混排使用時會有不錯的效果。而且可以只用大寫字母做排列，這點在草書體來說是很稀奇的事。此外，也適合搭配日本的行書體。

阿姆斯特丹鑄字廠（荷蘭） 1960 年代 285×151mm

呈現優雅感

取自高級住宅區名稱的 Murray Hill，字如其名通常被用於社交類的印刷品上（右頁）。尤其適合夢幻風格的印刷品。與花樣圖案活字或插圖等搭配排出的版面，能營造出女性及優雅感。

美國聯合字型公司（American Type Founders Company，ATF，美國）
1960 年代 280×217mm

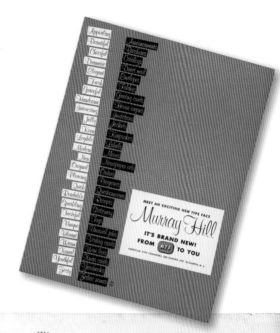

JULIANOS

Menu

AND BEVERAGE LIST

TREAT THE WHOLE FAMILY	AFTER EVERY SHOW
"*Bruncheon*"	"*Date Stuff*"
SUNDAYS UNTIL 12 NOON	EVERYBODY MEETS HERE

"say it with flowers"

Regina Selwyn
2918 HAWTHORNE AVENUE · BALDWIN 5-9428
GREENWOOD 2, OHIO

"say it with flowers"

Regina Selwyn
2918 HAWTHORNE AVE. · BALDWIN 5-9428
BARBARA SELWYN

Regina Selwyn
2918 HAWTHORNE AVE.
GREENWOOD 2, OHIO

To wish you and yours
a Happy Holiday
Season

GERALD and JANET FREEMAN

...and Gerry and Betty and little Bobby, too

Zsa Zsa
Dedicated to Beauty
COSMETICS

HOW TO CARE FOR
YOUR PRECIOUS

Rarlon
THE DOWNY SYNTHETIC
Sweater

DIRECTIONS
ON OTHER SIDE

Announcement

THE HENDON ENGINEERING CO.
has moved the entire staff
to new and larger quarters
on the 37th floor

283 Madison Avenue
NEW YORK 18, NEW YORK

Murray Hill 4-5598

Fresh, New Type Design
MURRAY HILL is a contemporary style, as interpreted by
AMERICAN TYPE FOUNDERS, 200 ELMORA AVE., ELIZABETH, N.J.

WHAT IS IT?

that Gentlemen
Prefer...

YOUR PERFECT GIFT IS HERE

Shirts all the favorite styles	3⁹⁵	up
Ties many patterns and fabrics	1²⁹	up
Socks every famous brand	1¹⁹	up
Robes with the feel of luxury	9⁹⁵	up
Jewelry the important accessory	1⁹⁵	up

WE WILL HELP YOU TO MAKE A SELECTION

Melvin's Men's Shop
214 DOLPHIN ST. · HOBART 3-7428

do you
know
how
lovely
you
can
look?

in just ten days you can shed
ten unwanted pounds with
no exercise, diet or pills. Call
now for your appointment.
You'll be glad if you do. You
will look and feel like new.

CAROL'S
Slenderizing
SALON
1288 FLETCHER AVENUE
CALL WAVERLY 4-9316

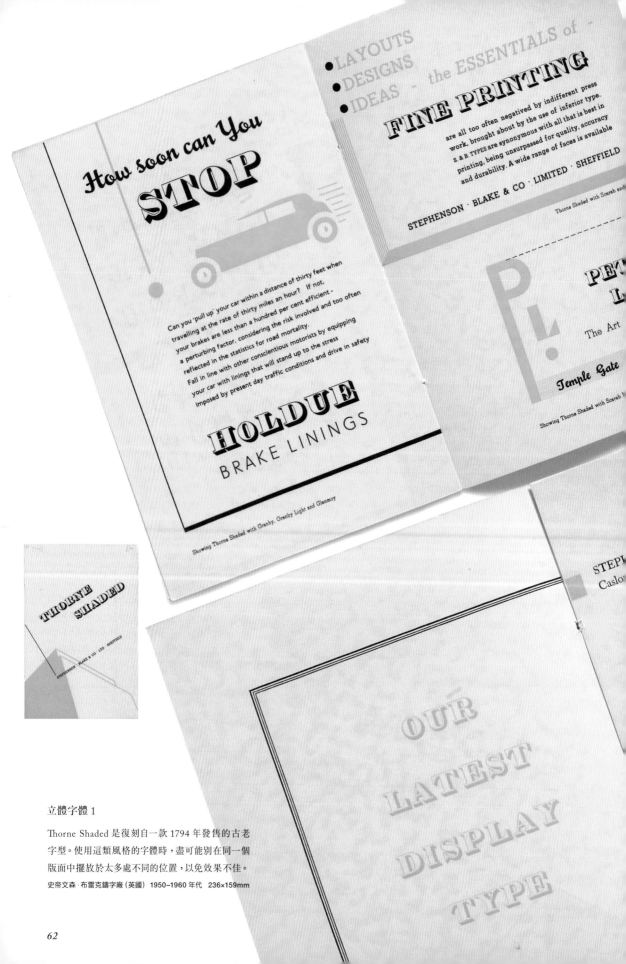

立體字體 1

Thorne Shaded 是復刻自一款 1794 年發售的古老字型。使用這類風格的字體時，盡可能別在同一個版面中擺放於太多處不同的位置，以免效果不佳。

史帝文森·布雷克鑄字廠（英國） 1950–1960 年代 236×159mm

fly

SABENA

TIME IS MONEY

FILM
STUDIO

AVION

WARDOUR STREET

RAYON
REVUE

Saltino, Duo solid, Kabel medium - Duo, Marathon - Duo outline and solid in three colors

ART OF
THE
THEATRE

*a series of essays
in slim and handy format*

*All aspects of Stage production
are dealt with by
eminent Actors and Producers*

Duo outline, Gavotte — Duo outline and solid, Kabel medium

立體字體 2

Duo Solid、Duo Outline 是年代久遠的立體字體。可以發揮童心多加嘗試不同的字體組合所帶來的樂趣。不過，也要注意別使用過頭了。

克林斯波爾 (Klingspor Typefounders) 鑄字廠 (德國)
1950 年代　293×188mm

THORNE SHADED

Robert Thorne who succeeded Mr. Cottrell in 1794, engraved this shaded letter, probably about 1810. It was the first design of its kind to be offered to printers, but it did not appear in any specimen book until after the purchase by William Thorowgood of Thorne's Foundry in 1820. No complete specimen book was issued by the Thorne Foundry after 1803, the new faces being shown only in the form of loose specimens

Thorne Shaded with Caslon Old Face

This convertible sedan by Le Baron on the 150 horsepower Lincoln V-12 for
1936 is, at will, a formal chauffeur-driven car, a sedan for informal family use,
and a smart phaeton for the owner-driver. There is a glass partition between
front and rear seats which disappears completely. The top folds compactly,
to blend with the body lines. The 1936 Lincoln includes many refinements
in mechanical design and appearance. The Lincoln Motor Car Company.

THE LINCOLN

AVAILABLE IN TWO SEDAN BODY TYPES

B 16

缺乏特徵的粗襯線體 Egyptian

Beton 的字型家族從細體（light）到特粗
體（extra bold）共有四種粗細，還有兩種
粗細的窄體（condensed），加上中空字體
（open）的款式，一套字型家族就可以滿
足各式各樣的使用方式。雖然最好盡量避
免用於排長篇文章，但由於造型上是較為
洗鍊而不具有特徵的粗襯線體，拿來用在
型錄中專欄左右字數的短文排版上，閱讀
性還是可以的。

鮑爾鑄字廠（德國）1960 年代　265×190mm

較有特徵的粗襯線體

Playbill 是將 19 世紀的木活字複刻成金屬
活字後重獲新生的字體，能呈現出穩定且強
勁的視覺感受。

史帝文森‧布雷克鑄字廠（英國）1950 年代　254×191mm

WHO'S WHO IN ART

WHO'S WHO IN ART

6TH EDITION

ART TRADE PRESS

Biographies of eminent artists,
designers, craftsmen, critics, writers,
teachers, collectors, curators.
With an appendix of signatures.

SIXTH EDITION

Playbill
a new-old type
from
Stephenson Blake

Playbill on these pages
the lighter versions of the
Note (opposite page) the us

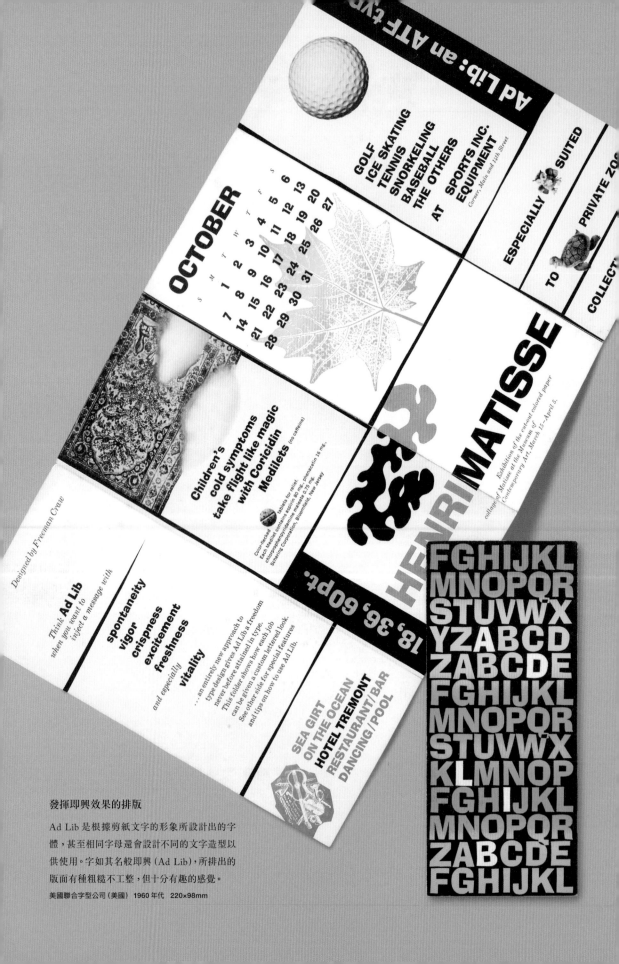

發揮即興效果的排版

Ad Lib 是根據剪紙文字的形象所設計出的字
體，甚至相同字母還會設計不同的文字造型以
供使用。字如其名般即興（Ad Lib），所排出的
版面有種粗糙不工整，但十分有趣的感覺。

美國聯合字型公司（美國）　1960 年代　220×98mm

活字鑄字廠所製作的字型樣本，最初只是像傳單一樣的簡單印刷品（可參考166頁）。近代由於金屬活字鑄造業的蓬勃發展及同業彼此競爭，才開始製造出越來越大本的樣本冊（可參考178頁之後：卡斯隆、史帝文森·布雷克、ATF等鑄字廠的樣本冊，發行時間從1800年代後期到1900年代前期）。隨著字型套數逐年增多，也需要耗費越來越多的金錢與人工投入樣本冊的製作。第二次世界大戰前左右仍有文件本形式的樣本冊（可參考184頁，蒙納公司的樣本冊），但以1930年代為分水嶺，大本的字型樣本冊此後就消失了，取而代之的是小本子的型錄或介紹單套字體的手冊，或者在印刷機材相關展覽會的場合，另外製作一些文宣小物提供給參加者。

字型樣本裡通常不會標記製作年份，原因是若加上日期之後，隨著時間一年一年的過去，對照下會讓人覺得字體有老舊的印象或感受。第二次世界大戰以前，樣本中雖然會刊登一些字體的使用範例，但都只是簡單的插圖搭配文字或是邀請卡之類的排版，較少有針對廣告的排版設計。直到戰爭結束，商業活動又蓬勃起來後，從事廣告製作的設計師變多，連帶影響字型樣本的內容，從以往只針對印刷業者的推廣樣本，逐漸轉為把廣告相關業者或平面設計師作為客群的樣本。

戰後復興期間，金屬活字字型的新字體一套接一套持續不斷地誕生，直到70年代，新發明的照相排版技術取代金屬活字成為最主流的排版方式，活版印刷業自此開始衰退，各家字型公司也就沒有心力開發新字體了。雖說照相排版的字型樣本一定也有優良的作品，不過由於本公司所收藏的照排資料比較少，其中區區數本的歐文照排樣本，也並非值得展示的珍貴之作，所以在此就不多加著墨。此外本公司也有收藏一些數位字型的樣本，大多是單套字體的介紹手冊或是多套字體的集合型錄，不過內容通常只是單純地將文字進行排列與展示而已。近年來，只有優秀的字體會專門推出型錄，但幾乎看不到用紙張印刷的實體樣本了。

Now you can have the Contour Comfort you've always wanted

A feature of the modern contemporary designed chair is the "free form" comfort which is "tailored" to hold the body in an ever restful position. Its form fitting comfort coupled with solid, hard-wearing workmanship gives you a combination that will always reflect your good taste. For the setting that requires something more conventional . . . there is a chair for the choosing . . . maybe something with an "old world" look. Chairs for all uses . . . office, factory, institution . . . all available in a large variety of coverings for immediate inspection at Chicago's real best chair specialist

CHAIR BUD 136 SOUTH MAINSTREET CHICAGO 3

察覺不到網格（grid）的版面擺位

Información 與 Optima 搭配組合的版面。讓人察覺不到網格構圖的刻意感，擺位相當精湛。

斯坦普爾鑄字廠（德國）1960 年代　297×210mm

soirs de Fontainebleau

FRANCE

à la barrière d'enfer

Jean Luc, restaurateur • 225 Av. du Parc Montsouris • Paris 14 • POR 21-58

la guerre de troie n'aura pas lieu

HECTOR. – Tu as fais aussi un beau coup
ce jour-là !

PARIS. – Ce que tu es frère aîné !

Scène cinquième

LES MÊMES. DEUX VIEILLARDS.

PREMIER VIEILLARD. – D'en bas, nous la
voyons mieux...

SECOND VIEILLARD. – Nous l'avons même
bien vue !

PREMIER VIEILLARD. – Mais d'ici elle nous
entend mieux. Allez ! Une, deux, trois !

TOUS DEUX. – Vive Hélène !

DEUXIEME VIEILLARD. – C'est un peu fati-
gant, à notre âge, d'avoir à descendre et

41

ACADÉMIE NATIONALE DE MUSIQUE

12 BOULEVARD DU THÉÂTRE - TOULOUSE

RAMEAU

DU 22 JUIN AU 3 JUILLET 1965 - TOUS LES JOURS DE 10 A 17 HEURES

INAUGURATION LE 3 JUILLET A 16 H. 30 PAR MONSIEUR DURAND, MINISTRE DES BEAUX-ARTS

invitation pour 2 personnes

TOUR DE LIBOURNE

1957

Appellation contrôlée

SEBASTIEN LAPEROUSE, VITICULTEURS DE PERE EN FILS
LIBOURNE - GIRONDE

ROUGUIER
équipements et matériels électronique
25, AVENUE DES AMANDIERS - PARIS 20° · PYR. 12-3

MARS 1965

DIM	LUN	MAR	MER	JEU	VEN	SAM
28	1	2	3	4	5	6
7	8	9	10	11	12	13
14	15	16	17	18	19	20
21	22	23	24	25	26	27
28	29	30	31	1	2	3

CHAUFFAGE CENTRAL
HOUDIARD & COSTE

Société à responsabilité limitée au cap. de 31.000 F
REG. DU COM. SEINE 59 B 6135 - C.C.P. PARIS 30.526

Siège social
25 Rue de Villiers
ROSNY-SOUS-BOIS (SEINE)
LAV. 32-56

Ateliers
46 Rue La Fontaine
PLESSIS-ROBINSON (SEINE)
ROB. 24-30

INSTALLATIONS REPARATIONS ENTRETIEN TOUS TRAVAUX SUR TUBES

柔軟的無襯線體 Antique Olive

使用 Antique Olive 的一些範例。筆畫較粗的款式常被用在傳
單類小型印刷品的標題等等，也被法國航空（Air France）拿來
用在 LOGO，是深受法國人喜愛的柔軟感無襯線體。字型款式
與系列也相當豐富。

奧利夫鑄字廠（法國） 1970 年代 右上：250×156mm

During the first decades of the nineteenth century there
was a flourishing of new letterforms created to meet the
requirements of commercial printing, which had reached
a stage of great development. Among these new forms,
the black ornamented face after the Bodoni design took
a pre-eminent place. Normandia Outline revives the
nineteenth century designs which are still applicable
for present day typography.

Normandia
A NEBIOLO TYPE SERIES

216-60-24 - A 8, a 13 - 1-7 - lb. 9 3/4
Kg. 4,50

It had been found in the forest

HARMONIOUS TYPE FACES

216-60-30 - A 6, a 11 - 1-6 - lb. 11 3/8
Kg. 5,20

We are manufacturers and

NEAT ADVERTISEMENT

216-60-36 - A 4, a 8 - 1-4 - lb. 12 7/8
Kg. 5,90

Urban man lives with

FELINES ARTISTIC

216-60-48 - A 4, a 4 - 1-4 - lb. 15 5/8
Kg. 7,10

Modern wizard

PROSPEROUS

人氣很高的輪廓線字體

Normandia Outline 的手冊。Normandia 雖然有粗黑體 (Black) 的實心款式，但以橫線細直線粗的高對比設計 (fat face type) 版本的輪廓線 (outline) 款式相當受到好評。直粗橫細高對比設計是 18–19 世紀時誕生的字體風格，因此樣本中也特別搭配上復古風格的插圖。以輪廓線空心字體排短文，其中想強調的部分再換用實心粗黑體來排，會有不錯的視覺效果。

內比歐羅鑄字廠 (義大利)　1960 年代　245×172mm

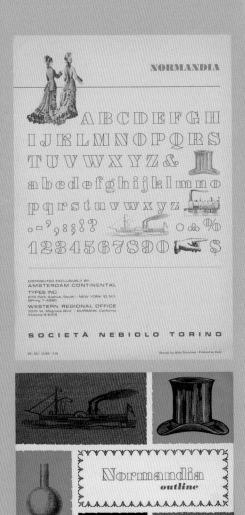

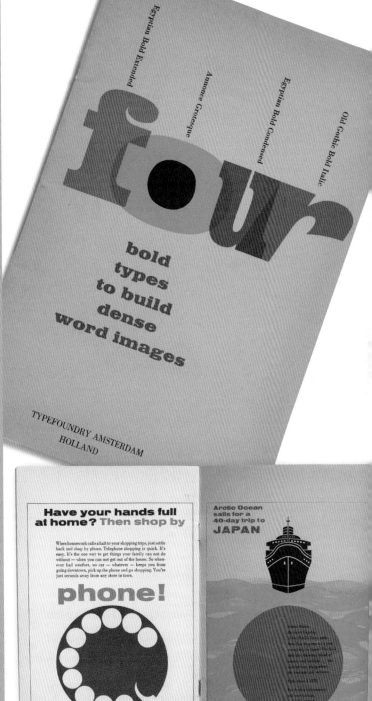

直粗橫細高對比設計的字型家族們

Egyptian Bold Extended、Bold Condensed、Annonce Grotesque、Old Gothic Bold Italic 的樣本冊。將筆畫粗的粗襯線體、無襯線體們集合起來用於標題等等的排版範例，效果相當不錯。

阿姆斯特丹鑄字廠 (荷蘭)　1960 年代　240×159mm

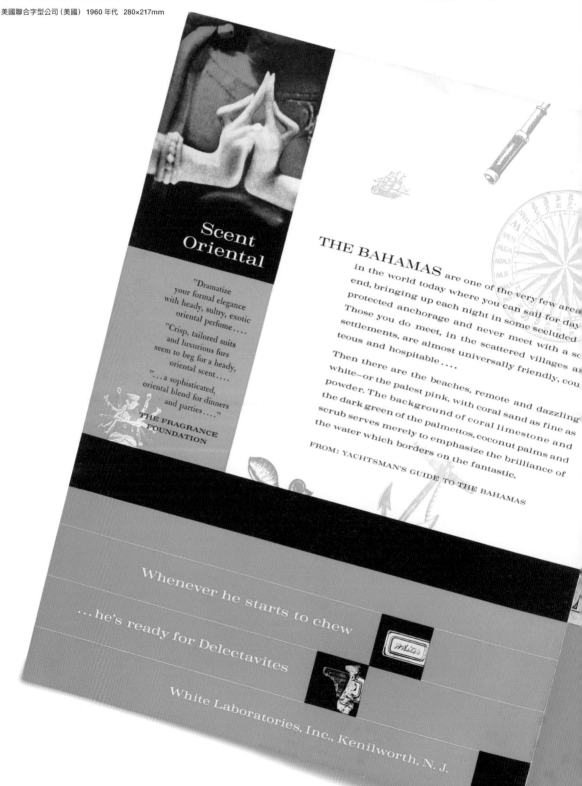

FEIERSTUNDE

ANLÄSSLICH

DES HUNDERTJÄHRIGEN JUBILÄUMS DER PHOENIX GUMMIWERKE AG

IM GROSSEN SAAL DES VERWALTUNGSGEBÄUDES

AM 13. JUNI, 10.30 UHR

FÜR DIE UNS ZUR VERLOBUNG ÜBERMITTELTEN WÜNSCHE,

DIE SCHÖNEN BLUMEN UND GESCHENKE, DANKEN WIR

AUCH IM NAMEN UNSERER ELTERN AUFS HERZLICHSTE.

ELFRIEDE RICHTER RICHARD HOLDER

Blumen aus Seriensehmuck Nr. 2352 Figur f (Bleiguß)

HANDELS-KONTOR C·A·BRAUNS

STUTTGART, NECKARSTRASSE 86
FERNSPRECHER 035 92
WERKSVERKAUF
INDUSTRIEVERTRETUNGEN

IHR ZEICHEN IHRE NACHRICHT VOM MEIN ZEICHEN STUTTGART, DEN

AM TAGE UNSERER GOLDENEN HOCHZEIT DURFTEN WIR SO VIEL LIEBE

UND AUFMERKSAMKEITEN ERFAHREN,

DASS WIR IHNEN AUF DIESEM WEGE UNSEREN BESTEN DANK

AUSSPRECHEN MÖCHTEN.

THOMAS MOSER UND FRAU GERDA

Jubiläumskranz Vignette Nr. 2574 (Galvano ausgeklinkt)

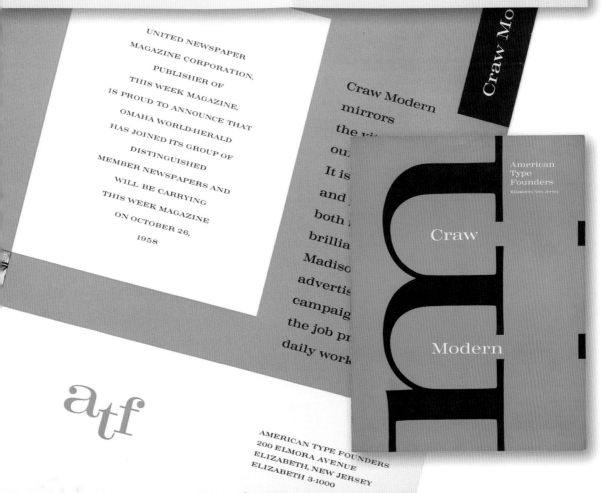

UNITED NEWSPAPER
MAGAZINE CORPORATION,
PUBLISHER OF
THIS WEEK MAGAZINE,
IS PROUD TO ANNOUNCE THAT
OMAHA WORLD-HERALD
HAS JOINED ITS GROUP OF
DISTINGUISHED
MEMBER NEWSPAPERS AND
WILL BE CARRYING
THIS WEEK MAGAZINE
ON OCTOBER 26,
1958

Craw Modern
mirrors
the vi...
ou...
It is...
and...
both...
brillia...
Madiso...
advertis...
campaig...
the job pr...
daily work...

Craw Mo

American
Type
Founders
Elizabeth, New Jersey

Craw

Modern

atf

AMERICAN TYPE FOUNDERS
200 ELMORA AVENUE
ELIZABETH, NEW JERSEY
ELIZABETH 3-1000

現代羅馬體（Modern Face）的華麗演出

下方是恩斯赫德鑄字廠旗下的 Bodoni 與 Falstaff（左上）的頁面。Bodoni 是最有名的現代羅馬體，無論是長篇文章排版時的閱讀性，加上與裝飾花樣、筐線等裝飾活字搭配後能排出相當華麗的版面。而右方 Bauer Bodoni 的樣本冊，是以德國人偏好的硬朗排版風格排出的戲劇台詞本。

下：恩斯赫德鑄字廠（與 35 頁相同）
右：鮑爾鑄字廠（德國） 年代不明　263×190mm

BODONI

ANTIQUA

HARMONIUM

URKUNDE

KONSUM

BERLIN

BAUERSCHE GIESSEREI · FRANKFURT A·M · BARCELONA · NEW YORK

YOUTH
and
white
paper
take
any
impression

The indonesian art-company
'Sini Timoer' will give a few
performances in the hall of the
Tropical Museum, Amsterdam

1. KEBOGIRO, *welcoming by the gamelan-orchestra*
2. SEMPERI, *female dance from Java*
3. SARA, *female indonesian Hindulance*
4. TARI PIRING, *ceremonial dance from Sumatra*
5. MASKDANCE, *accompanied by Anglidim-players*
6. SAGREMO, *a dance from the Wijangweng (Java)*
7. CEREMONIAL DANCE *from Bali*
8. KRONTJONG MUSIC *on original instruments*
9. KETOEPRAK, *dramatic theatre from Java*
10. PERANG TJAKIL, *a part from the Mahabharata*
11. PENTJAK PADANG, *sword-dance from Sumatra*
12. KEBOGIRO, *finale by the gamelan-orchestra*

W.M.Thackeray

HISTORIEN OM
SAMUEL TITMARSH
OCK DEN STORA
HOGARTYDIAMANTEN

STOCKHOLM
OLLE GUSTAVSSON
BOKFÖRLAGET

The twelve great Italian virtuosi known as I Musici will return to America in 1962-63. On previous visits they established themselves unforgettably as the very reincarnation of the perfection, elegance and exuberance that were the glory of the 17th & 18th century Italy

October 24th–30th

Books
of Psalms
translated
into sixty
languages
on view on
the first
floor

DEUXIEME EXPOSITION NATIONALE SUISSE DE L'AUTOMOBILE ET DU CYCLE

Une visite à cette exposition ne vous décevra pas! La grande diversité des modèles exposés offre une excellente impression de l'expansion de l'industrie automobile à partir de 1910 jusqu'à nos jours. On peut dire d'un toutes les marques sont représentées quant aux cycles, on a même résumé à retrouver les modèles les plus anciens. Voici quelques détails. L'exposition a été organisée par la Fédération de Commerçants d'Automobiles et de Cycles dans les anciens atelliers de menuiserie de la Ville de Genève. La superficie du terrain est de 800 x 1200 mètres. Vous y trouverez trois grandes salles d'automobiles et deux de cycles, reliées entre-elles par des passerelles aériennes. Dans la première salle « A1 » vous verrez des modèles très anciens, pour ainsi dire antiques. La salle A2 expose des modèles encore utilisables, mais déjà désuets. Quant à la salle A3, vous y trouverez les modèles les plus modernes. Par contre, les cycles n'ont pas été exposés par ordre chronologique. Chaque fabricant montre, côte à côte, son premier modèle et le dernier sorti. L'exposition est ouverte: jours ouvrables de 10-17 heures, dimanche de 13-17 et 19-22 heures, durant les mois de septembre et d'octobre. Le prix d'entrée est de 2 Frs pour personnes adultes et de 1 Fr. pour lycéens, étudiants et militaires. Les groupes peuvent profiter d'une réduction spéciale. Visites-guidées sur demande.

DON GIOVANNI: Ich steh zu meinen Worten,
Du schreckst mich nicht, ich komm!

KOMTUR: Reich mir die Hand zum Pfande.

DON GIOVANNI: Nimm sie denn! (schlägt ein) O weh!

KOMTUR: Was ist?

DON GIOVANNI: Mich faßt ein kalter Schauer.

KOMTUR: Beuge dich, gehe in dich,
In letzter Stunde höre!

DON GIOVANNI: (versucht vergebens, sich loszuwinden):
Nein, nie werd' ich mich beugen,
Hebe dich fort von mir!

KOMTUR: Beuge dich, frecher Bube!

DON GIOVANNI: Nein, läst'ger alter Schwätzer!

71

Observations
on
the
Genesis
of
the
Didot
Letter

Firmin Didot,
an
Amsterdam
Continental
typeface

T HE DIDOT FAMILY in 18th Century France — authors, inventors, publishers — played a major role in the intellectual life of the age. As printers and typographers their influence continues strong until this day.

The elder Didot, Francoise Ambroise, so greatly restructured Fournier's pre-existing system of type measurement that the Didot system remains the standard in European typography. Benjamin Franklin placed his grandson, Benjamin Franklin Bache, with Didot in 1785; the boy engraved his first punch with Didot's younger son, Firmin.

That younger son became the most renowned of all the Didots. In the spirit of the Age of Reason, he made his own translation of — among other works — Virgil's *Bucolics*, printed from type that he designed and cut. Firmin Didot designed and cut faces for editions of Horace, Virgil and Molière, among others. Under Napoleon, he became Director of the Imperial typefoundry. He influenced type design and typography throughout Europe in the direction of the spirit of his time: towards clarity, lucidity, and a neo-classical dignity. These features — clarity, lucidity, dignity — characterize the typeface which bears the name of Firmin Didot, the final culmination of the Didot family's type design. For almost a century, it exerted a major influence over typography in Europe and America alike, with its brilliance, hard integrity, and affinity to the Roman of the copperplate engraver.

Today, nothing remains of the original Didot matrices. Firmin Didot has been recut from the drawings which survived, and from the works Didot printed in his typeface, lasting monuments to the printer's art. In its modern recreation, it has been refined in consonance with contemporary technology and reproduction techniques, retaining all the lucidity of the eighteenth Century design.

Firmin Didot is now available for the first time on American point body.

創新的標題呈現

若要列舉最具有代表性的現代羅馬體,除了義大利的 Bodoni 字體之外,源自 18 世紀法國的 Firmin Didot 也是相當典型的現代羅馬體。此頁中,標題的斷句方法跟呈現的擺位都非常創新。以「T」作為開始的文章抬頭放在如此偏中間的位置,可說是遊走在合理與誇張的邊緣,卻又如此絕妙。

路德維希與梅耶鑄字廠 (德國) 1960 年代 270×186mm

將版面收斂緊緻的羅馬體

Excelsior SemiBold 草書體的樣本冊。利用羅馬體 Egmont 收斂了插圖與草書體具有的柔和曲線感,呈現出緊緻的版面。

阿姆斯特丹歐陸字型公司 (Amsterdam Continental,美國) 1962 年 239×160mm

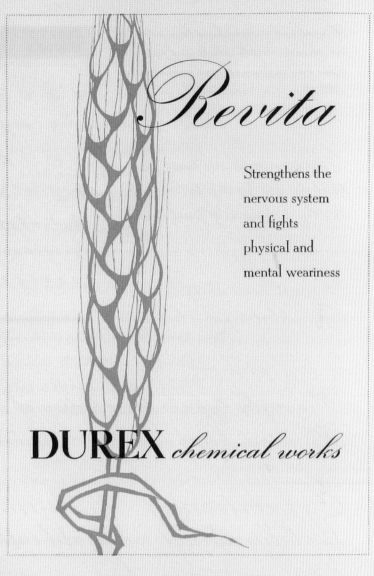

Revita

Strengthens the
nervous system
and fights
physical and
mental weariness

DUREX *chemical works*

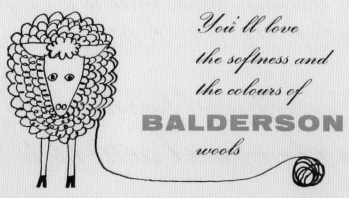

*You'll love
the softness and
the colours of*

BALDERSON

wools

Excelsior semibold 24, 36 and 72 pt; Egmont light 12 and bold 30 pt; Annonce Grotesque 18 pt

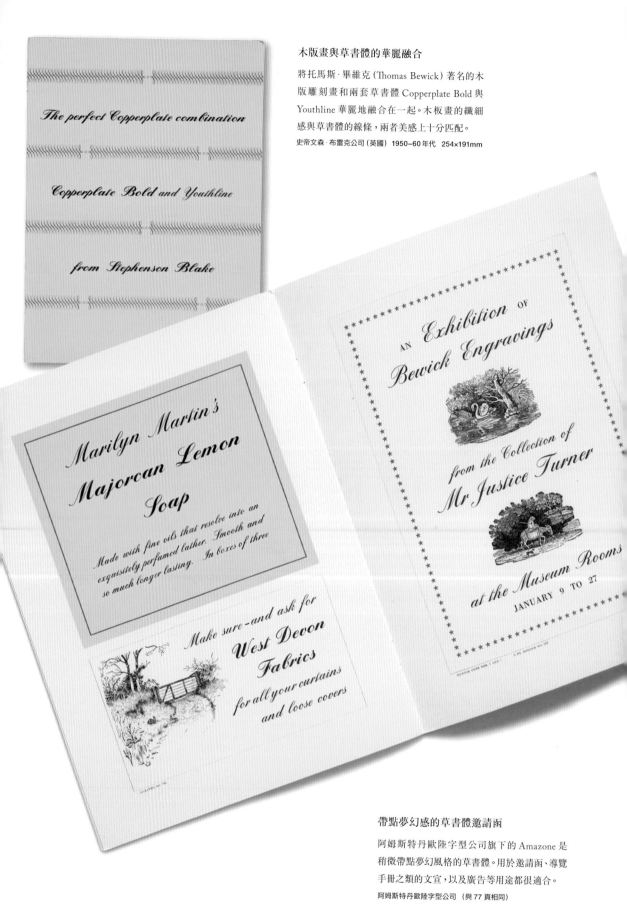

木版畫與草書體的華麗融合

將托馬斯·畢維克 (Thomas Bewick) 著名的木版雕刻畫和兩套草書體 Copperplate Bold 與 Youthline 華麗地融合在一起。木板畫的纖細感與草書體的線條，兩者美感上十分匹配。

史帝文森·布雷克公司 (英國) 1950-60年代 254×191mm

帶點夢幻感的草書體邀請函

阿姆斯特丹歐陸字型公司旗下的 Amazone 是稍微帶點夢幻風格的草書體。用於邀請函、導覽手冊之類的文宣，以及廣告等用途都很適合。

阿姆斯特丹歐陸字型公司 (與 77 頁相同)

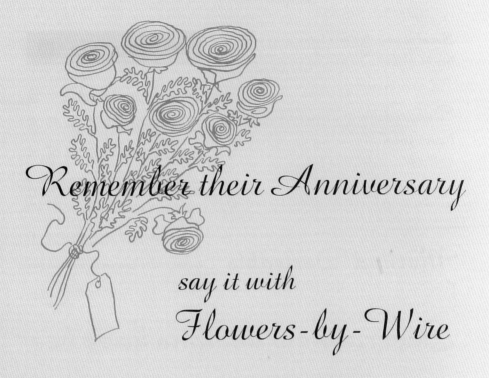

Remember their Anniversary

say it with
Flowers-by-Wire

Let your Flowers-by-Wire be a part of
their happy celebration. F.T.D. will carry
your sentiments, to those you love…
when you can't be there.
Fast, worldwide delivery is guaranteed by
your F.T.D. Florist… the shop that displays
the famous Mercury Emblem.

phone or visit
your F.T.D. Florist

FLORISTS' TELEGRAPH DELIVERY ASSOCIATION, DETROIT, MICHIGAN

Amazone 18, 36 and 48 pt; Nobel light 10 pt

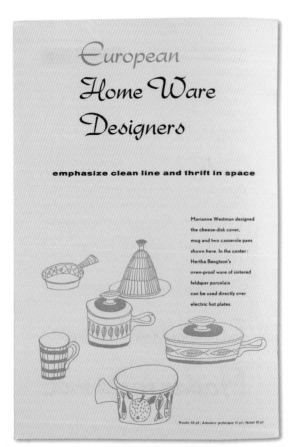

European
Home Ware
Designers

emphasize clean line and thrift in space

Marianne Westman designed
the cheese-disk cover,
mug and two casserole pans
shown here. In the center:
Hertha Bengtson's
oven-proof ware of sintered
feldspar porcelain
can be used directly over
electric hot plates.

Rondo 48 pt; Annonce grotesque 12 pt; Nobel 10 pt

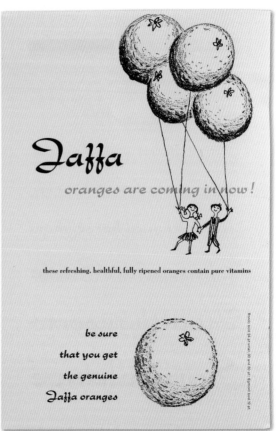

Jaffa

oranges are coming in now !

these refreshing, healthful, fully ripened oranges contain pure vitamins

be sure

that you get

the genuine

Jaffa oranges

Rondo bold 24 pt cursief; 30 and 60 pt; Egyptiati serie 18 pt

留意文字的尺寸

Rondo 的型錄。Rondo Bold 根
據字型尺寸的不同,所排出
的文字氛圍也會有所變化。
阿姆斯特丹歐陸字型公司(與77頁相同)

與較剛硬的字體做搭配

這是 Rondo 字體較現代感的
使用方式。Rondo 字型中包含
帶有柔軟曲飾線的首尾字母
造型 (terminal letter)(譯注:
可以注意觀察本頁的圖例,小
寫 o 與 e 等等都有兩種不同
造型)。與較為剛硬的字體一
起組合使用時,會有很好的
效果。
阿姆斯特丹鑄字廠(荷蘭) 1960 年代
285×151mm

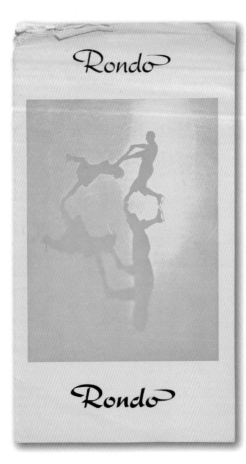

不規律卻相當舒服的排版

伯特霍爾德鑄字廠與造紙公司共同合作的紙樣。使用草書體 Caprice 與最下方的 Akzidenz-Grotesk Serie 57 Kursiv 印刷而成。行文排版沒有遵照任何一種對齊方式，但最後呈現的不規律效果非常的舒適。

伯特霍爾德（H. Berthold AG）鑄字廠（德國）1968 年　92×176mm

德語文字與現代羅馬體

將裝飾性的德語系草書體 Rhapsodie 與現代
羅馬體嚴謹地組合在一起的排版。

路德維希與梅耶鑄字廠（德國） 1960 年代 243×172mm

Rhapsodie

A decorative type face, fresh in its
appeal, full of possibilities in typographic
display. With special swash caps.

A L&M series

Ludwig & Mayer Type foundry
Frankfurt W-Germany

distributed by
Amsterdam Continental Types and Graphic Equipment, Inc.
276 Park Avenue South · New York, N. Y. 10010 · Spring

J·FLANNIGAN & SON

flannigan

Galleries

established 1892

402 Madison Avenue, New York 17, N. Y., Murray Hill 8-6524

Photographs of old Masters

English · Dutch · flemish · Italian

sent on application

Enquiries Welcomed

WE ARE PLEASED TO ANNOUNCE OUR ENGAGEMENT

Mary Durbridge William Hamilton

ABC

DEFGHI

JKL Swash Caps

MNOPQ

RSTUVW

XYZ

24 point No.6G 8A
30 point No.6H 7A
30 point No.6I 6A
42 point No.6K 4A

Derby is streamlined to the epitome of illustrative
perfection in a letter cut for portrayal of vigorous composition.
The horizontal stress in the animated caps, and the
excitement displayed in the Swash characters permit
the creative printer to use this face effectively in ads
targeted to the male e m n r t

Derby is impressive and definitely different. Designed by G.G.Lange.
Derby is cast without overhang from 10-36 point.

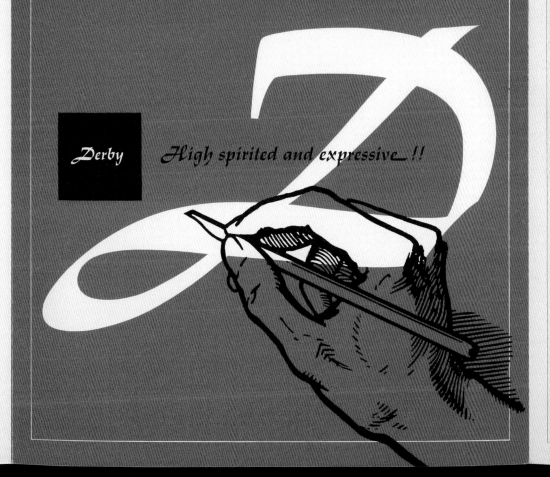

Derby

High spirited and expressive !!

將草書體現代化

Derby 是使用較粗的鋼筆手寫，帶有正式感的草書體。版面背景選用紅色呈現出現代感。

芝加哥鑄字聯合公司（Typefounders of Chicago / Neon Type Division，美國），1960 年代，300×196mm

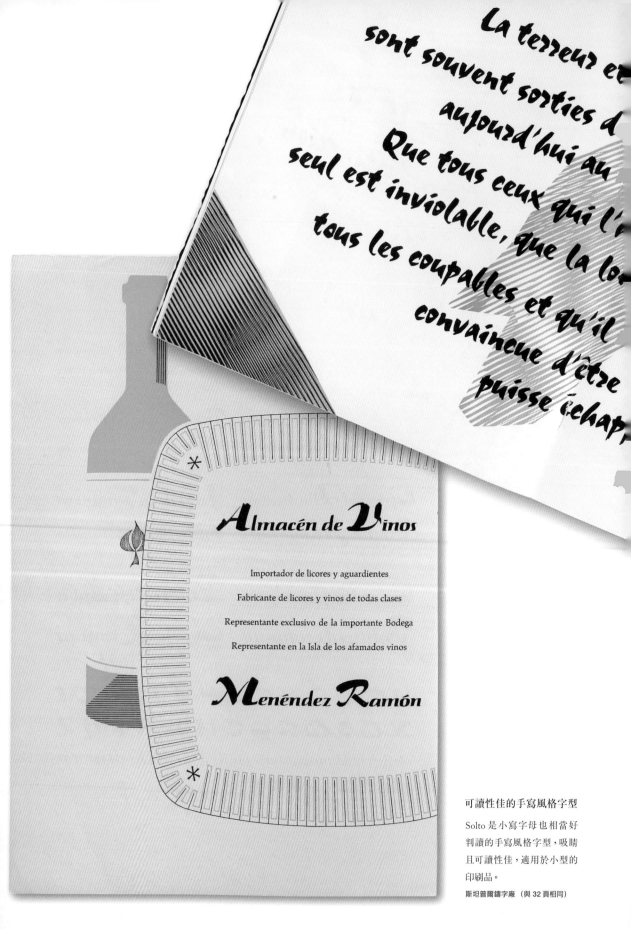

La terreur et
sont souvent sorties d
aujourd'hui au
Que tous ceux qui l'
seul est inviolable, que la lo
tous les coupables et qu'il
convaincue d'être
puisse échapr

Almacén de Vinos

Importador de licores y aguardientes

Fabricante de licores y vinos de todas clases

Representante exclusivo de la importante Bodega

Representante en la Isla de los afamados vinos

Menéndez Ramón

可讀性佳的手寫風格字型

Solto 是小寫字母也相當好
判讀的手寫風格字型，吸睛
且可讀性佳，適用於小型的
印刷品。

斯坦普爾鑄字廠（與 32 頁相同）

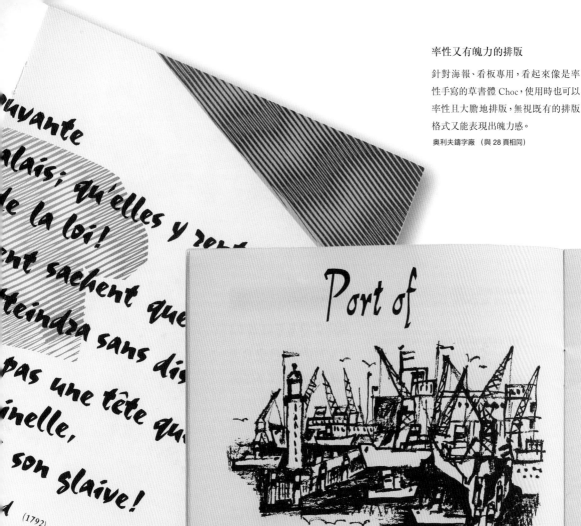

率性又有魄力的排版

針對海報、看板專用，看起來像是率性手寫的草書體 Choc，使用時也可以率性且大膽地排版，無視既有的排版格式又能表現出魄力感。

奧利夫鑄字廠 （與 28 頁相同）

Port of

Rotterdam

the largest seaport of the continent

for import and export

Frequent regular sailings to
the whole world.
Modern quays and mechanical
equipment for all types
of ships and cargoes.
For further information
please apply to Havendienst,
Rotterdam, P.O.B. 420

Reiner Script 30 pt large and 84 pt; Nobel 10 pt

活用筆刷草書體的排版

稀有的窄體（condensed）筆刷風草書體 Reiner Script。排版時要盡量別用在太多地方，搭配的字體越剛硬的話，字體的效果就越會被襯托出來。

阿姆斯特丹歐陸字型公司（與 77 頁相同）

帶有夢幻感的草書體傑作

伯特霍爾德鑄字廠製作的 Ariston
型錄（封面是印「歐陸聯合字型公
司」，請參考 114 頁的解說）。被視
為帶有夢幻感的草寫體傑作，曾
被用於柏林奧運的獎狀上。若是與
LOGO 等等作搭配的話容易顯得
有點俗氣，所以建議在版面上單獨
使用，更能展現這套字體的美感。

伯特霍爾德鑄字廠（德國） 戰前　298×210mm

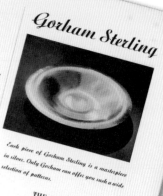
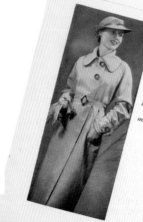

Gold Band
Ladies Bags
that set the fashion

Gorham Sterling

Each piece of Gorham Sterling is a masterpiece
in silver. Only Gorham can offer you such a wide
selection of patterns.

THE GORHAM COMPANY
PROVIDENCE · RHODE ISLAND
America's leading silversmiths, makers of everything in silver.

In this model a proper regard for practically and real comfort go
hand in hand with simple elegance. Originality, skill and the finest of
materials all combine to place our models in the leading style stores.

Juwelette
The perfect coats of pure silk

William Skinner & Sons
Silk Manufacturers
NEW YORK · CHICAGO · BOSTON · PHILADELPHIA · SAN FRANCISCO
Established 1848

New York, N.Y.

William Skinner & Sons
Silk Manufacturers
New York, N.Y.

COTY
claims that with

10 MINUTES MORNING AND EVENING

you will have done full justice to your personal appearance

Yes, 10 minutes, and no more, for the use of the new
Coty beauty treatment is surprisingly and marvellously
simple.

There are neither complicated preparations nor tedious
waiting between the various stages of the treatment. These
aids to beauty were scientifically evolved by Coty's spe-
cialists, and are prepared with the exactitude character-
istic of all the products of this famous firm. A small
number of products are sufficient to give any skin, regard-
less of its quality and state, the attention which possesses
its softness and delicacy. Their efficacy has been con-
firmed in practice in countless cases.

That is the programme submitted by Coty for the
approval of the modern woman, a programme which
every woman can adopt, for the Coty aids to beauty are
not expensive.

THE COTY BEAUTY TREATMENT
provides fresh possibilities for the woman of to-day

morocco

WHERE EAST MEETS WEST

morocco Here, at the Gateway to
the Orient, life still burns with the sullen splendor
of the days of the great Caliphs. East meets West
over a demi-tasse of ambergris-perfumed mocha in
a bazaar. The muezzin crys his prayer to Allah. The
Ouled Nails sway deliriously in curtained chambers.
And, from the impassive reaches of the desert, sounds
the tinkling of the camel's bell.

a dolphin cruise

古典與現代感兼具的草書體

源自歐文書法 (Calligraphy) 中
名為 Civilité 的中世紀草書體，
再以現代手法復刻設計的新字體
Legend。若想搭配其他字體混排
使用時，最好挑選較無個性的字
體並留意尺寸大小，若尺寸太大
組合起來會變得較俗氣，要多加
注意。

鮑爾鑄字廠（德國）1937 年　268×193mm

Legend

M. KNOEDLER AND COMPANY

HAVE THE HONOR TO ANNOUNCE

A SHOWING OF

Paintings and Etchings

BY OLD AND MODERN MASTERS

AT THE

Atlanta-Biltmore

DURING THE WEEK OF FEBRUARY 20TH 1937

FROM 10 TO 5

𝕬m Ende des alten Jahres
danken wir für die angenehme Zusammenarbeit
und wünschen ein frohes Weihnachtsfest
und ein gutes neues Jahr

ACHIZAVILA GMBH FRIEDBERG

*28. Juni 1974

ASTRID EVI

In Dankbarkeit und Freude
zeigen wir die Geburt unserer dritten
gesunden Tochter an
Marga und Georg Sehringhausen
Konstanz Baseler Straße 29

Wir haben uns Pfingsten verlobt

Anneliese Ropert Gunter Foredie

DÜSSELDORF-OBERKASSEL FRANKFURT-RÖDELHEIM
LUISENSTRASSE 108 NIERSTEINER WEG 1

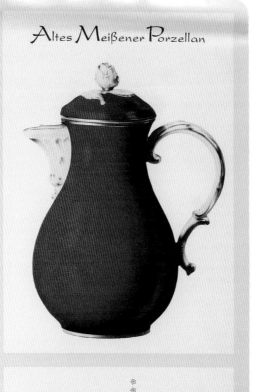

Altes Meißener Porzellan

Antike
nzen aus
Ländern

edaillen

nd Verkauf

ktionen

smatische
eratur

zkabinett
hard Bucerius
idelberg

Blumenhaus
Rosenkulturen
Baumschule

Felix Scharf
Lüneburg, Waldschneise 2
Telefon 3986

Würzburg

Reich an Sehenswürdigkeiten im Tal des Mains gelegen, präsentiert
sich die alte Barockstadt Würzburg. Besonders bekannt sind der Dom,
die Residenz mit den gepflegten Gartenanlagen und die Marienburg.

Pommersfelden

Hier sollten Sie das im 18. Jahrhundert erbaute und für den deutschen
Schloßbau dieser Zeit als vorbildlich geltende Schloß besichtigen.

Bamberg

ist ein idealer Ferienort in der reizvollen Landschaft Oberfrankens.
Vielbesuchter kulturhistorischer Mittelpunkt, den Sie auf jeden Fall
besichtigen sollten, ist der Dom mit dem Bamberger Reiter.

可輕鬆使用的優良草書體

Present 是很容易與許多不
同字體做組合搭配的草書
體。由於閱讀性佳，只要不
用錯分量與大小的話，使用
範圍非常廣泛。

斯坦普爾鑄字廠 (德國) 1970 年代
299×211mm

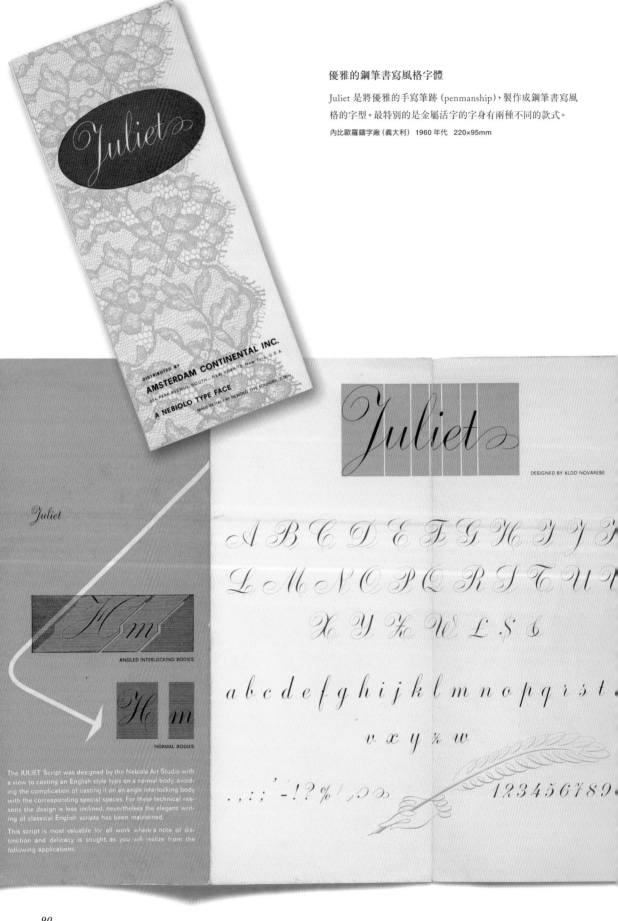

優雅的鋼筆書寫風格字體

Juliet 是將優雅的手寫筆跡（penmanship），製作成鋼筆書寫風格的字型。最特別的是金屬活字的字身有兩種不同的款式。

內比歐羅鑄字廠（義大利） 1960 年代 220×95mm

在近代規格訂定以前的活字，往往「有大小但沒有尺寸」。因為當時幾乎每間印刷廠都是自行鑄造活字且僅供內部使用，所以沒必要嚴格規範尺寸大小。隨著近代化與工業化的時代來臨，機械的精密度提升了，也出現專門的活字鑄字廠，所以必須擬定一套可供眾人參照的基準。使用頻率最高的尺寸有：English（相當於 14 point）、Pica（相當於 12 point）、Small Pica（相當於 10.5 point）、Brevier（相當於 8 point）、Agate（相當於 5.5 point）、Ruby（等同 5.25 point）等等，各種尺寸都有專門的命名，不過當時不同活字鑄造廠製造的相同名稱的活字，大小往往不相同。

隨著工業化的腳步持續前進，以點（point）為單位的尺寸制度誕生了。雖然明定以 1/72 公寸（inch）為 1 點，卻因此產生了非常令人困擾的事情。由於公寸的單位長度在歐洲大陸與美國兩地不一樣，自然導致以公寸作為基準的點制也因不同地區而產生了尺寸差異。

歐洲大陸地區以迪多點制（Didot Point）為基準，美國、英國與西班牙則以美國點制（American Point）作為活字大小與高度的基準。相同的 point 數值，套用美國點制的活字會稍小一些。

順帶一提，1/72 inch 為 1 pt，而 12 pt 對應到的 1 pica，被用作決定行長或是印刷位置時的基準單位。而 Pica 或 Ruby 的尺寸名稱，就算在 Point 制度訂定後仍被沿用及定義相近的尺寸單位，並持續使用至今。

而木活字的大小單位，由於字型較大的關係，以 12 點（point）定為 1 線（line），72 pt 即為 6 line 的方式稱呼木活字的大小。

日本業界是引入美國點制，但另外也有稱作「號數」（日文：号數）的尺寸單位所以十分複雜。嘉瑞工房裡所使用的活字有迪多點制、美國點制、號數，共計三種的尺寸標準。此外，活版印刷所需的東西不是只有活字，還需要有名為鉛角（日文：込め物）的金屬塊，填充到活字之間形成間距或構成其餘版面的留白，鉛角同樣也必須有三種尺寸標準。一般印刷業者只會具備自己國家所通用的規格與設備，像本公司一樣擁有三種不同尺寸標準的鉛角，聽說在印刷業界中也是相當稀有的。

活字的高度也各自有不同的差異。若以美國點制作為基準來比較，迪多點制為 0.928 inch，美國點制為 0.918 inch，而日本的活字高度很巧地落在兩者正中間的 0.923 inch。迪多點制與美國點制的活字高度差距，差不多是一張薄名片紙張的厚度，雖然聽起來差距很微小，但實際印刷的成果卻有大大的不同。

INTRODUCTION

THE Peignot type, paradoxical as it may seem, is neither a creation nor a novelty - certainly not in the commercial sense so often misapplied to these words. The alphabet we submit to the public in this specimen is one whose essential character is that its design, and above all its conception, differ radically from the whole host of other founts of type hitherto produced. Indeed, as far as "design" is concerned, the Peignot type has only the interest - albeit very great - of the materialisation of an idea. It is not one more variety of a traditional conception artificially justified by the ability of a clever designer. It is a creation, a newly planned alphabet, the essential validity of which may be the starting point of successive "styles" and "designs."

The plan of the Peignot type is the result of exhaustive study of the evolution of the form of the roman alphabet. The makers of the type realized that the principle of evolution implicit in the history of letter-formation could be logically pursued in this twentieth century; and, if the logic were consistently distributed throughout the fount, the resulting design would possess artistic as well as scientific merit. It was felt that the paramount necessity was to achieve, in the most absolute degree, all the requirements of legibility; and the whole of the evidence made available by extensive study of letter formation, whether in books and documents on the one hand, or stone and metal inscriptions on the other, demonstrated that, from the point of view of legibility, the technique of the engraved letter was vastly more useful to the printing trade than that

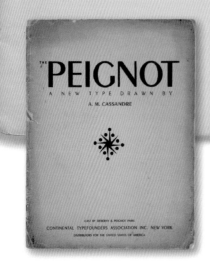

Artist's sketch of the 200-foot Perisphere within which visitors to the New York World's Fair of 1939 will view, from a revolving platform suspended in mid-air, a dramatization of the World of Tomorrow. Clusters of fountains will screen the piers supporting the Sphere so that the great ball will appear to be poised on jets of water. The 700-foot triangular Trylon at the left - a unique architectural form - will serve as a Fair beacon and broadcasting tower.

Medium 16 point

1939

卡桑德爾的奇特字型

身為平面設計師的卡桑德爾（Cassandre）所設計的字體傑作：Cassandre。具有普通的大寫字母與像是大寫字母般的小寫字母，兩者混合在一起而形成的奇特字體。不適合拿來編排長篇文章。使用時就算全用大寫字母排版也可以，但與小寫文字混排的話字體特色不但最明顯，還能給人深刻的印象。

佩尼奧（Deberny & Peignot）鑄字廠（法國）1930 年代　317×245mm

WIESBADEN

Uralte Heilkraft
Ewigjunge Schönheit

FUTURA

THE
TYPE
OF
TODAY
AND
TO
MOR
ROW

THE BAUER TYPE FOUNDRY INC · 235–247 EAST 45TH STREET · NEW YORK

IT'S
THE THING TO DO

To go to Europe. The right wing of the movement began
seasons back when the European trip was in the category
of a luxury. But, it's a forward march for everybody now-
the trip is a necessity. It is, if you will keep up with the
times. Book on the Majestic, Olympic, Homeric, Belgen-
land, Minnewaska or Minnetonka, if you can. But if you're
too late for these or they don't suit your convenience -
take any White Star, Red Star or Atlantic Transport liner.
Every one of them has the same charming atmosphere
of smart informality - interesting people of the world sail
on them - their service and cuisine are matchless. You'll
have the assurance that no one has ever traveled better.

Adress: No. 1 Broadway, New York City, our offices
elsewhere or authorized agents

WHITE STAR LINE
RED STAR LINE · ATLANTIC TRANSPORT LINE
INTERNATIONAL MERCANTILE MARINE COMPANY

富有動感的現代構圖

蒙太奇風格的照片拼貼與 Futura
具有的幾何剛硬感相輔相成，發
揮出良好的視覺效果。像 Futura
之類的現代無襯線體，能排出既
現代且富有動感的版面構圖。

鮑爾鑄字廠（德國） 戰前 上：265×190mm
右：308×226mm 右頁：385×262mm

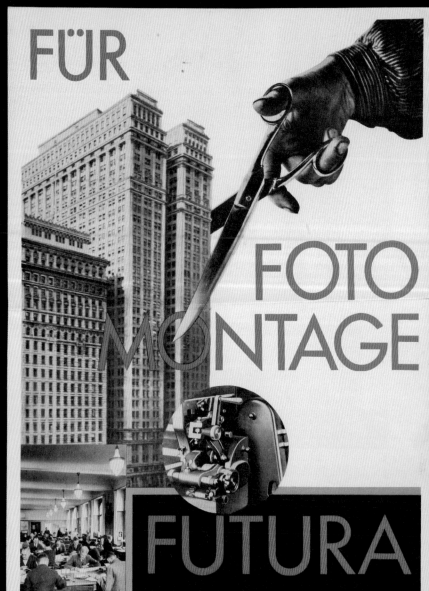

FÜR

FOTO
MONTAGE

FUTURA

SOMMER
DER MUSIK

FRANKFURT AM MAIN 1927
1. JUNI BIS 28. AUGUST

6. WOCHE

M BACHSAAL
ÄGLICH 16 UHR
RGELKONZERTE

Tag	Programm	Ort/Zeit
Sonntag 17. Juli	Morgenfeier des Hessischen Sängerbundes Teatro dei Piccoli, Marionettenspiele Gamelan-Orchester und Javanische Tänze Tanz- und Gesangsgruppen aus Rußland	Bachsaal 9 Uhr Bachsaal 20 U. Saxophon 17 U. Opernh. 20 Uhr
Montag 18. Juli	Tanzabend »La Argentina«, Span. Tänze Quartett »Pro Arte«, Belg. Kammermusik Teatro dei Piccoli, Marionettenspiele Gamelan-Orchester und Javanische Tänze	Opernh. 20 Uhr Beethovensaal Bachsaal 20 U. Saxophon 17 U.
Dienstag 19. Juli	Tanzabend »La Argentina«, Span. Tänze Quartett »Pro Arte«, Belg. Kammermusik Teatro dei Piccoli, Marionettenspiele Gamelan-Orchester und Javanische Tänze	Opernh. 20 Uhr Beethovensaal Bachsaal 20 U. Saxophon 17 U.
Mittwoch 20. Juli	Tanz- und Gesangsgruppen aus Rußland Teatro dei Piccoli, Marionettenspiele Gamelan-Orchester und Javanische Tänze Hausfrauen-Nachmittag mit »Küchenmusik«	Opernh. 20 Uhr Bachsaal 20 U. Saxophon 17 U. Unterhalt.-Park
Donnerstag 21. Juli	Tage für mechan. Musik, Leitg. P. Hindemith Teatro dei Piccoli, Marionettenspiele Gamelan-Orchester und Javanische Tänze Streichorchester-Konzert, Leitg. Joh. Strauß	Beethovensaal Bachsaal 20 U. Saxophon 17 U. Unterhalt.-Park
Freitag 22. Juli	Tanz- und Gesangsgruppen aus Rußland Tage für mechan. Musik, Leitg. P. Hindemith Teatro dei Piccoli, Marionettenspiele Gamelan-Orchester und Javanische Tänze	Opernh. 20 Uhr Beethovensaal Bachsaal 20 U. Saxophon 17 U.
Samstag 23. Juli	Tanz- und Gesangsgruppen aus Rußland Teatro dei Piccoli, Marionettenspiele Tage für mechan. Musik, Leitg. P. Hindemith Streichorchester-Konzert, Leitg. Joh. Strauß	Opernh. 20 Uhr Bachsaal 20 U. Beethovensaal Unterhalt.-Park

IM
UNTERHALTUNGS
PARK: JEDEN TAG
KONZERT U. TANZ

YP: LEISTIKOW

MUSIK IM LEBEN
DER VÖLKER
INTERNAT. AUSSTELLUNG

STEILE FUTUR

heißt unsere neue, von Paul Renner entworf

Schrift, die zur Fahrt in die große, weite Welt

Buchdruckerkunst bereit ist. Die Steile Futura

ein neues Mitglied der Futura-Familie, und der e

fahrene Typograph erkennt auf den ersten Blick

welche Fülle unverbrauchter Möglichkeiten diese

Schrift unserer modernen Typographie erschließt:

welch eine neuartige Wirkung das geschlossene,

einprägsame Bild ihrer Zeilen dem Schriftsatz zu

geben vermag. Die Steile Futura halbfett ist sofort

lieferbar. Der magere und der fette Schnitt und

die drei Kursivschnitte werden in Kürze folgen.

BAUERSCHE GIESSEREI

Sammeln Sie unsere Kleinpropaganda
sie gibt Ihnen wertvolle Anregungen !

BG

Stapellauf

STEILE FUTURA fett

窄體版本的 Futura

窄體的 Steile Futura 是 Futura 多樣的字型家族款式中的其中一款，將原本字母是由圓形
與直線所構成的 Futura，壓縮後變成四四方方的造型與特色。雖然設計概念上有特別重
視與 Futura 混排時的相容性，但單獨作為窄體使用也可以，是一套相當出色的字體。

鮑爾鑄字廠（德國） 推測為戰後 270×193mm

萊諾鑄字廠的現代無襯線體

模仿鮑爾鑄字廠的 Futura，由萊諾
(Linotype) 鑄字廠所製作的現代無
襯線體 Spartan 的型錄。透過精湛
的排版範例展現了字體具有的幾何
剛硬特性質。

萊諾鑄字廠（德國） 1950 年代 264×191mm

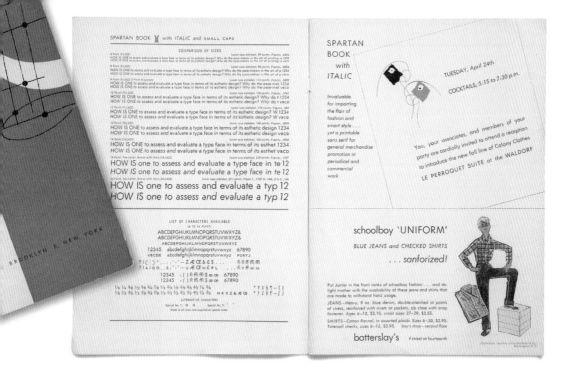

精采無比的 Gill 範例集

最暢銷字體 Gill 的使用範例。從內文排版到標題運用，將字體的所有可能性都發揮出來的精彩範例集。
恩斯赫德鑄字廠（與 35 頁相同）

The

WALDORF
ASTORIA

Rhine and Moselle Wines

Moselles and Rhine wines are the most famous of the German wines. The so-called "noble rot" is distinctly typical of the wine production of Germany, although it is practised elsewhere. The grapes are picked after they have started to decay on the vine. In early days the wine press could not be started until permission was granted by the Bishop of Fulda, and the process was discovered on an occasion when the Bishop's messenger was delayed by illness. Moselle is a slender wine, distinguished by a dry sharpness and highly prized for its rare bouquet

"FIRST TO PRESENT"

CARNATION, THE NEW PERFUME BY

MATCHABELLI THE TRUE SCENT

OF CARNATIONS IN A CHARMING NEW

ODEUR YBRY'S EAU DE COLOGNE,

AS FRESH AND FASCINATING AS EVER,

PRESENTED IN BOTTLES OF GRACE-

FUL ANTIQUE CHARM. CORDAY BATH

POWDER GARDENIA, LE POIS DE

SENTEUR, L'ORCHIDEE BLEUE, JASMIN

CORVINUS

像「貴婦人」般美麗的字型

Corvinus 是擁有「貴婦人」之美名的優雅字體。在圖頁中展示了純以大寫字母排版、以及大小寫字母混排時的範例，無論哪種方式都非常的美麗。由於是瘦長形的字體，行距要特別加大以便閱讀，另外行尾的連字號「-」與逗點「,」位置要稍微超出欄位邊界，這樣才會使得文章右側看起來視覺上是對齊的，這些都是文字排版必須留意的視覺調整。

鮑爾鑄字廠（德國）　推測為戰前　265×192mm

If to be venerated for benevolence, if to be admired for talents, if to be esteemed for patriotism, if to be beloved for philanthropy, can gratify the human mind, you must have the pleasing consolation to know that you have not lived in vain.

George Washington in a letter
to Benjamin Franklin
1789

GRAND HOTEL
THE ATLANTIC CASTLE

34-38 KENT AVENUE · FLORIDA
PHONE: PINEHALL 183

The latest designs for gowns, frocks and coats
for springtime by

MARION STEWART

will be put on exhibition in her showrooms at
four o'clock on Wednesday, March 15th.

REGENT STREET 28, LONDON W.I.

DE ROOS
Roman

DE ROOS
Italic

有氣質的羅馬體 De Roos

De Roos 是造型洗鍊、沒有多餘贅飾的纖細字體，相當適合用來排書籍。因為非常有氣
質，也能用於企業文宣的箋頭（letterhead）與邀請卡等等的場合。是由阿姆斯特丹鑄字
廠所販賣的字型，在美國也曾透過美國聯合字型公司發表及販售過。

阿姆斯特丹鑄字廠（荷蘭） 1947 年 307×216mm

*t*he extent to which architecture might be called an art has been the subject of investigation often enough. It seems to me that architecture is rarely/and then only to an inconsiderable degree/a true art; that is/it rarely can ascribe its origin to the desire for cognition and see its goal in the furtherance of understanding. Architecture does/to be sure/participate/along with other arts/in what we usually think is the essence of art/ particularly in its striving to achieve an aesthetic effect. But if we believe that architecture does not stand on a plane with the other arts simply because its works have a practical aim and purpose/we are in error/for a practical purpose does not prevent the other arts from remaining true to their artistic purpose. The reason is much more likely to lie in the nature of architecture itself. We usually limit the artistic qualities of our buildings to their aesthetic effect. Nevertheless/when we subtract all that/we still have a remainder which/though rarely recognized/may be the genuine and only significant artistic component in the works of architecture.–

Conrad Fiedler

R TYPE

N.J.

0298

presents

ecture might
the subject
. It seems to
ly/and then
ree/a true
ribe its origin
o see its goal
tanding.
participate/
t we usually
ticularly in
thetic effect.
ture does
other arts
e a practical
rror/for a
event the
rue to their
s much more
chitecture
stic qualities
hetic effect.
act all that/
ich/though
genuine and
onent in the
rrad Fiedler

36 point initials 3 A · 4.50 lb

**aBCDefG
hJKLNRU**

以安瑟爾書寫體字型營造手寫感

American Uncial 是維克多·漢默 (Victor Hammer) 所製作的活字字型，復刻自歐文書法風格中典型的安瑟爾 (Uncials) 手寫體。漢默不單只復刻安瑟爾體，也設計了許多類似的書法字體。行頭的位置故意不對齊，是為了營造出手寫的氛圍。

上：斯坦普爾鑄字廠（與 32 頁相同）
右：克林斯波爾兄弟鑄字廠　1950 年代　297×210mm

Klingspor Foundry types brins

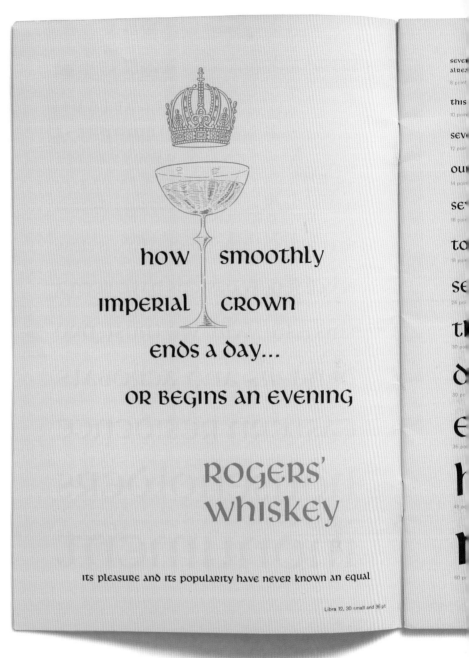

how smoothly

imperial crown

ends a day...

OR BEGINS AN EVENING

ROGERS'
whiskey

ITS PLEASURE AND ITS POPULARITY HAVE NEVER KNOWN AN EQUAL

Libra 12, 30 small and 36 pt

小寫字母造型演變之過渡階段的手寫風字體

Libra 是復刻自古早書法字體的活字字型，造型
風格是取自大寫字母演變為小寫字母的過渡階
段。有些文字仍保留了大寫字母的形貌，而有些
文字已經形成現在小寫字母的樣子，是相當特別
的一套字體。

上：阿姆斯特丹歐陸字型公司（與 77 頁相同）

存在感強烈的寬字幅字型

Carolus 是只有大寫字母的字體。用於起首文字（initial）的場合或者是排單字時，也會因為字幅較寬而有一定的存在感。

芝加哥鑄字聯合公司（美國） 1960 年代　298×214mm

獨特的平頭鋼筆手寫風格字體

Solemnis 是大寫字母與小寫字母造型混合，以平頭鋼筆書寫線條為特色的字體。使用在短文時會有獨特的視覺衝擊感。

下：伯特霍爾德鑄字廠（德國） 1950–60 年代　133×186mm
右頁：芝加哥鑄字聯合公司（美國） 1960 年代　292×196mm

PROBE NR. 422

solemnis die neue form der unziale

h. berthold ag · schriftgiesserei berlin-west / stuttgart

CASTCRAFT, INC., TYPEFOUNDERS OF CHICAGO, PRESENTS THREE EXCITING TYPE FACES MADE IN GERMANY BY THE BERTHOLD TYPEFOUNDRY, BERLIN

SOLEMNIS

Fox

Derby

SOLEMNIS

Serious and dignified best describe this beautiful uncial design by Gunter Gerhard Lange. Solemnis, available in caps and figures only, lends an aura of distinction to the printed piece.

SOLEMNIS

has an educated character which qualifies it well for book titles, church and school literature, as well as stamp work among other printing uses.

If the requirement is for a unique face, especially in work of a personal nature, the choice of Solemnis offers appealing quality for prize winning composition

SOLEMNIS

107

R. & M. Armstrong & Co.

Established 1898

STOCKS & BONDS

3 Rockefeller Plaza
Telephone · Circle 6-6141

MEMBER N...EXCHANGE

Sanders
BRAVO
VINEGAR
One Gallon

Let your
smoking
JOY
be
unconfined

Mild and mellow,
AROMA PIPE TOBACCO
will make your every puff
a real delight; and because
of Aroma's special ripening
treatment you are assured
no "after-bite.". . . Though
made by a careful blending
of the finest Virginia and
Turkish tobaccos the price
of Aroma's full two-ounce
tin will add to your pleasure

Aroma
PIPE TOBACCO
—15¢

TELEPHONE: MURRAY HILL 2-3
Royal Venetian Blind C
305 EAST 42ND STREET, NEW YO

William Hertzog

The Jason Gaynes Acade
will be pleased to consi
the applications of a limi
number of resident stude

Used in combination with Bernhard Modern, Bern
Modern Bold adds virility to a two-color tobacco ad, a simple bus
card and a school announcement.... On the opposite page in a bro
advertisement and a vinegar label the Bold also works to good advan

Bernhard
Modern
BOLD
AND
Bold Italic

AMERICAN TYPE FOUNDERS

銳利且纖細的字體

Bernhard Modern Bold 與 Bold Italic 的樣本
型錄。與 Bernhard Modern 一樣線條銳利且
具纖細感,適合用於富有時尚感的商品包裝
或型錄等等的場合。

美國聯合字型公司(美國) 戰前 264×191mm

THE RITZ-CARLTON FLOWER SHOP
FLOWERS FOR EVERY OCCASION
445 FIFTH AVENUE NEW YORK CITY 808 PARK AVEN

Egmont Light and Egmont Bold

GENERAL MOTORS

You are cordially invited to
view the annual showing of
the new General Motors cre-
ations, which are on exhibit
in our showrooms during the
month of October. We will
present there a fine collection
of our Chevrolet, Pontiac and
Buick cars, all distinguished

Egmont Medium Italic

YOU'LL ENJOY

a greater

movie

season

AT THE SHERIDAN

menu
for
fall

LUNCHEON SCOTCH BROTH—
the wearable wool plaid in clan colors. OCTOBER
ALE—*accessories in that rich, nut-brown shade*

TEA SPICE CAKE—*the crepe dress in cinna-*
mon with a creamy guanaco topping. PEKOE—
accessories with a pale amber glow that is sure to
pick up the weariest or set off the smartest wardrobe

DINNER PHEASANT—*feather-weight*
wool in a dinner suit, reflecting the subtle green-
gold tans of brilliant plumage. GRAPE—*accesso-*
ries that are purple, yet almost black. Excitingly new

At the left Bernhard
Bold Italic is used with Bernhard
Italic in a package stuffer or announ...
for a department store or specialty sho...
is suggested a decorative trade mark

FORSITE

TRADE MARK

FABRICS

Bernhard Modern B...
gives a touch of fresh distinction t...
lisher's letterhead on the opposite pa...
bined with artwork this type makes...
tion-getting cover for a movie announ...

GENERAL MOTORS
CHEVROLET
PONTIAC
BUICK

GENERAL MOTORS COMPANY, NEW YORK

EGMONT
CONTINENTAL
TYPEFOUNDERS ASSOCIATION INC

具有高級感且優雅的現代羅馬體

優雅的現代羅馬體 Egmont 的樣本
冊（封面是印歐陸聯合字型公司。請
參考 114 頁的解說）。可用於具有高
級感的商品廣告上。

阿姆斯特丹鑄字廠（荷蘭）戰前　299×220mm

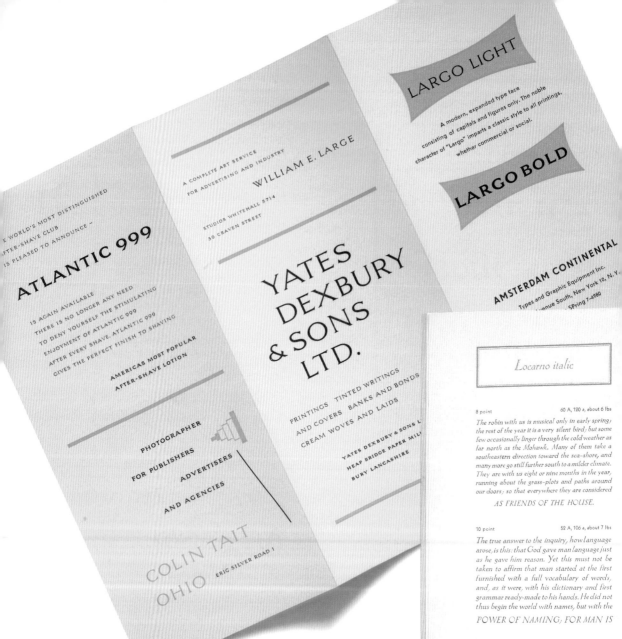

德國風格的銅板雕刻體

德國風格的銅板雕刻體 (copperplate gothic)Largo 的細體 (light)
與粗體 (bold)。適用於名片、邀請卡等等的社交印刷品上。

路德維希與梅耶鑄字廠(德國) 1950 年代 200×91mm

像女性般優雅的羅馬體

Locarno (Koch Antiqua) 字體在美國被
稱之為 Eve。介紹頁選用的是義大利體
的款式 Locarno Italic (Koch Kursiv)，大
寫字母有加上細線裝飾是這套義大利體
的特色，適用於充滿女性風味且時尚
的廣告上。

克林斯波爾兄弟鑄字廠(德國) 戰前　260×189mm

24 A, 52 a, about 11 lbs

*at refined taste and elegance
us productions of the printer
ld upon public consideration*

COULD NOT BE

18 A, 38 a, about 13 lbs

*y sends to their graves
r of the obscure men,*

ROUS PEOPLE

12 A, 20 a, about 14 lbs

*n all conditions of
lowest as well as*

HIGHEST

10 A, 14 a, about 18 lbs

sels Adopted

ORMED

6 A, 12 a, about 28 lbs

ning Morn

MPIRES

National Fashion

Bonwit May

FIFTH AVENUE AT 56TH STREET

NEW YORK

LONDON　　　　PARIS

*In this romantic era of fashion
Bonwit May presents collections
which borrow the picturesque
beauty of the past and add the
more sophisticated charm of the
present . . . clothes that make
young persons winsome and
women utterly charming!*

LOUIS HOUSMAN

*Cordially invite you to a great exhibition of Summer Fashions.
At Wheatons Inn, on tuesday and wednesday, October 7th and 8th*

THIRTY-FOURTH STREET

29

Why Caslon

In the larger sizes Caslon Old Face is emphatic—but never aggressive. A friendly type.

holds its own . . .

for over 200 years it has been a 'must'

Use it in

LARGE

spaces

Or in

THE SMALLS

The one type

It is Always SAFE to use

CONSIDER this size for the text of a manufacturer's message to the public! Isn't it dignified? And isn't it easy to read? Here is the reason:

CASLON OLD FACE was first produced in an age when all type punches had necessarily to be cut by hand. That is why in every size there is INDIVIDUALITY, for when the first Caslon cut this ageless masterpiece, he varied the details of design in every letter. It is the pre-eminent publicity type, the supreme masterpiece of type design—use it *to-day & every day*

Desborough & Charterhouse

High-class Printers, Bookbinders, & Publishers

Colour Printing, Showcards, Wrappers, Coloured Supplements, Magazine Insets, Labels, Children's Picture Books, Picture Post Cards, View Books, Chromo Almanacs & Card Calendars, & Pictures for Box Tops, etc., etc.

125 CAMBRIDGE NEW ROAD, NORTHAMPTON

ROYAL ANTIQUARIAN SOCIETY

Established during the Reign of King George I. to Promote and Encourage Historical Research and Study

Excursion to Cambridge

Arrangements have been made for a visit to Cambridge on Saturday next October the 25th. It is proposed to visit places of historical interest, and among these the lesser colleges of Peterhouse, Clare, Pembroke, Emmanuel Caius, Trinity Hall, and Corpus Christi. Trinity College and St. John's are included in the itinerary. The library of St. John's is of special interest

MEMBERS WHO PROPOSE GOING SHOULD ACQUAINT THE SECRETARY NOW

ARTHUR G. NEWTON
Manager

FRANK W. MARSHAM
Secretary

ESTABLISHED THIRTY YEARS

Birmingham Manufacturing Co

Inventors & Patentees of Improved Machinery for Farmers, Agriculturists & Market Gardeners

CONTRACTORS BY APPOINTMENT TO H.M. GOVERNMENT INSTITUTIONS AND AGRICULTURAL COLLEGES

Telegrams:
"DESMAN BIRMINGHAM" BIRMINGHAM

用古典羅馬體呈現現代感

Caslon 是一度被歷史忽略的古典羅馬體（Old Roman）字型，
排版後所呈現的高品質版面讓人再度肯定起它的美麗與價值。

卡斯隆（H. W. Caslon & Co. Ltd.）鑄字廠（英國） 戰前 318×250mm

19 世紀後半，當時歐洲的活字鑄字廠主要是製造並販售針對國內市場會使用的活字，但由於規格幾乎相同，所以歐陸地區各地生產的活字就開始互相流通了。到了19 世紀末與 20 世紀初，關於印刷或平面設計的雜誌不僅可見於歐陸地區，甚至跨越國界推廣到英國與美國。

1919 年，包浩斯學校正式成立，符合包浩斯主義及其理想所設計出的字體 Futura，也在 1927 年時由德國鮑爾鑄字廠推出販售，在歐洲掀起一波巨大的流行風潮。

藉由 Futura 打響名號後，鮑爾鑄字廠旗下的字體開始廣被各國所知，其中來自美國市場的需求及呼喚逐漸增加，鮑爾因此在紐約設立了名為鮑爾字母（Bauer Alphabets，又被通稱為紐約鮑爾〔Newyork Bauer〕）的分公司。美國區所販售的活字是由尺寸規格與美國相同的西班牙地區分公司負責生產，鑄好後再送往紐約販售。在美國市場，造型上幾何剛硬且具現代感的 Futura 受到絕佳的好評。

第二次世界大戰開戰後，西班牙鮑爾分公司（Spain Bauer）由於是歸屬西班牙的公司，所以免去了資產凍結的下場，但和西班牙與德國關係密切的鮑爾字母公司就被美國政府下令凍結了公司資產。

此外，戰前受到鮑爾字母公司成立所帶來的刺激，針對美國市場專賣歐陸體系字型的歐陸聯合字型公司（Continental Type Founders）也成立了，歐洲各家活字鑄造廠也因此增設了美國點制規格的設備，也為了將字型輸出海外而開始印製英語版的字型樣本。Egmont（109 頁）的樣本冊，就印上了當時全美國 21 間（代理店）的名稱。

不過，第二次世界大戰爆發後，字型輸出的管道也受影響而中斷，鮑爾字母公司與歐陸聯合字型公司也因此紛紛關廠。

雖然鮑爾字母公司戰後又恢復營運，但當時 Futura 字型已經透過美國聯合字型公司進行販售，再加上萊諾公司推出的 Spartan 或蒙納公司的 Twentieth Century 等等，市面上出現許多款與 Futura 非常相似的字體，加上鮑爾總公司的販售業績不佳的影響，最後因此而倒閉。

順帶一提，西班牙鮑爾分公司後來一度成為 Neufville 字型公司，不過現在公司名稱又回歸「西班牙鮑爾」並持續地生產營運中。

阿姆斯特丹歐陸字型公司（紐約、加州分部）是在二次大戰後，模仿戰前歐陸聯合字型公司的經營方式，專門提供歐陸體系字型給美國市場的販售公司。嘉瑞工房所收藏的許多字體型錄就是當時所製作的。

另外有一個名稱非常相像的字型公司稱作阿姆斯特丹鑄字廠（Typefoundry Amsterdam），這是位於荷蘭阿姆斯特丹的鑄字廠，要小心不要混淆了。

本書中圖解說明之所以會標記一個以上的公司名稱，或明明是位於歐陸的鑄字廠卻使用英文排樣本等等的情形，這些無形中都記錄了那段字型外銷到美國的時代。我們公司所收藏的英語樣本型錄之所以會那麼多，也許要歸功於當時阿姆斯特丹歐陸字型公司真的非常熱心且努力地推銷他們的字型吧！

※關於重要活字鑄造廠的介紹，請參考 192 頁。

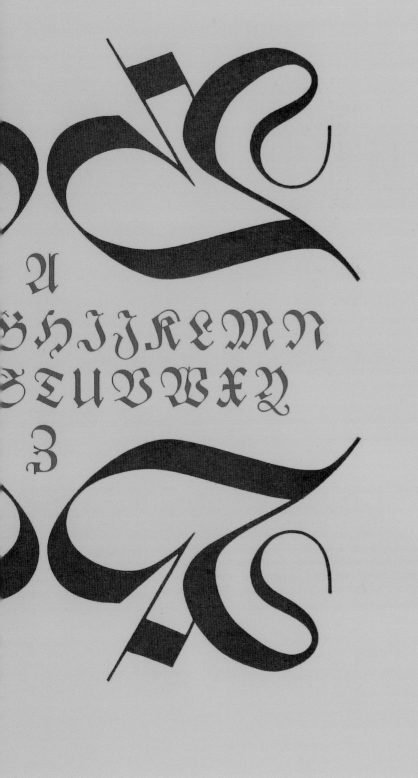

各國活字鑄造廠的樣本冊

各国の活字会社のパンフレット

117

值得多加欣賞的美麗質感

118–123 頁是取自蒙納公司的型錄折頁。首先是 Garamond、Bembo、Poliphius 等字體的優良排版範例。比起各自的篇幅內容，更值得多加欣賞字體整體所呈現出的美麗與質感。右側的排版範例（Poliphilus）是複製 15 世紀時由阿圖斯（Aldus）出版社所發行的書籍。以現在的眼光來看仍然毫不遜色，是水準非常高的排版作品。

蒙納公司(英國) 1960 年代 248×185mm

Garamond

At the end of the 19th century the French National Printing Office, founded in 1643 by Cardinal Richelieu, reminded the world through a number of scholarly monumental books that it had been for centuries a great repository of typographical material. In the course of these researches there were brought to light three sets of punches of remarkable beauty and personality. These punches were evidently of an age equal to that of the office itself, and their description, *Caractères de l'Université,* had in the course of centuries also acquired an ascription to Claude Garamond.

When these types were copied by various type-founders after the first world war, they were issued under the name of Garamond; but in 1926 Paul Beaujon's researches in *The Fleuron* identi-fied the designer as Jean Jannon. It was then too late to rename the face, and Jannon remains better known as the printer of a famous minia-ture Bible than as the originator of one of the most popular 20th-century types.

Jannon, a self-taught punch-cutter, was prin-ter to the Calvinist Academy at Sedan. Owing to political disturbances in 1615, he was deprived of his type supplies from Frankfurt and in the space of only six years he cut and struck a magnificent range of sizes. Based on Garamond's

models, his design is much lighter and more open and characterized by the sharply-cupped top serifs to some of the letters.

'Monotype' Garamond was the first series to be cut in the ambitious programme of matrix production undertaken by the Corporation in 1922, and it is a close reproduction of Jannon's original. Its early use by the Pelican, Cloister and Nonesuch Presses swiftly made it a "classic", and it is now one of the most widely-used book, periodical and jobbing faces, particularly on the Continent. It is by no means an all-purpose face. Originally designed to stand up to heavy inking and "bash" impression on a damp hand-made paper, it tends to look thin and fussy on coated paper, but it reproduces well by offset.

The italic is taken from a fount of Granjon, which appeared in the repertory of the Imprime-rie Royale and was probably cut in the middle of the 16th century. Its letters are decidedly irregular in slant and steeply inclined, but an alternative, more regularized italic (Series 174) is also available. Both italics are equipped with an extensive range of swash letters and ligatures: a complete range of the 8-point size is shown on the back page. There is also a companion bold face design (Series 201) with one of the best italics available for display work.

BEMBO

'Monotype' Bembo has achieved that "permanent future", forecast by a reviewer in *The Fleuron* (1930). "It will be used by the 'undistinguished' as well as the distinguished printer, for it possesses all the virtues in an eminent degree; a first-class legibility in its own right, an Englishness conferred by our use of Caslon for two centuries, economy in a-z space, adequate but not extravagant ascenders and descenders, agreeable variety of thicks and thins, a perfect grace in combination and, above all, a due capacity for enlargement."

With Bembo (1929), The Monotype Corporation restored to the printer's typographic heritage the earliest, and undoubtedly the most beautiful, old face design in the history of typography. Cut by Francesco Griffo, one of the most accomplished goldsmiths and engravers of the 15th century, it was first used by Aldus Manutius in a tract by the humanist scholar and poet, Pietro Bembo, published in Venice in 1495.

The superb quality of the design and the great prestige of the printer carried the pattern all over Europe. It was copied by Claude Garamond for the Paris printers, and by Robert Granjon for Christopher Plantin and others. It took deep root in the Netherlands, where it was recut by van Dijck; and it was this version that Caslon took as his model when the English typefounding trade was revived in the 18th century.

It is not surprising that Bembo has in, the last few years, become the most popular face in the annual selection of British books for the N.B.L. exhibitions of book design. Quite apart from its typographic charm, it is an ideal book face. Economically a good space-saver, it requires minimum leading for easy readability. It is a versatile face, which prints well on most paper surfaces, and it has been successfully reproduced by photo-offset and photogravure.

The first italic to Series 270 was a new chancery, Bembo Condensed Italic, designed by Mr. Alfred Fairbank, but this letter was found to be too individual to harmonize with the roman. The standard italic was based on chancery types used by the great writing master, Tagliente, but extensively revised for machine composition. There is a companion bold, which is both useful and pleasing as a bold face design.

Bembo: 11 point, 2 point leaded

ALDUS MANUTIUS the great scholar-printer, published in Venice in 1499 the *Hypnerotomachia Poliphili*, one of the most famous illustrated books in the history of printing. The importance of its type face in the history of type design was not, until the twentieth century, fully recognized and attention was concentrated on the beauty of its wood-cuts and the historic interest of the book as an expression of the humanists' passionate regard for the newly discovered wonders of classical antiquity. The type of the *Hypnerotomachia* (from which the design of Poliphilus was taken) together with the earlier version of the same design which appeared in a tract by Cardinal Bembo (later re-cut by The Monotype Corporation in 1929 as 'Monotype' Bembo) constitutes the prototype of what we now call the "old face" types. The general principles of the design – its relatively narrow curves, diagonal disposition of weight and bracketed serif formation – dominated type design in France, the Low Countries and eventually England until the appearance of the "modern" face in the eighteenth century.

In the re-cutting of this type, no effort was made (as it was later to be in Bembo) to produce a design resembling the face as it must have appeared before the outline of the letters had been softened and thickened by impression into damp hand-made paper. Moreover the effects of the ink squeeze were deliberately retained in the re-cut version and the face has, as a result, a warmth of colour and an absence of fine lines which make it suitable for printing on art paper. The fine proportions of the letters are not obscured by such superficial irregularities.

The italic face which has been mated with the Aldine roman face is based upon the finest of the letters used by Antonio Blado who occupied the office of Printer to the Holy See during the years 1515 to 1567. The elegant chancery italic is, by reason of its regularity, one which can stand very well on its own and it has had a distinguished history independent of Poliphilus, particularly in the printing of verse, beginning with the famous Nonesuch *Dante*.

Poliphilus: 13 point, 1 point leaded

There is scarcely a poet of the same eminence, whom I have found it so delightful to read *in*, or so tedious to read *through*. Give me Chaucer in preference. He slaps us on the shoulder, and makes us spring up while the dew is on the grass, and while the long shadows play about it in all quarters. We feel strong with the freshness round us, and we return with a keener appetite, having such a companion in our walk. Among the English poets both on this side and the other side of Milton, I place him next to Shakespeare; but the word *next*, must have nothing to do with the word *near*. I said before, that I do not estimate to highly as many do the mushrooms that sprang up in a ring under the great oak of Arden.

Poliphilus: 10 point, 2 point leaded

AUTHORS of the highest eminence seem to be fully satisfied with the view that each species has been independently created. To my mind it accords better with what we know of the laws impressed on matter by the creator, that the production and extinction of the past and present inhabitants of the world should have been due to secondary causes, like those determining the birth and death of the individual. When I view all beings not as special creations, but as the lineal descendants of some few beings which lived long before the first bed of the Silurian system was deposited they seem to me to become ennobled. Judging from the past, we may safely infer that not one living species will transmit its unaltered likeness to a distant futurity. And of the species now living

Poliphilus: 10 point, 2 point leaded

I saw the clouds and dark vapours open gradually to right and left, rolling over one another in great smokey wreaths, and the tide (as it flowed gently in upon the sands) first whitening, then slightly tinged with gold and blue; and all at once a little line of insufferable brightness that (before I can write these five words) was grown to half an orb, and now to a whole one, too glorious to be distinctly seen. It is very odd it makes no figure on paper, yet I shall remember it as long as the sun, or at least as long as I endure. I wonder whether anybody ever saw it before. I hardly believe it.

Blado: 11 point, 1 point leaded

IN THE DAIES of *Augustus Caesar* the Emperour, there was a Dolphin entred the gulfe or poole Lucrinus, which loved wonderous well a certain boy, a poore mans son; who using to go every day to schoole from Baianum to Puteoli, was woont also about noone-tide to stay at the water side, and to call unto the Dolphin, *Simo, Simo,* and many times would give him fragments of bread, which of purpose hee ever brought with him and by this means allured the Dolphin to come ordinarily to him at his call. Well, in process of time, at what houre of the day this boy lured for him and called *Simo*, were the Dolphin never so close hidden in any secret or blind corner, out he would come and abroad, yea and scud amaine to this lad; and taking bread and other victuals at his hand, would gently offer his backe to mount upon, and then downe

Poliphilus: 11 point solid

We seek to know the moving of each sphere,
And the strange cause of the ebbs and floods of Nile;
But of that clock within our breasts we bear
The subtle motions we forget the while.

We that acquaint ourselves with every zone
And pass both tropics, and behold the poles,
When we come home, are to ourselves unknown,
And unacquainted still with our own souls.

Blado: 12 point, 2 point leaded

After many days of wandering, the Assassins pitched tents in the valley of Bethzatanai. For ages had this fertile valley lain concealed from the adventurous search of man, among mountains of everlasting snow. The men of elder days had inhabited this spot. Piles of monumental marble and fragments of columns that in their integrity almost seemed the work of some intelligence more sportive and fantastic than the gross conceptions of mortality, lay in heaps beside the lake, and were visible beneath its transparent waves. The flowering orange-tree, the balsam, and innumerable odoriferous shrubs grew wild in the desolated portals. The fountain tanks had overflowed, and amid the luxuriant vegetation of their margin, the yellow snake held its unmolested dwelling. Hither came the tiger and the bear to contend for those once domestic animals who had forgotten the secure servitude of their ancestors. No sound, when the famished beast of prey had

Poliphilus: 11 point, 2 point leaded

NARRA QVIVI LA DIVA POLIA LA NOBILE ET ANTIQVA ORIGINE SVA.ET COMO PER LI PREDE CESSORI SVITRIVISIO FVE EDIFICATO.ET DIQVEL LA GENTE LELIA ORIVNDA. ET PER QVALE MO DO DISA VEDVTA ET INSCIA DISCONCIAMENTE SE INAMOROE DI LEI IL SVO DILECTO POLIPHILO.

E MIE DEBILE VOCE TALE O GRA tiose & diue Nymphe absone peruenerãno & inconcine alla uostra benigna audiétia, quale laterrifica raucitate del urinante Esacho al sua ue canto dela piangeuole Philomela. Nondi meno uolendo io cum tuti gli mei exili conati del intellecto, & cum la mia paucula sufficie tia di satisfare alle uostre piaceuole petitone, non ristaro al potere. Lequale semota qualũque hesitatione epse piu che si conguerebbe altronde, dignamente meritano piu uberrimo fluuio di eloquentia,cum troppo piu rotunda elegantia& cum piu exornata poli tura di pronũtiato,che in me per alcuno pacto non si troua, di cõseguire il suo gratio so affecto Ma a uui Celibe Nymphe & adme alquáto,quan túche & confusa & incomptaméte fringultiéte haro in qualche portiun cula gratificato assai. Quando uoluntarosa & diuota a gli desii uostri & postulato me prestaro piu presto cum lanimo nõ mediocre prompto hu mile parendo,che cum enucleata tersa,&uenusta eloquentia placédo.La prisca dunque& ueterrima geneologia,& prosapia,& il fatale mio amore garrulando ordire. Onde gia essendo nel uostro uenerando conuentuale conspecto,& uederme sterile& ieiuna di eloquio& ad tanto prestáte & di uo ceto di uui O Nymphe sedule famularie dil acceso cupidine.Et itan to benigno & delecteuole & sacro sito,di sincere aure & florigeri spirami ni afflato.Io acconciamente compulsa di assumere uno uenerabile auso, & tranquillo timore de dire. Dunque auante il tuto uenia date,o bellissi me & beatissime Nymphe a questo mio blacterare & agli femelli & terri geni,& pusilluli Conati,si aduene che in alchuna parte io incautamente

Poliphilus: 16 point solid

'MONOTYPE'

BASKERVILLE

JOHN BASKERVILLE of Birmingham was a writing-master and stone-cutter whose experiments with the printed book were of profound typographical importance. While Caslon had been strongly influenced by the Dutch letter, Baskerville broke with tradition and reflected in his type the rounder, more sharply-cut letter of 18th-century stone inscriptions and copy books. His types foreshadow the "modern" cut in such novel characteristics as the increase in contrast between thick and thin strokes and a shifting of the stress from the diagonal to the vertical.

Born in 1706, it was not until 1750 (after he had amassed a fortune in the japanning business) that Baskerville turned to typecutting and printing. He realised that his new style of letter would be most effective if cleanly printed on smooth paper with really black ink. He built his own presses, experimented with ink and evolved a method of hot-pressing the printed sheet to a smooth, glossy finish. It was this that gave his books a machine-made appearance very different from the hand-made look of normal 18th-century presswork.

Baskerville's types never entered into general commercial use in England (the 18th-century printer and the later 19th-century "old face" revivalist remained satisfied with Caslon), but their recutting by The Monotype Corporation in 1923 achieved such immediate success that other foundries and composing-machine manufacturers followed suit. Baskerville's seventeen sizes of type varied considerably from size to size. The model for series 169 was his great primer design, which was regularised in form and slightly tightened in fit.

Although widely set, its letters combine well into words, and it benefits from being leaded. The consistent proportioning of the capitals harmonises well with the lower case. The form of the letters is arranged so that the upright strokes and curves support and complement each other, and their general width and roundness avoid the aridity of the typical "modern" face. The italic is somewhat narrow, but its general treatment is pleasant and reflects the genius of the one-time writing-master.

It is a useful face for seven-alphabet work with either its bold companion (series 312) or the handsome semi-bold (series 313) which has its own italic. Series 169 is well equipped for linguistic setting and it has also been used for mathematical composition. It achieves good results on many different kinds of paper and it is particularly successful when reproduced by gravure or offset.

Van Dijck：戰前　286×222mm
Barbou：1960 年代　286×222mm
其他：與 118 頁相同

'MONOTYPE'
EHRHARDT

In the 17th century Leipzig, as an expanding centre of the book trade, began to develop into an important typefounding centre, where some of the finest romans and italics of native German design were cut. The principal features of this new style of type design were the relative darkness, narrowness and close fit of the letters, influenced partly by the Germanic feeling for black letter and partly by an appreciation of the value of economy of form. The condensed style of letter represents an attempt to "fit a roman to compete successfully with Fraktur and Schwabacher" by making it the same apparent size on the body and by increasing its weight.

Among the first punch-cutters to design letters of this kind in Germany was Anton Janson, a Dutchman, who printed a specimen in 1672. His work was copied and improved on, and one particular design of a graded series of fourteen sizes appeared in an undated specimen sheet of the Ehrhardt foundry. The precise origin of these founts is uncertain, but it has been suggested that most of them were cut by Nicholas Kis, a Hungarian, who left them in Leipzig for sale in 1689.

In 1938 The Monotype Corporation produced a regularized version of one of the romans in the Ehrhardt specimen. It is a narrow and closely-fitting letter, rather dark and fairly large on the body, so that it makes a fine space-saver without any loss of legibility or of distinctiveness of form. It has sufficient weight, strength of serif and graduation of curve thickness for use on art paper or for reproduction by offset and gravure. The italic, like the roman, is regular in form, narrow and closely fitting.

Ehrhardt Semi-Bold, cut in 1956, has none of the coarseness which spoils the appearance of many bold faces. Although the letters have been thickened to serve as a related bold design, the quality of the original Ehrhardt type has been successfully preserved, so that it can be used on its own where there is need of a crisp and economical design of good colour.

Ehrhardt: 11 point, 3 point leaded

'MONOTYPE' VAN DIJCK

Christoffel Van Dijck, the leading Dutch typefounder in the middle of the 17th century, followed on from Garamond in developing the Aldine tradition of roman type design. In an article in Signature, No. 6 (July 1937), Harry Carter writes: 'Van Dijck may be put in historical perspective as the best exponent of the well-rounded, large-bodied style of lettering that was in fashion just before the tendency towards the modern cut gave type design a revolutionary turn at the beginning of the 18th century. Only a thorough study of 17th century printing and founding could show how far Van Dijck was himself the originator of that style: he was certainly among the first to work in it.'

Little evidence has been discovered about his life. He was born in the Rhine Palatine at Dexheim in 1606 or 1607. It is known that he was working as a goldsmith in Amsterdam before 1640, that he set up in business as a typefounder a few years later, and that he remained in Amsterdam until his death in 1669-70. Since he was prepared to sell other people's types, it seems clear that he regarded the trade of typefounding more as a business than as an intellectual duty or creative pursuit, but there is no denying his superb craftsmanship. In Mr. Carter's opinion, his productions suggest "that he was less a theorist than a man who thought with his hands".

His types were used by a number of English printers, and Moxon says of them that they possessed "all the accomplishments that can render Letter regular and beautiful". Caslon modelled his own types on them, and the similarity is so close that until twenty-five years ago the types used in Selden's Works (1726) were ascribed to Caslon, whereas they were actually those of Van Dijck and Johannes Kannewet. The only type specimens of Van Dijck's work that have come to light were produced after his death by the purchasers of his foundry: Daniel Elzevir whose widow published a broadside in 1681; Joseph Athias who issued a sheet in 1684; and Jan Roman who printed specimens in 1756 and 1762. In 1767 the foundry was acquired by the Brothers Ploos van Amstel of Amsterdam and Johannes Enschedé of Haarlem.

In the Enschedé specimen book of 1768, a roman and italic ("Kleine Text Romein No. 2" and "Kleine Text Curcyf No. 2") were attributed to Van Dijck, but only the punches of the italic survive. It was the intention of The Monotype Corporation to copy these two specimens when a "Van Dijck" series was contemplated in the early thirties, and the late Jan van Krimpen (designer of such faces as Romulus, Lutetia and Spectrum) was called in to advise. He doubted whether the two faces were the work of the same hand and whether either of them actually originated with Van Dijck. He decided to keep to the design of the italic but to look elsewhere for a roman companion. He eventually found a suitable roman, which appealed to him to come from the same designer as the italic, in a translation of Ovid's Metamorphosis, printed in Amsterdam in 1671. Six experimental punches were cut by P. H. Rädisch; these were used as a guide for the Corporation's cutting of the 13-point size in the following year, and a range of sizes was released in 1937. Series 203 may not claim direct ancestry to Van Dijck, but it is still a fitting tribute to a great master of letter-cutting.

11 point, 2 point leaded

'MONOTYPE' BARBOU

A SPECIMEN OF THE NEW COMPOSITION RANGE
OF THIS TYPEFACE

The year 1968 marks several bicentenaries of typographic interest. Giambattista Bodoni took up his appointment at the Royal Printing House, Parma, in 1768. In Germany, Justus Erich Walbaum was born. Baskerville was hard at work in England, though no book of his was completed in that year. Here we are mainly concerned with Pierre Simon Fournier, who after a very productive life died in 1768 at the age of 56.

He was born in 1712, the son of a typefounder. The order of his two Christian names varies in different sources, and – in contrast to the cases of Charles James Fox or William Makepeace Thackeray – he seems to have been indifferent which came first. He studied drawing as a boy and engraved designs on wood before beginning to cut type punches. The first punches he seems to have made were for large-size types, such as previously had been produced in wood only.

He designed and cast type flowers early in his career, and he also worked out a point system which was more scientific than anything previously achieved. His Modèles des Caractères came in 1742 in large oblong format. A facsimile of this has appeared in recent years, although in a necessarily expensive edition, and this has given somewhat wider circulation to a book of admirable type forms and exuberant ornament. There are those, like the late Eric Gill, to whom ornaments in metal are not acceptable, and the exponents of clinical design today reject decoration of any kind; but to all others these pages are surely as refreshing as a walk between tightly-packed herbaceous borders in full bloom – or perhaps in those green gardens and open spaces which Updike tells us still existed even in the crowded Paris of Fournier's own time.

Fournier collected some essays he had written on the origin of printing and related subjects into a delightful small volume, of a size becoming more popular in mid-eighteenth-century France. The type in which the present words are set has been given the name of 'Barbou', and it was Barbou who printed this volume. Later in this article we discuss the typeface and say something of the Barbous themselves.

Fournier was interested in all aspects of printing and book production; among other topics, he gave a good deal of attention to music types and their improvement. His varied activities led him at times into conflicts and frustration, especially when he tried to set up as a printer in his own account. These worries may have helped to shorten his life – he did not, for instance, live to Gutenberg's age! In this outline, however, we remember him chiefly for his rational and elegant type forms and the attractive books which he helped to create for the delight of his own and later ages. There were fine artists and engravers to illustrate them, and the quality of printing was better than in Louis XIV's age.

The eighteenth century is the source of the typefaces generally called 'transitional', whose modern revivals have been of enormous value to printers in our own century. About 1900 the connoisseurs of printing were still obsessed with the Middle Ages – with the semi-gothics or heavy romans which succeeded them in the incunable period. (However, just before this, when eighteenth-century types were either scornfully dismissed or entirely ignored, one French critic did write: 'It must be remembered that Fournier's types were well engraved and of pleasing design'.) The virtues of the classic 'old face' were next in favour, and Caslon became a highly approved face for the fine book. But scholars like the late Stanley Morison and Sir Francis Meynell quickly pointed out the excellence of later faces – and accurate reproductions of historic designs from almost every period were quickly made available. The transitional Baskerville letter had, and still has, immense success, but Morison's practical mind was also well aware of the advantages of more condensed and economical forms. The first size of 'Monotype' Fournier, Series 185, reproduced from one of the faces in Fournier's Manuel Typographique, was completed in 1925.

Two influences were particularly important on the designer: the 'geometrical' approach practised at the Imprimerie Royale, and the narrow-letter fashions in Holland and Germany. Fournier produced a letter which approached the rectangle rather than the square in general proportions. The shading was regularised to some extent, and the italic – while losing nothing of its pleasant individuality – was given a standard slope.

Series 185 became popular with many designers and publishers. The books of Chatto and Windus, for example, show a fine range of Fournier productions. Some firms, among which the Oxford University Press may be named, showed that Fournier display sizes were highly attractive on book-jackets and as drop initials in the text. In the great Nonesuch Press Shakespeare, edited by Herbert Farjeon, Fournier was chosen by Sir Francis Meynell (in a version with shortened capitals), and many considered this to be the best production of the Press. More recently, an equal excellence of design has been seen in the fine series of anthologies of poetry from various countries brought out by Penguin Books. A prose translation here presents special problems to the designer as it runs at the

Continued on page 12

10 point, 2 point leaded

'MONOTYPE'

FOURNIER

The roman and italic types cut by Pierre Simon Fournier (Fournier-le-jeune) midway in the 18th century have the freshness and interest which is so often found in those periods of design and decoration which are called "transitional" – that is, works produced by an ingenious mind working towards a new style yet still drawing nourishment from the old.

Fournier, born in 1712, was the son of the manager of the ancient Le Bé typefoundry. He was first employed by his brother to cut wood blocks and headpieces and he later turned to engraving punches and designing his own types. Besides being the author of the famous Manuel Typographique, his many activities included experiments with music type-cutting, efforts to establish a universal point system, and researches into the history of typecutting. Fournier's types, which simplified many features of old face without attempting the sharpness of cut of the Didot-Bodoni school, were largely responsible for accustoming the eyes of educated readers in France and elsewhere to the sharper and more logical letter design introduced by the Imprimerie Royale at the beginning of the 18th century.

Series 185, cut in 1925, is a facsimile version of one of the medium text types cut by Fournier in 1745. It is sharper and more open than the old face types and is fairly light in weight. Its comparative narrowness makes it a useful face for lengthy texts but, although primarily a book face, it has been used effectively in a wide range of jobbing work, where its delicacy and precision of cut can be shown to advantage. The italic, influenced by the handwriting of the day, is decorative and has unusual figures. The capitals of Series 185 are especially tall and bold in relation to the lower-case and there are alternative shortened capitals (Series 285), originally cut for the first Nonesuch Press Shakespeare.

Fournier: 12 point, 2 point leaded

蒙納公司的 Sabon、Spectrum、Century Schoolbook、Bell、Walbaum 等字體的優良排版範例。Spectrum、Sabon 是用於內文排版，Century Schoolbook 是為了學校教育領域而專門開發出的字體，Bell 是過渡時期的羅馬體，而 Walbaum 是典型的現代羅馬體。不妨好好比較一下這些用途與歷史不同的字體，各自所呈現出的不同質感。

'MONOTYPE'

Walbaum

Justus Erich Walbaum was born in Steinlah, Brunswick in 1768. A clergyman's son, he was apprenticed at an early age to a confectioner but later became an engraver and caster of metals. Finally he turned to letter-cutting and learned to make typefounders' matrices and tools. In his thirtieth year he started his own type foundry at Goslar, and five years later he moved to Weimar, where he remained until his death in 1837.

During his lifetime his types were celebrated and admired. But, through the change in taste in the mid-nineteenth century away from the "classical", his importance was forgotten almost immediately after his death. It is only recently, with the return to popularity of the 'modern' letter, that the intrinsic value of his Antiqua has been recognized. Its slight and almost imperceptible irregularities provide an interest and human quality that is often lacking in other nineteenth-century faces.

Walbaum's types, the original matrices of which are still extant in Germany, were so faithful to those of Firmin Didot that their elegance may be said to be characteristically French. Carefully modelled and cut, they are particularly suitable for certain kinds of bookwork and display. The italic is beautifully legible and reminiscent of both Didot's and Bodoni's designs.

'Monotype' Walbaum (Series 374) was cut in 1934. It is surprisingly versatile for a 'modern' face, and it appears best on a smooth-surfaced paper. To do it full justice, it needs to be leaded, especially in the smaller sizes where it is eminently readable. Its related bold face, Walbaum Medium (Series 375), can be used in combination with Series 374 or on occasions as a text face on its own, and it is excellent for displayed headings.

Walbaum 12D on 13 pt., 2 pt. leaded

Sabon：1960 年代　300×209mm
Century Schoolbook：1960 年代　286×222mm
其他：與 118 頁相同

'Monotype' Sabon and Sabon Semi-bold　　　　　a new typeface designed by Jan Tschichold
Series 669 and 673

669: 12D on 13 pt, 4 pt leaded

Sabon has been jointly developed and manufactured by Linotype GmbH, Setzmaschinen-Fabrik Monotype GmbH and D. Stempel AG of Frankfurt, in response to a common need of German master printers for a typeface to be made in identical form for mechanical composition by linecasting and single-type methods, and also for hand composition in foundry type. The commission was given to the distinguished typographer and type designer, Jan Tschichold, whose adroit skill and sympathetic understanding of the problems involved has resulted in the design of a typeface of great character and adaptability.

The sources for Tschichold's design are to be found on a specimen sheet of the Frankfurt typefounder, Konrad Berner, who married the widow of another typefounder, Jacques Sabon – hence the name of the face. The roman is based on a fount engraved by Garamond and the italic on a fount by Granjon, but Tschichold has introduced many improvements and refinements to make these models suitable for the typographic needs of today and for the varying requirements of the three manufacturing companies.

As can be seen from this setting in the 12-Didot size, the roman and italic have adequate weight to print well on a wide variety of surfaces, and they will undoubtedly lend themselves to reproduction by photolithography and photogravure. Considerable care was taken to make the semi-bold version in a weight which would contrast sufficiently to allow it to be used in conjunction with the roman as a distinctive, bolder type; but at the same time, it was not made so heavy as to exclude it from being used on its own.

'MONOTYPE'
THIS CLASSIC TYPEFACE WAS CUT
SPECTRUM
BY THE MONOTYPE CORPORATION LIMITED
DESIGNED
IN JOINT COLLABORATION WITH
BY JAN VAN
J. ENSCHEDE EN ZONEN, HAARLEM
KRIMPEN

A SPECIMEN OF 'MONOTYPE' CENTURY SCHOOLBOOK, SERIES 227

CENTURY SCHOOLBOOK

THE CENTURY FAMILY of typefaces originated in 1894, when Theodore L. De Vinne commissioned the cutting of a new type design for his production of the *Century Magazine*. Many different versions have appeared over the years, including this slightly less condensed text face which became popular for the setting of school text books. The letterforms reflect the taste for the modern face of the late 19th century, but the design is nearer to the old styles in having sturdier serifs and no fine hair lines. Though an open face with generous counters, it is comparatively narrow and closely fitted. The large x-height, coupled with short but adequate descenders, makes it very legible in the smaller sizes, and in the larger sizes it takes on a clean, handsome appearance, uncluttered by extraneous detail. The exceptional evenness of colour has brought it into favour again in recent years, and the cutting of additional sizes and a companion bold face is likely to popularise its use even more.

14 point, 1 point leaded (fixed 3-unit word spacing)

THE CENTURY FAMILY of typefaces originated in 1894, when Theodore L. De Vinne commissioned the cutting of a new type design for his production of the *Century Magazine*. Many different versions have appeared over the years, including this slightly less condensed text face which became popular for the setting of school text books. The letterforms reflect the taste for the modern face of the late 19th century, but the design is nearer to the old styles in having sturdier serifs and no fine hair lines.

THOUGH AN OPEN FACE with generous counters, it is comparatively narrow and closely fitted. The large x-height, coupled with short but adequate descenders, makes it *very legible* in the smaller sizes, and in the larger sizes it takes on a clean, handsome appearance, uncluttered by extraneous detail. The exceptional evenness of colour has brought it into favour again in recent years, and the cutting of additional sizes and a companion bold face is likely to popularise its use even more.

12 point, 2 point leaded (fixed 3-unit word spacing)　　12 point, 1 point leaded (fixed 3-unit word spacing)

'MONOTYPE'

BELL

BELL is the first English modern face, and one of extraordinary dignity and charm. It was no antiquarian interest, but appreciation of a masterly type that led Bruce Rogers to save from the melting-pot an old fount of unknown origin and to use in some of his most beautiful Riverside Press books the face which he called *Brimmer*. Updike admired these types and traced their history to Stephenson, Blake & Company from whom he obtained strikes for his own casting. But it was not until 1926 that examination of a copy of the "Address to the World by Mr. Bell, British Library, Strand, London" showed their true origin.

John Bell (1745-1831) was the leading journalist and newspaper proprietor, the most courageous bookseller, almost the only publisher of important *éditions de luxe*, and the most influential typographer of his day. The Bell type, although undoubtedly French in the proportion of its letters, reflects its native insularity: it was in fact Bell's intention "to retrieve and exalt the neglected art of printing in England". Much credit is due to Richard Austin, the engraver of the punches, for achieving the unique sharpness of taper which was given to all the serifs; and it is this finely tapered and bracketed serif that became in due time an essential part of the Anglo-Scottish modern face.

The Monotype Corporation in collaboration with Stephenson, Blake & Company cut Series 341 in 1931-2 as an exact facsimile of the original. It has proved increasingly popular with publishers particularly for the composition of the more literary sort of book, for it has the great virtues of compactness and relative legibility, combined with an elegance and charm that are lacking in later modern faces.

Bell has less colour and is sharper and narrower than Baskerville. The letters are large on the body with a stress that is almost, but not consistently, vertical. The capitals are slightly pronounced in weight and a fraction lower than the ascenders. The italic is regular, cursive and closely set. An original feature of Bell's type was that the figures ranged with each other instead of differing in height.

Bell: 12 point, 1 point leaded

Sabon-Antiqua

*Erstmalig
in der Geschichte
der Schrift*

| Zeilensatz der Linotype GmbH | Einzelbuchstabensatz der Monotype GmbH | Handsatz der D. Stempel AG |

*formengleich,
in Größe und Weite
identisch*

Sabon-Antiqua

ABCDE
FGHIJKLMNOPQ
RSTUVWXYZ
abcdefghijklmnopqrs
tuvwxyz
1234567890

D. Stempel AG Frankfurt am Main

Was ist neu an der Schrift?

Aus Erfahrung und Kenntnis der Schriftgeschichte und des Schriftenmarktes konnte es nicht das Ziel sein, etwas in der Form völlig Neues zu suchen. Neu hingegen war die Aufgabe, bei der Entwicklung der Schrift die in den beiden Maschinensystemen liegenden unterschiedlichen technischen Besonderheiten zu berücksichtigen. Während bei dem einen System auf bestimmte Dickten-Einheiten Rücksicht genommen werden muß, verlangt das andere System die gleiche Schriftweite für Grundschrift und Auszeichnungsgarnituren, so daß bei der Harmonisierung auf die beim Einzelbuchstabensatz sonst gegebenen Möglichkeiten einer besonders schmallaufenden Kursivschrift verzichtet werden mußte. Zahlreiche technische und ästhetische Probleme waren daher zu lösen, bis Einzelform, Wortbild und Satzgefüge in Harmonie und Rhythmus makellos durchgebildet waren. Ein gründlich vorbereiteter und sorgfältig ausgearbeiteter Entwurf und enge Zusammenarbeit der drei beteiligten Firmen, der Linotype GmbH, der Setzmaschinen-Fabrik Monotype Gesellschaft mbH und der D. Stempel AG, waren hierzu notwendig.

ABCDEFGHIJKLMNOPQRSTUVWXYZ
abcdefghijklmnopqrstuvwxyzßchckfffififlft&
ÄÀÁÂÃÅÆÇÉËÊÈGÏIÍÌÎÑÖÓÔÒØÕŒŞÜÚÙÛ
äàáâãåæçéëêègïiíìîñöóôòøõœşüúùû
1234567890 1234567890 %
.,:;-!?·"'()[]*†§£$/‚""«»¡¿–

ABCDEFGHIJKLMNOPQRSTUVWXYZ
abcdefghijklmnopqrstuvwxyzßchckfffififlft&
ÄÀÁÂÃÅÆÇÉËÊÈGÏIÍÌÎÑÖÓÔÒØÕŒŞÜÚÙÛ
äàáâãåæçéëêègïiíìîñöóôòøõœşüúùû
1234567890 1234567890 %
.,:;-!?·"'()[]*†§£$/‚""«»¡¿–

ABCDEFGHIJKLMNOPQRSTUVWXYZ
abcdefghijklmnopqrstuvwxyzßchckfffififlft&
ÄÀÁÂÃÅÆÇÉËÊÈGÏIÍÌÎÑÖÓÔÒØÕŒŞÜÚÙÛ
äàáâãåæçéëêègïiíìîñöóôòøõœşüúùû
1234567890 1234567890 %
.,:;-!?·"'()[]*†§£$/‚""«»¡¿–

Die Maßstäbe für Schönheit und Zweckmäßigkeit einer Drucktype wurden vor Jahrhunderten gesetzt und haben bis zum heutigen Tage ihre Gültigkeit behalten. Aus der bewußten Besinnung auf die hohe Schriftkultur der Renaissance ist die Sabon-Antiqua entstanden. Sie verkörpert in Maß und Form den klassischen Typus der Antiqua; sie ist entwickelt für die vielfältigen Satz- und Druckaufgaben unserer Zeit und verwirklicht mit den Mitteln und Möglichkeiten heutiger Schriftschneide- und Gießtechniken. Klar und unaufdringlich im Ausdruck erfüllt sie die anspruchsvolle Aufgabe, durch einen hohen Grad an Lesbarkeit dem Auge wohlzutun. Neu und einmalig ist die Identität in drei Setzverfahren bei den kleinen Graden: Einem Satzbild aus der Sabon-Antiqua ist es nicht anzusehen, in welchem der drei Setzverfahren es hergestellt ist, denn Linotype-Satz und Monotype-Satz stimmen mit dem Handsatz überein. Das erweitert die Einsatzmöglichkeit dieser Schrift und erhöht ihren Gebrauchswert. Schon heute liegen Urteile von Schriftkennern des In- und Auslands vor, die dieser Schrift eine große Zukunft voraussagen.

Sole importers for the U.S. and Canada:
AMSTERDAM CONTINENTAL TYPES, INC.
276 Park Avenue South, NEW YORK, N.Y. 10010 212777-4980
4422 Beverly Boulevard, LOS ANGELES, CALIF. 90004 213 663-8581
429 W. Superior Street, CHICAGO, ILL. 60610 312 664-8223

D. STEMPEL AG 6 FRANKFURT 70 POSTFACH 701160 TELEFON (0611) 610391 TX 411003

Sabon Antiqua

ABCDEFGHIJKLMNOPQ
RSTUVWXYZÄÖÜ
abcdefghijklmnopqrstuvwxyz
ßchckfffififlft&äöü
1234567890 1234567890
.,:;-!?.'()[]*†‹›»«„‚"/£$

Sabon Kursiv
Sabon Antiqua halbfett

Sabon Antiqua 10 p

1p Durchschuß DER WERDEGANG JAKOB SABONS als Schriftschneider ist unbekannt. Seine Herkunft aus Lyon verbindet sich für uns unwillkürlich mit dem Gedanken an die beste Schriftschneider-Tradition Frankreichs. Robert Granjon wirkte in Lyon; es wäre denkbar, daß Sabon noch in seiner Heimat mit ihm zusammengetroffen ist, aber wir haben keine Beweise. **Granjon** lieferte seine Schriften an Christophe Plantin in Antwerpen. Große Anerkennung fanden seine Civilité-Schriften – Schriften, die er im Sinne einer Nationalschrift der französischen Schreibschrift nachgeschnitten hatte – in den Niederlanden, und seine persönliche Anwesenheit in Antwerpen ist überliefert. Auch Sabons Weg führte in diese Stadt, so daß beide schon in persönlicher Verbindung gestanden haben können, *bevor Sabon in Frankfurt ansässig wurde und die Schriften Granjons* zum ständigen Bestand seiner Gießerei gehörten. Der zweite große Stempelschneider Frankreichs, Claude Garamond, starb bereits 1561 in hohem Alter. Wenn wir hier keine persönlichen Beziehungen vermuten können, so hat doch die Egenolff-Sabonsche Schriftgießerei lange Zeit Garamonds Schriften gegossen, und sie begegnen uns immer wieder auf den Schriftproben ihrer Nachfolger. Garamond und Granjon dürfen wir als

2p Durchschuß DER WERDEGANG JAKOB SABONS als Schriftschneider ist unbekannt. Seine Herkunft aus Lyon verbindet sich für uns unwillkürlich mit dem Gedanken an die beste Schriftschneider-Tradition Frankreichs. Robert Granjon wirkte in Lyon; es wäre denkbar, daß Sabon noch in seiner Heimat mit ihm zusammengetroffen ist, aber wir haben keine Beweise. **Granjon** lieferte seine Schriften an Christophe Plantin in Antwerpen. Große Anerkennung fanden seine Civilité-Schriften – Schriften, die er im Sinne einer Nationalschrift der französischen Schreibschrift nachgeschnitten hatte – in den Niederlanden, und seine persönliche Anwesenheit in Antwerpen ist überliefert. Auch Sabons Weg führte in diese Stadt, so daß beide schon in persönlicher Verbindung gestanden haben können, *bevor Sabon in Frankfurt ansässig wurde und die Schriften Granjons* zum ständigen Bestand seiner Gießerei gehörten. Der zweite große Stempelschneider Frankreichs, Claude Garamond, starb bereits 1561 in hohem Alter. Wenn wir hier keine persönlichen Beziehungen vermuten können, so hat doch die Egenolff-Sabonsche Schriftgießerei lange Zeit Garamonds Schriften gegossen, und sie begegnen uns immer

2p Durchschuß DER WERDEGANG JAKOB SABONS als Schriftschneider ist unbekannt. Seine Herkunft aus Lyon verbindet sich für uns unwillkürlich mit dem Gedanken an die beste Schriftschneider-Tradition Frankreichs. Robert Granjon wirkte in Lyon; es wäre denkbar, daß Sabon noch in seiner Heimat mit ihm zusammengetroffen ist, aber wir haben keine Beweise. **Granjon** lieferte seine Schriften an Christophe Plantin in Antwerpen. Große Anerkennung fanden seine Civilité-Schriften – Schriften, die er im Sinne einer Nationalschrift der französischen Schreibschrift nachgeschnitten hatte – in den Niederlanden, und seine persönliche Anwesenheit in Antwerpen ist überliefert. Auch Sabons Weg führte in diese Stadt, so daß beide schon in persönlicher Verbindung gestanden haben können, *bevor Sabon in Frankfurt ansässig wurde und die Schriften Granjons* zum ständigen Bestand seiner Gießerei gehörten. Der zweite große Stempelschneider Frankreichs, Claude Garamond, starb bereits 1561 in hohem Alter. Wenn wir hier keine persönlichen Beziehungen vermuten können, so hat doch die Egenolff-Sabonsche

Sabon Antiqua 16 p und 48 p

THEODOR FONTANE

Grete Minde
Schach von Wuthenow
Der Stechlin
Meine Kinderjahre
L'Adultera
Irrungen-Wirrungen
Frau Jenny Treibel
Briefe

SCHULTEN & HÖLZER
WIESBADEN

容易閱讀又有氣質的羅馬體

Sabon 是具有時代感、造型上沒有多餘贅飾、擁有良好閱讀性又具有氣質的字體。無論是單行 (linotype) 或單字式 (monotype) 的自動鑄字排版機所鑄出的文字，或者手工排版專用的字型版本，所有字型版本的字母都設計成一樣的寬度，所以無論是正體或義大利體，a–z 所排出的長度都是一致的。也因此金屬活字的義大利體的文字寬度感覺稍稍寬了些，這個情況到電腦數位字型的版本才做出了適當的修正。相當適合用在書籍之類的長篇文章，或是圖錄上的英文解說等場合。

斯坦普爾鑄字廠(德國) 1960 年代後半　左：297×200mm　上：221×210mm

可用於標題或內文的無襯線體

Syntax 這款無襯線體的特徵是收筆處切角是傾斜的，以大尺寸或較粗的款式排版時可營造出視覺衝擊感。無論使用在標題或說明文字上都能有很好的閱讀性。具有豐富的字型家族款式，就算整個版面都使用 Syntax 排版也沒問題。

斯坦普爾鑄字廠(德國) 1970 年代中期 下：220×212mm 右：245×172mm

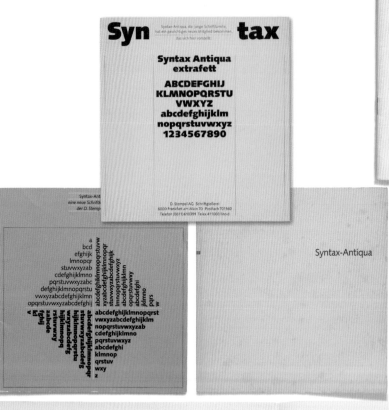

Es gibt zu viele uneinsichtige Leute, die sich
Meter um Meter im Schneckentempo durch die
Stadt quälen.
 Sie sehen nicht ein, daß sie ihre Einkäufe in
der Stadt zu Fuß viel schneller erledigen können.

Geh zu Fuß
durch die Stadt contra Autofahrer-Schneckentempo

Fahr nicht im Käfig durch die Stadt. Geh zu Fuß durch die Stadt.

Lassen Sie Ihr Fahrzeug am Rande
der City stehen. (Sie finden dort
„Ihren" Parkplatz)

Kaufhäuser, Modesalons
und Boutiquen lassen sich
zu Fuß angenehmer
besichtigen

Zu Fuß können Sie noch
Menschen treffen, gutge-
launte, traurige, einsame
und verliebte (im Auto
treffen Sie nur Autos)

Geh zu Fuß
durch die Stadt

Unsere wurmstichigen
Innenstädte......!

Müssen unsere
wurmstichigen
Innenstädte vollends
ungenießbar werden,
ehe wir begreifen, daß
Autofahren und
Parken unsere Citys
kaputtmacht?

Warum 20 Min. nach
einem Parkplatz in der
Innenstadt suchen?
Parken Sie Ihr Fahrzeug
am Rande der City und
gehen Sie ein Stück zu
Fuß oder fahren Sie
2 bis 3 Haltestellen mit
der Straßenbahn oder
dem Bus.

Es wird angenehmer sein,
als im luftverpestenden
Verkehrswurm Auspuff
an Auspuff durch die
Innenstadt zu fahren.

Geh zu Fuß
durch die Stadt

»Denkmal für das unbekannte Bein«!

Jeder Fußgänger, der sein
Auto am Rande der City
parkt, entlastet den City-
Verkehr, hilft mit die Luft
zu verbessern, den Lärm zu
verringern und hat außer-
dem wieder Spaß an der
Stadt. (Es gibt wieder
Beine in der Stadt.)

Es gibt Menschen in der
Stadt, denen man begegnen
kann.

Es gibt Menschen,
Freunde, Bekannte, denen
man guten Tag sagen kann.
Es gibt fröhliche, traurige,
einsame und verliebte
Menschen! Mit dem Auto
treffen Sie nur Maschinen!

Geh zu Fuß
durch die Stadt

hel
ve
tica
hel
ve
tica

light
regular
medium
bold
light italic
regular italic
medium italic
bold compact italic
regular extended
bold extended
extra bold extended
regular condensed
bold condensed
extra bold condensed
compact
compact capitals

® D. Stempel AG
Type-Foundry
Frankfurt am Main

Melior

An original type design
by Hermann Zapf

Melior regular
Melior italic
Melior semi bold
Melior bold condensed

D. Stempel AG Typefoundry
6 Frankfurt am Main 70 Postfach 701160
Telefon (0611) 610391 Telex 411003 lino d

Virtuosa I & II

Salto

D. Stempel AG · Typefoundry

Frankfurt am Main

West Germany

Sole importers:

Amsterdam Continental Types
and Graphic Equipment Inc.

276 Park Avenue South

New York 10, N.Y., SPring 7-4980

30 pt. initials 85329 3 A

abcd
efghii
jklmn
opq
qrstuv
wxyz

D. Stempel AG Typefoundry 6 Frankfurt am Main

Sole importers for the U.S. and Canada:
Amsterdam Continental Types and Graphic Equipment Inc.
276 Park Avenue South, New York 10, N.Y., SPring 7-4980

Printed in Germany 50 x 156

SAPPHIRE

ABCDEFGHIJKL
MNOPQRST
UVWXYZ &..-::!?'
$1234567890

AMERICAN UNCIAL

ABCDEFGHIJKLMNOPQR
STUVWXYZ
abcdefghijklmnopqrst
uvwxyz ff &
$ 1234567890 .,/-':;!?

Optima regular

8/9
Chor-Konzert des Gesangvereins »Frohsinn« anläßlich des hundertjährigen Besteh

7
Ein unvergeßliches Erlebnis wird ein Urlaub in einem fremden Lande s

8/9
Technical journal of engineering drawing for students and draftsm

10
Großer Lichtbildervortrag über moderne Werbemittelgestaltu

12/13
Winterspielplan des Schauspielhauses Frankfurt am Ma

12/13
Ministerio de Instrucción Pública y Bellas Art

14
Die technische Entwicklung des Fernseher

16
Système de canalisation rayonnant

24/27
Monatshefte für Radiotechni

24/0
Deutsche Wandervereine

36
Codice di procedura

Kunstausstellung

48
Eftergivenhet

Palatino

Classic, therefore immune to
short-time fashion · Free
of excessive, individualistic
details · A culmination in type design

Clasico, no influenciado por la
moda pasajera · Carente de
exageraciones individualistas
Una culminación de la
creación tipográfica

D. Stempel AG
Type-Foundry · Fundición Tipográfica
Frankfurt am Main · Germany / Alemania

MICHELANGELO
SISTINA

Melior

An all-purpose type
designed by
Hermann Zapf
for all printing processes

Un tipo de uso universal
creado por Hermann Zapf
para todos los procedimientos
de impresión

D. Stempel AG
Type-Foundry
Fundición tipográfica
Frankfurt am Main
Germany / Alemania

Discus Script and Discus Semi-bold
Escritura Discus y Discus Seminegra

Discus

D. Stempel AG Frankfurt am Main
Type-Foundry · Fundición Tipográfica
Germany · Alemania

Optima regular italic

...ion mit bekannten Bergsteigern und Alpinisten ins Himalayagebiet
Fernsehübertragungen von den Tischtennismeisterschaften
...ettering and design by students at the Dorland House
...er Internationalen Forschungsgesellschaft für Physik
...chleute begutachten die neueste Herbstmode
...us och applåder vid varje föreställning
...ngen für Küche und Wohnzimmer
...ated spirits of wine for burning
...chte Schwarzwälder Uhr
...amento delle pecore
...reise um die Welt
...sione annuale
...menstrand

Optima medium

Vortragsreihe über die Entwicklung des Offsetdruckes von der Erfindung bis heute
The Trans World Airways Corporation arranges connections to all the world
Neuer Spielplan der Städtischen Bühnen für die kommende Saison
Ein Buch mit den schönsten Photographien der letzten Jahre
Vacances dans la Champagne avec excursions à Cognac
Internationale Offenbacher Lederwarenmesse
Neues vom Zeitschriften- und Büchermarkt
Exposición permanente de muestras
Deutsche Kurorte und Bäder
Rundfunk und Fernsehen
De sköna konsterna
Schriftgießereien
New Orleans

Optima medium italic

Die moderne Musik zeigt offene Perspektiven zur Musikrichtung vergangener Zeiten
Leading houses are showing their creations for sp...
Papeles para periódicos, de escribir y para ...
The Extent to which Architecture migh...
Delegaciones en todos los pu...
General education in sch...
Prähistorische Funde
Handballweltm...

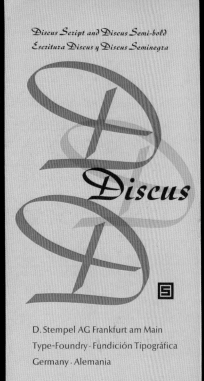

An original type design
by Hermann Zapf

Optima

Optima regular
Optima regular italic
Optima medium
Optima medium italic
Optima semi bold
Optima black

D. Stempel AG, Typefoundry
6 Frankfurt am Main 70 Postfach 701160
Telefon (0611) 610391 Telex 411003 lino d

斯坦普爾鑄字廠(德國) 1970 年代 210×100mm

Bauersche Giesserei Frankfurt am Main IMPRIMATUR
HORIZON

i!.i!.i!.i!.i!
i!.i!.i!.i!.i!

Bauersche Giesserei Frankfurt am Main SERIFA
IMPRESSUM
VOLTA
BETON

IMPRESSUM
SERIFA
IMPRESSUM
BETON
IMPRESSUM
VOLTA

Bauersche Gießerei Frankfurt am Main Zentenar-Fraktur
Manuskript-Gotisch

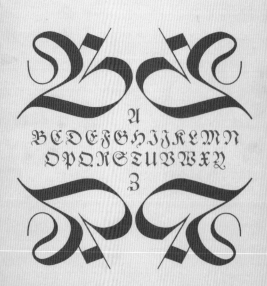

A
BCDEFGHIJKLMN
OPQRSTUBWXY
3

Bauersche Giesserei Frankfurt am Main Folio

單套字體的型錄

比折頁內容更豐富的單套字
體型錄。不過內容與其說是
以設計師為客群，更像是以
促銷字型為目的，是提供給
有在購買字型的公司作為
參考的型錄。

鮑爾鑄字廠(德國) 1960–70 年代
298×200mm

各種使用方法的示範

作為 Stelie Futura 的使用
範例，以資料夾形式發送
的文宣品。裡面各式各樣
精緻的印刷範例，不僅可
作為字型運用的靈感來
源，或純粹以喜愛字體的
角度來看也是充滿樂趣的
宣傳小物。

鮑爾鑄字廠(與 97 頁相同)

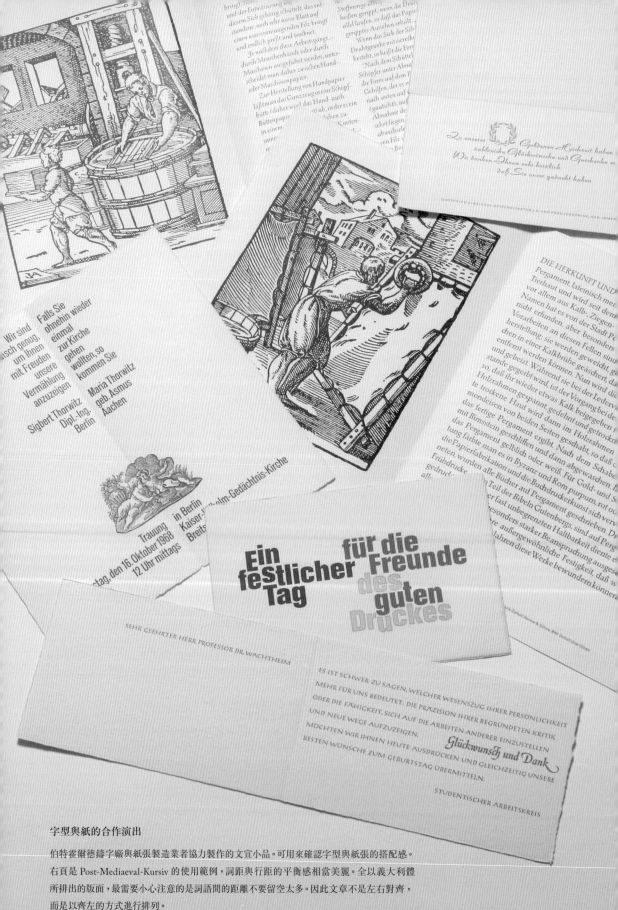

字型與紙的合作演出

伯特霍爾德鑄字廠與紙張製造業者協力製作的文宣小品。可用來確認字型與紙張的搭配感。
右頁是 Post-Mediaeval-Kursiv 的使用範例，詞距與行距的平衡感相當美麗。全以義大利體
所排出的版面，最需要小心注意的是詞語間的距離不要留空太多。因此文章不是左右對齊，
而是以齊左的方式進行排列。

伯特霍爾德鑄字廠(與 81 頁右上相同)

\mathcal{D}ie Bildung des Papiers erfolgt dadurch, daß man das mit Wasser verdünnte Ganzzeug auf ein Metallsieb bringt, zum Zweck der Faserverfilzung und der Entwässerung auf und mit diesem Sieb gehörig schüttelt, das entstandene, noch sehr nasse Blatt auf einen wasseransaugenden Filz bringt und endlich preßt und trocknet.

Je nachdem diese Arbeitsgänge durch Menschenhände oder durch Maschinen ausgeführt werden, unterscheidet man daher zwischen Hand- oder Maschinenpapier.

Zur Herstellung von Handpapier läßt man das Ganzzeug in eine Schöpfbütte (daher wird das Hand- auch Büttenpapier genannt) ab, in der es ein in einem aus dünnen Stäbchen zusammengesetzten Zylinder (Knotenmaschine) stehender Rührapparat fortwährend in Bewegung und ein kleiner Ofen (Blase) oder ein Schlangendampfrohr warm hält.

Aus dieser Bütte von etwa 1,80 m Durchmesser - sie war zuweilen rund, zuweilen eckig - hebt der Büttgeselle oder Schöpfer eine Portion Zeug vermittels der Form und schüttelt diese so

lange, bis das Wasser abgelaufen ist. Die Form besteht aus einem hölzernen Rahmen mit einem darübergespannten, durch aufgenagelte Streifen festgehaltenen Drahtsieb und einem abnehmbaren Deckel, dessen Höhe die Stoffmenge abmißt. Die Formen heißen gerippt, wenn die Drähte parallel laufen, so daß das Papier ein geripptes Aussehen erhält.

Wenn das Sieb der Schöpfform aus Drahtgewebe mit viereckigen Maschen besteht, so heißt die Form Velin.

Nach dem Schütteln übergibt der Schöpfer unter Abnahme des Deckels die Form auf dem Büttenbrett einem Gehilfen, der es mit dem Papierblatt nach unten auf ein Stück Filz drückt (gautscht), auf dem bei behutsamer Abnahme der Form das Papier unversehrt liegen bleibt. Man stellt durch abwechselndes Übereinanderschichten von Filz und Papier einen Stoß von 180 Bogen und 181 Filzen (Pauscht, Bauscht oder Buscht) her, preßt ihn, nimmt dann den Stoß auseinander, unterwirft die Bogen ohne Filze einer zweiten Pressung und trocknet sie durch Aufhängen in Trockenräumen.

Papier: Zerkall-Bütten Nr. 7625 halbmatt, etwa 53,5 × 76,0 cm, der Papierfabrik Zerkall Renker & Söhne, 5161 Zerkall über Düren Rhld.

奧利夫鑄字廠的草書體 Choc、Mistral、Diane 的排版範例。有許多可供參考的創意與靈感，像是與羅馬體的字型一起作絕妙的搭配等等。尤其可以多加留意的是，使用兩套字體時該如何分配兩者在畫面上的大小與位置，並營造出舒服的平衡感。

奧利夫鑄字廠（與 29 頁相同）

3 scriptes

"JEAN QUI GROGNE ET JEAN QUI RIT"

Jean Grimace

L'HEBDOMADAIRE CRITIQUE DES GENS DE LETTRES

COMITÉ DE RÉDACTION
Jean-Paul Gérôme, Jacques Laffon, Nicole Estelle,
Roger Ducret et André Raffel

DOSTED CALCIUM D³

enfants /

fatigues de la croissance et
vie scolaire, manque de ga
force, d'appétit, de grand
une cuillerée à soupe de g
chaque jour à chaque repas.
le flacon (27 cm³) dose à 0,0000004)

adultes /

décalcification, surmenage
fessionnel, vie trop séde
dans les bureaux des villes
cure de dix suppositoires,
un chaque soir avant de se co
la boîte de 10 suppositoires (dosé à 0,8

vieillards /

les déchéances, les infirm
l'âge, l'usure, le manq
résistance :
par injection intramusculair
une fois par semaine.
la boîte de 5 ampoules (dosé à 0,0005)

LABORATOIRE NOVELLA AV

HAC
HELICOPTÈRES AIR COMPANY

vous présente
ses meilleurs vœux pour
1957

Au temps des mois qui s'envolent
songez aux mois à venir,
aux paysages de l'été
que vous découvrirez grâce au

TOURISME
A VOL
D'OISEAU

125 AVENUE DES CHAMPS-ÉLYSÉES - PARIS VIII'

Nº 6

"Premiers de
tous les grands arbres
les oliviers
portent des œufs"

EMPEDOCLE D'AGRIGENTE

L'OLIVIER

OUVRAGES DÉJÀ PARUS : LE POIRIER
LE NEFLIER — LE JUJUBIER
LE NOYER
LE PECHER

PUBLICATION DE LA SOCIÉTÉ PROTECTRICE DES VERGERS

action internationale du cinéma

AIC

tzigane

CRISTAUX DE BOHÊME

services de table,
lampes, flacons, verres,
cendriers

ESONI machines électroniques à calculer

les cellules de hasard
de la cybernétique offrent désormais
au chef d'entreprise, à l'homme d'action
toutes les ressources poétiques,
toute l'efficacité d'un délire logique dans la comptabilité,
les bilans, les inventaires, la traduction,
la vérification des chiffres et des matières. L'erreur même est devenue
prétexte d'invention, source de profit ou de progrès.
Enfermés dans des coupoles blindées les radio-isotopes projettent
géométriquement leur oui et leur non, leur 1 et leur 0,
se précipitent avec une effrayante
et prodigieuse régularité, identiques et contraires,
à la vitesse de la lumière
pour éclater en des réponses que
vous n'espériez plus.

Milan-Londres

Stop... à la belle hirondelle

CHAMBRES
SUR LA MER
HOTEL
NOCES
& BANQUETS

le cognac · 1892 · 1957 · nombreuses
Jay
des familles

Contre
toutes les maladies
imaginaires

Molierana

en suppositoires avant chaque repas

La direction
du prisunic
élevé sur l'emplacement de
l'ancienne caserne
convie à un vin d'honneur
tous les anciens
de notre héroïque régiment

14 juillet à 18 heures

SPINOZA

Corollaire

*Il suit de cette proposition que tout corps qui se
meut suivant une ligne courbe est continûment
détourné de la ligne suivant laquelle il devrait
se mouvoir par la force d'une cause extérieure.*

Démonstration

*Tout corps qui est mû circulairement est
constamment empêché par une force extérieure de
continuer à se mouvoir suivant une ligne droite
(par le corollaire de la proposition précédente);
si cette action venait à s'interrompre le corps
continuerait de lui-même à se mouvoir suivant
une ligne droite (par la proposition), et je dis,
en outre, qu'un corps qui est mû circulairement*

詞距與行距皆美麗的義大利體

恩斯赫德鑄字廠的樣本書中 Spectrum 的頁面。最上方三行所呈現的平衡感，與下方用義大利體排出的短文，其詞距、行距都相當美麗。整體配置上的平衡感也值得多加以欣賞。由於筆畫與文字造型源自歐文書法字體，所以若像右頁一般以中心對齊的方式排版，會更加凸顯字體的美感。

恩斯赫德鑄字廠(與 35 頁相同)

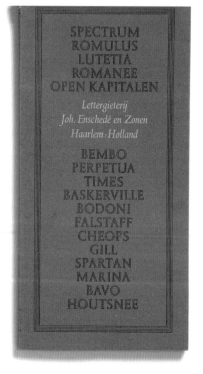

Yes, of course you do.
Perhaps you want to go to
Holland next holidays.
Than it's fine to speak
and understand dutch
like a native.
That's not impossible.
With the Crown-Method
you read already a novel
within four months.
Just send us your name and
address on a postal card.
In return, we will send you
the first lesson at no
obligation to you.
Write that card today!
CROWN-METHOD
783 LOW SQUARE
DETROIT 21
MICHIGAN

KUNSTGESCHICHTE

Georg
Simoniss
Verlag

Le Rat de ville et
le Rat des champs,
fable de La Fontaine

Autrefois le rat de ville
Invita le rat des champs,
D'une façon fort civile,
A des reliefs d'ortolans.

Sur un tapis de Turquie
Le couvert se trouva mis.
Je laisse à penser la vie
Que firent ces deux amis.

Le régal fut fort honnête ;
Rien ne manquoit au festin :
Mais quelqu'un troubla la fête
Pendant qu'ils étoient en train.

A la Porte de la salle
Ils entendirent du bruit :
Le rat de ville détale ;
Son camerade le suit.

Le bruit cesse, on se retire
Rats en campagne aussitôt ;
Et le citadin de dire :
Achevons tout notre rôt.

C'est assez, dit le rustique ;
Demain vous viendrez chez moi.
Ce n'est pas que je me pique
De tous vos festins de rois :

Mais rien ne vient m'interrompre ;
Je mange tout à loisir.
Adieu donc. Fi du plaisir
Que la crainte peut corrompre!

*When issuing a book of
type specimens the typefounder aims at
giving as complete a survey as possible
of the available typefaces.
As a rule, such a survey consists
of a line of capitals and a
line of lower case ranging from
the smallest to the largest sizes
and a complete alphabet.
This time we have left the beaten
track and take pleasure in showing
a number of setting examples,
which, we hope, do justice to the
characteristic features of each
typeface. Once you have selected
a typeface we shall be glad to
let you have a more detailed
specimen of the chosen face.*

*Type Foundry
Joh. Enschedé en Zonen
Haarlem ⋅ Holland*

*En général les schémas des
épreuves de caractères se ressemblent beaucoup, puisqu'elles
servent toutes à donner un index aussi complet que
possible des caractères en stock. Ce patron, qui n'a pas
changé depuis longtemps, se compose généralement
d'une ligne de capitales et une ligne de bas de casse, allant
de la force de corps le plus minuscule jusqu'au plus
grand, avec un alphabet complet en annexe.
Nous avons préféré abandonner ce système un peu monotone.
Dans la présente épreuve vous ne trouverez que des
modèles de composition faisant ressortir le propre des
caractères utilisés. Aussi devrions nous appeler cette épreuve
un 'menu de caractères', puisqu'au fond notre but est de
vous faire prendre goût à notre programme de fonte!
Il va de soi que nous restons à votre entière disposition
pour vous montrer à l'aide d'épreuves plus détaillées les
possibilités des caractères choisis et de vous fournir tous
les renseignements dont vous pourriez avoir besoin.*

*Fonderie de caractères
Joh. Enschedé en Zonen
Haarlem ⋅ Hollande*

同樣出自恩斯赫德鑄字廠樣本書中 Perpetua 與 Times 的頁面。兩者雖然都是針對內文排版所設計的字體，但若能在構圖與平衡感方面多下點工夫的話，更能賦予版面現代感或精緻的印象。

恩斯赫德鑄字廠(與 35 頁相同)

Uw bezoeker
heeft
recht
op
een
goede
zitplaats

Die
zitplaats
heet

KOMFCHAIR
of Denmark

38
*VERSCHILLENDE
VERKOOPADRESSEN
OVER GEHEEL
NEDERLAND & BELGIË*

195270

uova fresche di campagna
arrivano ogni giorno agli
stabilimenti Pazi.
Ed è come se ogni giorno
migliaia di massaie
facessero la pasta in casa
per voi e per migliaia
di famiglie.

Pazi *la vera pasta all'uovo nelle
confezioni Pazi*

con 6 uova per chilo

THULE

*une caresse sur votre beauté, le rouge
à lèvres et le parfum Rêve d'Or*

*Oui, le rouge Rêve d'Or réunit vraiment
toutes les qualités: aussi tenace qu'un
rouge indélébile, aussi brillant qu'un rouge
gras. Choisissez votre rouge parmi
les dix teintes jeunes du rouge à lèvres Rêve d'Or*

AYUNTAMIENTO DE BARCELONA

Oficina Municipal de Turismo
e Informatión

OFICINA CENTRAL

Puerta del Angel	teléfono	21 39 80
Plaza de Cataluña	teléfono	45 22 97
Estación de Francia	teléfono	66 98 15
Aeropuerto del Prat	teléfono	93 47 82
Pueblo Español	teléfono	11 01 01
Ayuntamiento	teléfono	20 02 20
Estación Marítima	teléfono	12 33 47

El Pueblo Español, fué creado par la Exposición Internacional de Barcelona de 1929, para condensar en forma orgánica los aspectos más caracteristicos de la arquitectura regional de toda España.

Las fachadas de los edificios, fielmente reproducidas, están agrupadas según las antiguas divisiones de la geografia peninsular.

El Ayuntamiento de Barcelona ha dado vida a este Pueblo singular, instalando en él las industrias artesanas tradicionales: vidrio soplado y estirado, encajes, bordados, forja de hierro, calderería, platería, juguetes de estaño, estampado de tejidos, grabados, cerámica, alpargatería, muñecas, retablos, cuero, abanicos, tornería en madera, embarcaciones en miniatura, cestería, etc. Los trabajos se realizan ante el público.

Existe además en el Pueblo Español el Museo de Etnografia Peninsular, en el que está fielmente reproducido el interior de una casa ganadera de los Pirineos, al lado de instalaciones dedicadas a la vida de los pastores y a los trabajos e industrias populares más elementales. Tiene instalación separada el Museo de Belenes y elementos para formarlos.

Se celebran en el Pueblo Español fiestas infantiles y manifestaciones folklóricas, que ponen de manifiesto la gran riqueza y variedad del tipismo regional que se conserva en España.

En la Oficina Municipal de Turismo e Información situada dentro del recinto hay una Oficina de cambio de moneda extranjera.

Hedendaagse muziek

LP 15679

BÉLA BARTÓK **Concert voor orkest**
Symphonie Orchester van Berlijn
Dirigent: Harold Legrange

LP 15300 Stereo

DARIUS MILHAUD **Les Choéphores**
Maria Hrozny, *sopraan*
Electra: Clara Pitmann
Orestes: John de Bock, *bariton*
Spreekster: Claudine Vadé
Chorale de l'Université, Lyon
Dirigent: Jean Nodier

33 – LP 30476

CARL ORFF **Carmina Burana**
Hélène Hoppe, *sopraan;* Wilhelm Haas, *bariton*
Hans Petit, *tenor;* Eugen Blach, *bariton*
Koor en orkest van Radio Basel
Dirigent: Rudolf Betz

33 – LP 12970

IGOR STRAWINSKY Petrouchka *versie 1947*
Radio Symphonie Orkest
Dirigent: Sir John Dent

HOW TO DO IT 3

The
right way
to package

PRODUCE

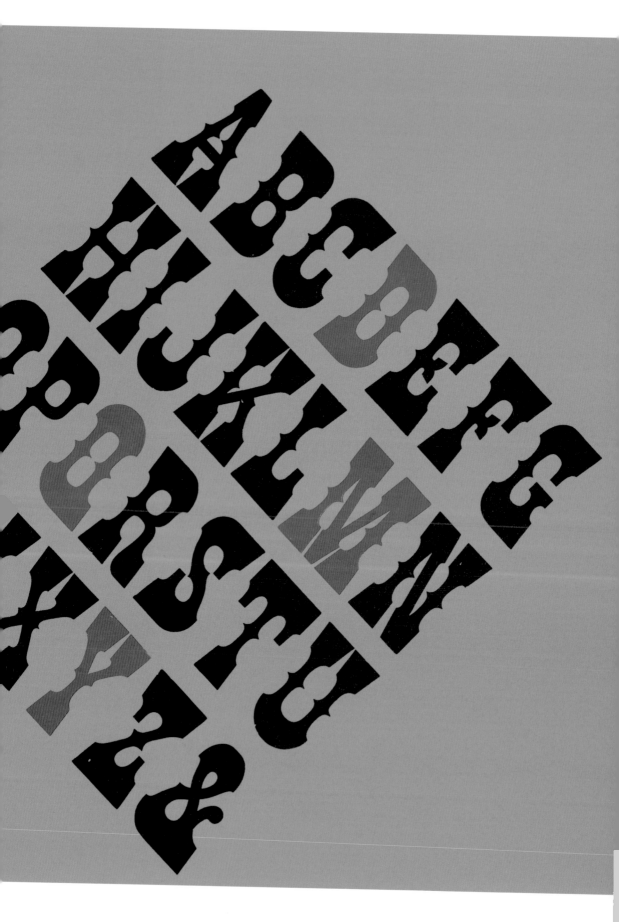

ABC
DEFGHIJKLMNO
QRSTUVV
Helve'

FG
RS
abcdefghi
stuvv

LMNO
VWXYZ
a Antiqua
ghijklm
wXyz & œ
1234567890

abcdefs
stuvv
1:
abcde
stuv
123

PQ
M

ALPHABETE
DER
D.STEMPELAG

Q

TUVV

Sabe

dison Ku

abcdef

efghijklm

uw

ABC
DEFGHIJKLMNOP

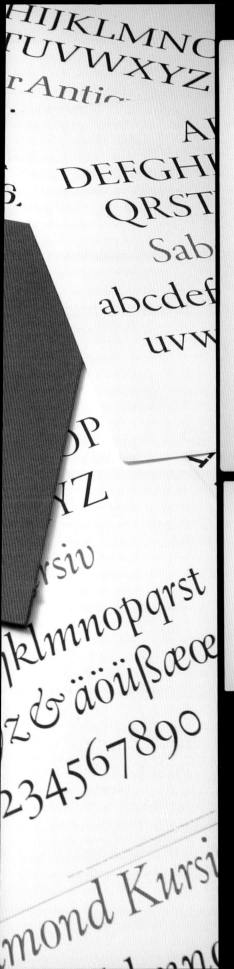

ABC
DEFGHIJKLMNOP
QRSTUVWXYZ

Garamond Antiqua

abcdefghijklmnopqr
stuvwxyz&ffftæ
1234567890

ABC
DEFGHIJKLMNOP
QRSTUVWXYZ

Garamond Kursiv

abcdefghijklmnopqrstu
vwxyz & äöüßæœ
1234567890

ABC
DEFGHIJKLMNOP
QRSTUVWXYZ

Palatino Antiqua

abcdefghijklmnopqr
stuvwxyz & fffitz
1234567890

斯坦普爾鑄字廠的大型展板宣傳單

142–145 頁是斯坦普爾鑄字廠於展覽會時使用的展板宣傳單。整組 21 張，收納在紅色的封套裡。由於尺寸很大而相當具有魄力，也特別選用較厚的紙，多用於機械材料展覽會的展板上或是公司內部牆面等的展示用途。

斯坦普爾鑄字廠 (德國) 1970 年代　551×551mm

ABC
DEFGHIJKLMNOP
QRSTUVWXYZ
Sabon Antiqua
abcdefghijklmnopqrst
uvwxyz & äöüßæœ
1234567890

ABC
DEFGHIJKLMNOP
QRSTUVWXYZ
Sabon Kursiv
abcdefghijklmnopqrst
uvwxyz & äöüßæœ
1234567890

ABC
DEFGHIJKLMNOP
QRSTUVWXYZ
Janson-Antiqua
abcdefghijklmnopqrs
tuvwxyz&äöüßæœ
1234567890

ABC
DEFGHIJKLMNOP
QRSTUVWXYZ
Janson Kursiv
abcdefghijklmnopqrstu
vwxyz & äöüßæœ
1234567890

ABC
DEFGHIJKLMNOP
QRSTUVWXYZ
Baskerville Antiqua
abcdefghijklmnopqr
stuvwxyz&äöüæœ
1234567890

ABC
DEFGHIJKLMNOP
QRSTUVWXYZ
Baskerville Kursiv
abcdefghijklmnopqrst
uvwxyz & äöüßæœ
1234567890

ABC
DEFGHIJKLMNOP
QRSTUVWXYZ
Caslon-Antiqua
abcdefghijklmnopqrst
uvwxyz&äöüßæœ
1234567890

ABC
DEFGHIJKLMNOP
QRSTUVWXYZ
Bodoni Antiqua
abcdefghijklmnopqrst
uvwxyz&äöüßæœ
1234567890

ABC
DEFGHIJKLMNO
PQRSTUVWXYZ
Melior Antiqua
abcdefghijklmnopqr
stuvwxyz&fiftæ
1234567890

ABC
DEFGHIJKLMNOP
QRSTUVWXYZ
Madison Antiqua
abcdefghijklmnopqrs
tuvwxyz&äöüßæœ
1234567890

ABC
DEFGHIJKLMNOP
QRSTUVWXYZ
Madison Kursiv
abcdefghijklmnopqrst
uvwxyz & äöüßæœ
1234567890

ABC
DEFGHIJKLMNO
PQRSTUVWXYZ
Memphis
abcdefghijklmnopqr
stuvwxyz&æßœ
1234567890

ABC
DEFGHIJKLMNO
PQRSTUVWXYZ
Clarendon
abcdefghijklmnop
qrstuvwxyz&ß
1234567890

ABC
DEFGHIJKLMNO
PQRSTUVWXYZ
Optima Antiqua
abcdefghijklmnopqr
stuvwxyz&œßæ
1234567890

ABC
DEFGHIJKLMNOP
QRSTUVWXYZ
Syntax Antiqua
abcdefghijklmnopqrst
uvwxyz&äöüßæœ
1234567890

ABC
DEFGHIJKLMNO
PQRSTUVWXYZ
Neuzeit-Grotesk
abcdefghijklmnopqr
stuvwxyz&æßœ
1234567890

ABC
DEFGHIJKLMNOP
QRSTUVWXYZ
Helvetica
abcdefghijklmnopqr
stuvwxyz&ßäöü
1234567890

ABC
DEFGHIJKLMNOP
QRSTUVWXYZ
Gotisch
abcdefghijklmnopqrst
uvwxyz& fffiflfilßtz
1234567890

鮑爾鑄字廠的大型海報

146–149 頁是鮑爾鑄字廠於展覽會時使用的大型海報。除了字型的家族款式介紹之外，還可以看到不同字體排版後呈現的特徵。

鮑爾鑄字廠（德國）1970 年代　586×322mm

Die Folio-Grotesk ist eine Schrift von sachlicher, neutraler Haltung. Ihre Formen sind in weitestem Maße allgemeingültig, während ein sauberer, spannungsreicher Rhythmus dieser Grotesk ein unterscheidendes, frisches Bild verleiht.

abcdefghijklm
abcdefghijklm
abcdefghijklm

nopqrstuvwxyz
nopqrstuvwxyz
nopqrstuvwxyz

ABCDEFGHIKLM
ABCDEFGHIKLM
ABCDEFGHIKLM

NOPQRSTUVWXZ
NOPQRSTUVWXZ
NOPQRSTUVWXZ

Bauersche Gießerei Frankfurt am Main

VENDÔME

François Ganeau, der die Vendôme entwarf, ist Bildhauer, Maler, Graphiker und Bühnenbildner, ein ungewöhnlich vielseitiger Künstler also, der auch hier seine Meisterschaft bewies. Die Vendôme ist französisch wie die Schlösser an der Loire, wie der Eiffelturm und wie die Place Vendôme, nach der sie ihren Namen trägt. Sie ist französisch und europäisch zugleich, wie so vieles Schöne und menschlich Bedeutsame, das unser alter Erdteil gallischem Genius verdankt.

abcdefghijklmn
opqrstuvwxyzchck
ABCDEFGHIJKLMNO
PQRSTUVWXYZ

abcdefghijklmn
opqrstuvwxyzchck
ABCDEFGHIJKLMNO
PQRSTUVWXYZ

abcdefghijklmn
opqrstuvwxyzchck
ABCDEFGHIJKLMN
OPQRSTUVWXYZ

Bauersche Gießerei · Frankfurt am Main

Imprimatur

Die besonderen Qualitäten des Entwurfs und
des Schnittes dieser Schriften, ihre Schönheit
und Prägnanz, werden in den großen sowohl
wie in den kleinen Graden mit der gleichen
Eindringlichkeit deutlich und wirksam.

ABCDEFGHIJKLMN
abcdefghijklmnopqrstuvwxyz
OPQRSTUVWXYZ

ABCDEFGHIJKLMN
abcdefghijklmnopqrstuvwxyz
OPQRSTUVWXYZ

ABCDEFGHIJKLMN
abcdefghijklmnopqrstuvwxyz
OPQRSTUVWXYZ

ABCDEFGHIJKLMN
abcdefghijklmnopqrstu
vwxyz
OPQRSTUVWXYZ

ABCDEFGHIJKLMN
abcdefghijklmnopqrstuvwxyz
OPQRSTUVWXYZ

Bauersche Giesserei 6 Frankfurt am Main 90

Die erste auf unserem Kontinent geschnittene
Clarendon wurde von Johann Christian Bauer,
dem Gründer der Bauerschen Gießerei, 1859
vollendet. Mit der in drei Garnituren geschnit-
tenen VOLTA wurde diese Tradition unseres
Hauses wieder aufgenommen.

VOLTA

abcdefghijklmnop
qrstuvwxyzchckßäöü
ABCDEFGHIJKLM
NOPQRSTUVWXYZ

VOLTA

abcdefghijklmnop
qrstuvwxyz ch ck ß
ABCDEFGHIJKLM
NOPQRSTUVWXYZ

VOLTA

abcdefghijklmnop
qrstuvwxyzchckß
ABCDEFGHIKLM
NOPQRSTUVWXZ

Bauersche Gießerei Frankfurt am Main

futura
futura
futura
futura

abcdef	**abcdef**	abcdef
ghijklm	**ghijklm**	ghijklm
nopqrst	**nopqrst**	nopqrst
uvwxyz	**uvwxyz**	uvwxyz
ABCDE	**ABCDE**	ABCDE
FGHIJK	**FGHIJK**	FGHIJK
LMNOP	**LMNOP**	LMNOP
QRSTU	**QRSTU**	QRSTU
VWXYZ	**VWXYZ**	VWXYZ

Bauersche Gießerei 6 Frankfurt am Main

a
b c d
e f g h ij
k l m n o p q
r s t u v w x y z
R S T U V W X Y Z
K L M N O P Q
E F G H IJ
B C D
A

Serifa

A
B C D
E F G H IJ
K L M N O P Q
R S T U V W X Y Z
r s t u v w x y z
k l m n o p q
e f g h ij
b c d
a

BAUER
BODONI

ABCDEFGH
IKLMNOPQ
RSTUVWXZ

abcdefghijklmn
opqrstuvwxyzchck
ABCDEFGHIJKLMNO
PQRSTUVWXYZ

abcdefghijklmn
opqrstuvwxyzchck
ABCDEFGHIJKLMNO
PQRSTUVWXYZ

abcdefghijklmn
opqrstuvwxyzchck
ABCDEFGHIJKLMNO
PQRSTUVWXYZ

Bauersche Gießerei · 6 Frankfurt am Main

TIMES

Am 3. Oktober 1932 erschien die Londoner »Times« in
neuem Gewand. Sir Stanley Morison hatte nicht nur die
Typografie und den Umbruch des Weltblattes reorganisiert,
sondern auch eine neue Grundschrift geschaffen. Eine
Schrift, die bis zum kleinsten Grad gut lesbar ist, die eng
läuft und damit guten Ausschluß und saubere Trennungen
erlaubt, eine Schrift, die kräftige und offene Formen hat
und damit für jede Reproduktionstechnik geeignet ist. Eine
Schrift, die jedem Bedruckstoff gerecht wird, und die sich
sowohl in der Einzelzeile als auch im Werksatz behauptet.

abcdefghijklmn
opqrstuvwxyz
ABCDEFGHI
JKLMNOPQRS
TUVWXYZ

abcdefghijklmn
opqrstuvwxyz
ABCDEFGHI
JKLMNOPQRS
TUVWXYZ

abcdefghijklmn
opqrstuvwxyz
ABCDEFGHI
JKLMNOPQRS
TUVWXYZ

Bauersche Gießerei · 6 Frankfurt am Main

IMPRESSUM

abcdefghijklmnop
ABCDEFGHIKLMN
qrstuvwxyzchckß
OPQRSTUVWXYZ

IMPRESSUM

abcdefghijklmnop
ABCDEFGHIKLMN
qrstuvwxyzchckß
OPQRSTUVWXYZ

IMPRESSUM

abcdefghijklmnop
ABCDEFGHIKLMN
qrstuvwxyzchckß
OPQRSTUVWXYZ

Beim Entwurf und Schnitt dieser Schrift war nichts
zu kopieren und nichts künstlich zu erfinden, aber
alles war mit klarem Blick auf das Ganze neu zu
durchdenken und neu zu formen, denn durch Be-
herrschung und Zügelung der graphischen Form
wird das Gesicht einer Schrift gebildet, die nützlich
und so schön ist wie ein gut gestalteter Gegenstand.

Bauersche Giesserei 6 Frankfurt am Main 90

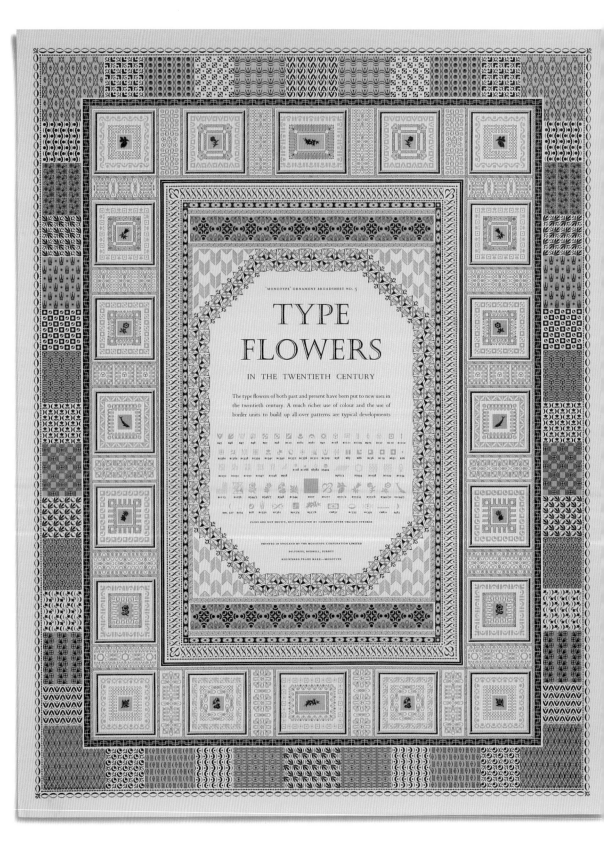

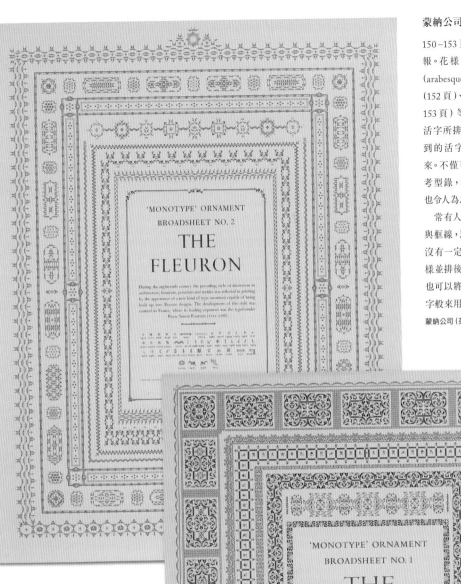

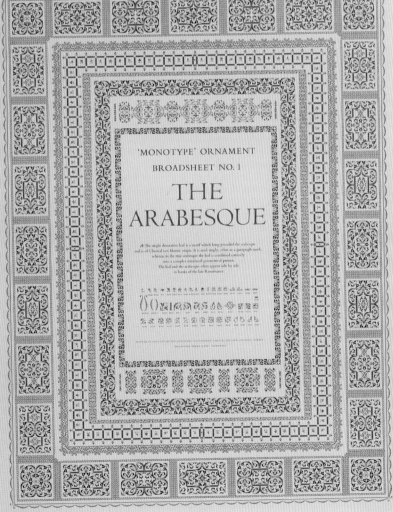

蒙納公司的大型海報

150–153 頁是蒙納公司的大型海報。花樣 (150 頁)、阿拉伯圖飾 (arabesque／唐草紋。151頁)、框線 (152 頁)、裝飾紋樣 (ornament。153 頁) 等運用各式各樣的圖案活字所排出的版面，並將所使用到的活字連同編號一同標記出來。不僅可作為活字販賣時的參考型錄，精美的版面設計與美感也令人為之傾倒。

　常有人會問說要如何區分花樣與框線，以及該如何使用。其實這沒有一定的標準答案。可以將花樣並排後如同框線一般的使用，也可以將框線切短後當作花樣活字般來用。

蒙納公司 (英國)　1960 年代　573×446mm

'MONOTYPE' ORNAMENT
BROADSHEET NO. 3

THE
BORDER

Classical key-patterns ▦, twining garlands ∞, diamonds ◆ and combinations of triangles ◀▣▶, mainly intended to be used as borders or strips, gave a new look to typographical decoration at the time that the modern face was emerging. The English typefounders such as Figgins and Fry were among the most inventive designers of these new decorative units

PRINTED IN ENGLAND BY THE MONOTYPE CORPORATION LIMITED, SALFORD, REDHILL, SURREY

REGISTERED TRADE MARK 'MONOTYPE'

ORNAMENT

BROADSHEET NO. 4

The Nineteenth Century

ORNAMENT

Of the many styles assumed during a period of extravagant
ornamentation it was perhaps the Gothic which the nineteenth-
century designers made most truly their own. The type-founders
took particular delight in building up elaborate architectural
edifices as specimens of their extensive range
of border material

PRINTED IN ENGLAND BY THE MONOTYPE CORPORATION LIMITED, SALFORDS, REDHILL, SURREY

REGISTERED TRADE MARK: MONOTYPE

THIS IS
A PRINTING OFFICE

CROSSROADS OF CIVILIZATION

REFUGE OF ALL THE ARTS
AGAINST THE RAVAGES OF TIME

ARMOURY OF FEARLESS TRUTH
AGAINST WHISPERING RUMOUR

INCESSANT TRUMPET OF TRADE

FROM THIS PLACE WORDS MAY FLY ABROAD

NOT TO PERISH ON WAVES OF SOUND

NOT TO VARY WITH THE WRITER'S HAND

BUT FIXED IN TIME HAVING BEEN VERIFIED IN PROOF

FRIEND YOU STAND ON SACRED GROUND

THIS IS A PRINTING OFFICE

專為 Perpetua 設計的海報

蒙納公司的大型海報,所排出的知名文章「This is a Printing Office」,是源自碧兒翠絲‧沃德(Beatrice Warde)在 1932 年宣傳並且排印 Perpetua 字體時所作的文章,也成為了字型運用於海報排版時的經典範文。

蒙納公司(英國) 收藏於 1970 年代 634×501mm

排版與用色都很出色的海報

將湯瑪斯‧卡萊爾(Thomas Carlyle)的詩以 Weiss 字體排出的海報。除了優秀的排版之外,那些環繞著中間文章的外圍文字也值得好好欣賞,可留意如何藉由用色達到良好的效果。

鮑爾鑄字廠(德國) 收藏於 1970 年代 615×434mm

A B C D E F G H I J K
A B C D E F G H I J K L
A
B
C
D
E
F
G
H
I
J
K
L
M
N

All that Mankind

has done, thought,

gained or been:

it is lying as in magic

preservation

in the pages of Books

THOMAS CARLYLE

M
N
O
P
Q
R
S
T
U
V
W
X
Y
Z

O P Q R S T U V W X Y Z
P Q R S T U V W X Y Z

Weiß-Antiqua und Weiß-Kapitale der Bauerschen Gießerei Frankfurt am Main

Tom Thumb's Alphabet
OF 'MONOTYPE' FACES

A was an Archer and shot at a frog
B was a Blind man and led by a dog
C was a Cutpurse and lived in disgrace
D was a Drunkard and had a red face
E was an Eater, a glutton was he
F was a Fighter and fought with a flea
G was a Giant and pulled down a house
H was a Hunter and hunted a mouse
I was an Ill man and hated by all
K was a Knave and robbed great and small
L was a Liar and told many lies
M was a Madman and beat out his eyes
N was a Nobleman, nobly born
O was an Ostler and stole horses' corn
P was a Pedlar and sold many pins
Q was a Quarreller and broke both his shins
R was a Rogue and ran about town
S was a Sailor, a man of renown
T was a Tailor and knavishly bent
U was a Usurer and took ten per cent
W was a Writer and money he earned
X was one Xenophon, prudent and learned
Y was a Yeoman and worked for his bread
Z was one Zeno the Great, but he's dead

A was an Archer who shot at a frog
B was a Butcher and had a great dog
C was a Captain all covered with lace
D was a Drunkard and had a red face
E was an Esquire with pride on his brow
F was a Farmer who followed the plough
G was a Gamester who had but ill luck
H was a Hunter and hunted a buck
I was an Innkeeper who loved to carouse
J was a Joiner and built up a house
K was King William, once governed this land
L was a Lady who had a white hand
M was a Miser and hoarded up gold
N was a Nobleman, gallant and bold
O was an Oyster girl who went about town
P was a Parson and wore a black gown
Q was a Queen who wore a silk slip
R was a Robber who wanted a whip
S was a Sailor and spent all he got
T was a Tinker and mended a pot
U was a Usurer, miserable elf
V was a Vintner who drank all himself
W was a Watchman and guarded the door
X was expensive and so became poor
Y was a Youth who did not love school
Z was a Zany, a poor harmless fool

THE MONOTYPE CORPORATION LIMITED
Salfords, Redhill, Surrey and 43 Fetter Lane, London E.C.4

REGISTERED TRADE MARK: MONOTYPE

PRINTED IN ENGLAND

蒙納公司的大型字體海報

展示許多款字體的廣告海報，每一句都使用了不同的字體。

蒙納公司（英國） 收藏於 1970 年代　538×457mm

Bauer Bodoni 的精彩海報

Bauer Bodoni 的海報，展現了世界各地專業人士給予高度評價的這款金屬活字字型。海報展示了字體本身具備的美感以及排版後的美感。儘管加大字距，依舊能撐住整個版面，是值得好好欣賞與學習的優良排版。

鮑爾鑄字廠（德國） 收藏於 1970 年代　617×436mm

A B C D E
F G H I K
L M N O P
Q R S T U
V W X Y Z

Keine andere Kunst hat mehr Berechtigung,

ihren Blick auf die zukünftigen Jahrhunderte zu richten

als die Typographie. Denn was sie heute schafft,

kommt der Nachwelt nicht weniger zugute

als der lebenden Generation.

GIAMBATTISTA BODONI

Bodoni-Antiqua der Bauerschen Giesserei Frankfurt am Main

158–162 頁是為了印刷商業用途的大型海報而製作的大尺寸木頭活字的印刷樣本。木活字從19 世紀英國發起工業革命後，為了滿足商業需求而開始大量製作。請多欣賞一下文字造型的創意及用色上的趣味性。

生產處不明（推測為英國） 1970 年代　640×453mm

ABCDEF
GHIJKL
MNOPQ
RSTUV
WXYZ!!

ABCDEFG
HIJKLM
NOPRST
UVWXY

ABCDEF
GHIJKL
MNOPR!
TUVXYZ

ABCDEFG
HIJKLMN
OPQRSTU
VWXYZ&

Helvetica 的大型海報

這是我們公司所收藏的 Helvetica 字體當年一系列廣告中的其中一張海報。版面視覺是當時所流行的風格。

斯坦普爾鑄字廠（德國）　收藏於 1970 年代　853×607mm

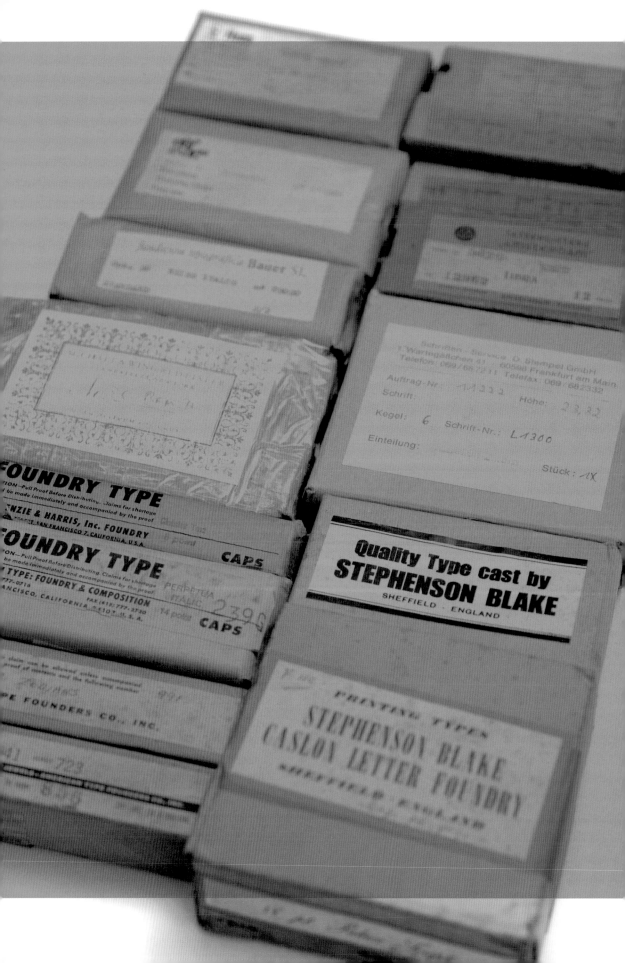

古早的字型樣本冊、其他寶貴資料

昔の書体見本帳、その他貴重資料

165

A SPECIMEN

By WILLIAM CASLON, Letter-Founder, in Chiswell-Street, LONDON.

French Cannon.

ABCD

Quousque tan-
dem abutere,
Catilina, pati-
Quousque tandem

DOUBLE PICA ROMAN.

Quousque tandem abutere, Cati-
lina, patientia nostra? quamdiu
nos etiam furor iste tuus eludet?
quem ad finem sese effrenata jac-
ABCDEFGHJIKLMNOP

GREAT PRIMER ROMAN.

Quousque tandem abutere, Catilina, pa-
tientia nostra? quamdiu nos etiam fu-
ror iste tuus eludet? quem ad finem fe-
fe effrenata jactabit audacia? nihilne te
nocturnum præsidium palatii, nihil ur-
bis vigiliæ, nihil timor populi, nihil con-
ABCDEFGHIJKLMNOPQRS

ENGLISH ROMAN.

Quousque tandem abutère, Catilina, patientia
noftra? quamdiu nos etiam furor iste tuus eludet?
quem ad finem sese effrenata jactabit audacia?
nihilne te nocturnum præsidium palatii, nihil
urbis vigiliæ, nihil timor populi, nihil confen-
fus bonorum omnium, nihil hic munitifsimus
ABCDEFGHIJKLMNOPQRSTVUW

PICA ROMAN.

Melium, novis rebus ftudentem, manu fua occidit.
Fuit, fuit ista quondam in hac repub. virtus, ut viri
fortes acrioribus fuppliciis civem perniciofam, quam a-
cerbiffimum hoftem coërcerent. Habemus enim fenatuf-
confultum in te, Catilina, vehemens, & grave: non deeft
reip. confilium, neque autoritas hujus ordinis: nos, nos,
dico aperte, confules defumus. Decrevit quondam fenatus
ABCDEFGHIJKLMNOPQRSTVUWX

Pica Black.

And be it further enacted by the Authority
aforesaid. That all and every of the said Ex-
chequer Bills to be made forth by virtue of
this Act, or so many of them as shall from
ABCDEFGHIJKLMNOPQRSE

Brevier Black.

And be it further enacted by the Authority aforesaid. That all and every
of the said Exchequer Bills to be made forth by virtue of this Act, or so
many of them as shall from time to time remain unbischarged and uncan-
celled, until the Discharging and cancelling the same pursuant to this Act,

Pica Gothick.

ATTA UNSAK ΦU IN HIMINAM VEIHNAI
NAMΩ ΦEIN UMAI ΦIUDANASSUS ΦEINS
VAIKΦAI VIAGA ΦEINS SVE IN HIMINA

Pica Coptick.

ϨЄΝ ΟΥΔΡΧΗ ΔϤΤ ΕϪΜΟ ΝΤϤΕ ΝΕϪ ΠΕ-
ϪΗΙ ΠЄϪϪЄΙ ΠЄ ΟϤΟΝΔϤ ЄΡΟϤ ΠΕ ΟΤΟΩ
ΠΔΤϹΟΩΤ ΟϤϪΔΚΙ ΠΔϤΧΗ ЄϪЄΝ ΦΝΟΥΝ ΟΤΟΩ
ΟΥΠΝΔ ΝΤЄΦϮ ΠΔϪΗΝΟΟϤ ϪϪЄΝ ΠΙΜΟΟΥ Ϫ- Ο-

English Italick.

Quousque tandem abutere, Catilina, patientia nof-
tra? quamdiu nos etiam furor iste tuus eludet?
quem ad finem sese effrenata jactabit audacia?
nihilne te nocturnum præsidium palatii, nihil ur-
bis vigiliæ, nihil timor populi, nihil confensis bo-
norum omnium, nihil hic munitifsimus habendi fe-
natus ABCDEFGHIJKLMNOPQRSTVU

Pica Italick.

Melium, novis rebus ftudentem, manu fua occidit.
Fuit, fuit ista quondam in hac repub. virtus, ut viri
fortes acrioribus fuppliciis civem perniciofam, quam a-
cerbiffimum hoftem coërcerent. Habemus enim fenatuf-
confultum in te, Catilina, vehemens, & grave: non deeft
reip. confilium, neque autoritas hujus ordinis: nos, nos,
dico aperte, confules defumus. Decrevit quondam fenatus
ABCDEFGHIJKLMNOPQRSTVUWXYZ

Double Pica Italick.

Quousque tandem abutere, Catili-
na, patientia nostra? quamdiu
nos etiam furor iste tuus eludet?
quem ad finem sese effrenata jac-
ABCDEFGHJIKLMNO

Great Primer Italick.

Quousque tandem abutere, Catilina, pa-
tientia nostra? quamdiu nos etiam fu-
ror iste tuus eludet? quem ad finem fese
effrenata jactabit audacia? nihilne te
nocturnum præsidium palatii, nihil ur-
bis vigiliæ, nihil timor populi, nihil con-
ABCDEFGHIJKLMNOPQR

Pica Armenian.

Աբացիր թռչապատու երելոց ՝ ե խոզոս, այս պետեr
ե պատուրիս, ոպեոս ե ե երե ես Չպամեbuրg
խւ երելա ՝ ե ոzpամմ̃ւուՆ̃ 5ե Չկ̃խ երե ρս
Չապտելtp ՝ ե ρանrա խրմիտ̃եՆ, պբ̃ոֆ ερերς

English Syriack.

ܕܬܒܝܬ ܐܝܝܬܢ ܒܪܐܠܚ ܐܚܚܘܕ
ܚܢܘܘܘܒ ܐܕ ܚܒܝܝܚܚܚܚ
ܚܒܚ ܒܒ ܐܚܬܚ ܕܡ̇ܚ̇ܚ̇ܚ̇

Pica Samaritan.

(Samaritan) ـ (Hebrew) ـ (Arabic)

卡斯隆一世的樣本傳單

patentia noftra?

Two Lines Great Primer.

Quoufque tandem
abutere, Catilina,
patientia noftra ?
quamdiu nos etiam

Quoufque tandem a-
butere, Catilina, pa-
tientia noftra ? quam-
diu nos etiam furor

Two Lines Englifh.

Quoufque tandem abu-
tere, Catilina, patientia
noftra ? quamdiu nos e-
tiam furor ifte tuus elu-

Quoufque tandem abutere,
Catilina, patientia noftra?
quamdiu nos etiam furor

SMALL PICA ROMAN. No. 2.

LONG PRIMER ROMAN No. 1.

LONG PRIMER ROMAN. No. 2.

BREVIER ROMAN.

Nonpareil Roman.

Pearl Roman.

Small Pica Italick. No. 2.

Long Primer Italick. No. 1.

Long Primer Italick. No. 2.

Brevier Italick.

Nonpareil Italick.

Hebrew with Points.

Hebrew without Points.

Brevier Hebrew.

English Greek.

Pica Greek.

Long Primer Greek.

Brevier Greek.

Long Primer Saxon.

Pica Saxon.

This SPECIMEN to be placed in the Middle of the Sheet 5 U u, Vol. II.

卡斯隆一世所印製的活字樣本傳單。由於當時是以折頁形式收錄於當時的百科全書中，所以排版時讓中間留空了一些。請留意字母的文字造型會依據尺寸大小不同而有差異。

卡斯隆鑄字廠（英國）1734 年 516×396mm

to

of

as

be

an

hat

em

nd

ce

EXTRACTS FROM A CHAPTER ON ENGLISH TYPES, 1500-1800, BY DANIEL BERKELEY UPDIKE, THE MERRYMOUNT PRESS, BOSTON, U.S.A., IN HIS RECENT TREATISE ON "PRINTING TYPES, THEIR HISTORY, FORMS & USE."

"Why 60-point
Caslon Old Face
areWilliam Caslon's
types so excellent &
so famous?
"To explain this and
make it really clear

17

CASLON

Caslon 的排版範例

上面是將丹尼爾·貝克萊·厄普代克 (Daniel Berkeley Updike) 對於 Calson 字體的讚美語句排版後的頁面，欣賞時可以注意第一行的抬頭位置非常靠右邊，以及第五行飛出欄位左邊的雙引號位置。右頁是 1844 年時所印製的《Lady Willoughby》其中一頁的複製品，這是歷史上重新賦予 Caslon 高度評價的重要作品。具有圖畫裝飾的起首文字的運用以及其他排版的手法，都很值得學習參考。

卡斯隆鑄字廠（英國）年代不明　320×253mm

Some Paſſages from the Diary
of Lady *Willoughby.*

1635.

A Roſe at my uſual houre, ſix of the clock, for the firſt time ſince the Birth of my little *Sonne;* opened the Caſement, and look'd forth upon the Park; a drove of Deer paſſ'd bye, leaving the traces of their Footſteps in the dewy Graſs. The Birds ſang, and the Air was ſweet with the Scent of the Wood-binde and the freſh Birch Leaves. Took down my *Bible;* found the Mark at the 103d *Pſalm;* read the ſame, and return'd Thanks to *Almighty God* that he had brought me ſafely through my late Peril and Extremity,

B

英國最早的裝飾字體

Union Pearl 是 1700 年左右在英國被製造出來最為古早的裝飾字體。1927 年斯坦利·莫里森 (Stanley Morison) 為了印刷名為《Fleuron》的系列叢書時，委託史帝文森·布雷克公司重新翻製這套字型，也僅訂製了一種尺寸。這套字型沒有包含數字，所以排版時會拿另套同樣是輪廓線風格字體的數字來搭配使用。由於文字造型風格太特別，盡可能在版面中少量使用才會有良好效果。選擇線條較細的字體來搭配排版也會有不錯的效果。

史帝文森·布雷克公司 (英國) 1950 年代　139×140mm

ABOVE: *Union Pearl* combines with *Old Face Open* numerals and *Caslon Old Face* for an effective small announcement.
OPPOSITE PAGE: *Union Pearl* and *Caslon Old Face* in a small-space publisher's advertisement.

Union Pearl

𝒜 ℬ 𝒞 𝒟 ℰ ℱ ℱ 𝒢 𝒞 ℋ ℐ 𝒥 𝒦 ℒ ℳ 𝒩
𝒪 𝒫 𝒬 ℛ 𝒮 𝒯 𝒯 𝒰 𝒱 𝒲 𝒳 𝒴 𝒵
a b b c d d e f g h h i j k l l m n
o p q r s ſ t u v w x y z
& ſ ſ ſt Qu

5 A, 27 a; about 7½ lb.

Even the revival itself had its modest excitements. Since the matrices came into our possession they have been rarely used, and, we need hardly add, we were not over-anxious to subject them too frequently to arduous employment. Even the best matrices shows signs of Time's harsh face after two hundred and fifty years, but in this revival the minimum of adaptation and revision of these antique matrices has been made by one of our most experienced craftsmen. The type is available in one size only.

Grey
Indian Lamb
coat
extravagantly
cut

From
Browns
of
Chester

OPPOSITE PAGE: *Union Pearl* in an announcement for a large North of England fashion house
ABOVE: *Union Pearl* shows its talents in letterheads and notices

終極的現代無襯線體

以「The Type of Today and Tomorrow（代表今天與未來的字體）」的稱號席捲世界、無與倫比的無襯線體 Futura。上下分割畫面中的 r、n、m、& 等字母造型都不一樣（圖中沒有 &），最初發售時是上方分割畫面中的文字造型。

鮑爾鑄字廠（德國）　戰前　265×190mm

FUTURA
DIE SCHRIFT
UNSRER ZEIT

FUTURA
THE TYPE OF
TODAY AND
TOMORROW

SER SCHRIFT LIEGT EIN NEUER GEDANKE ZU GRUNDE.
unterscheidet sie von allen ähnlich aussehenden Künstler-
teskschriften. Die Futura will nicht zum Eklektizismus unse-
Drucktypen beitragen durch die persönliche Färbung einer
der Tradition kritiklos übernommenen Form. Sie ist über-
pt nicht von einem Vorbild ausgegangen; sondern zu For-
, die der Grotesk ähnlich sind, erst durch die ihr innewoh-
de Idee hingeführt worden.

HABEN HEUTE EINEN EIGENEN ZEITSTIL. Er füllt nicht
seinen Bauten das Land bis in jeden Winkel aus; aber das
en frühere Zeitstile auch nicht getan. Der Stil einer Zeit ist
er mehr eine Idealität als eine Realität; ist immer mehr
ung als Gegenwart; er ist die Konzeption einer Formen-

FIRST IMPRESSION OF "FUTURA" MAY BE THAT OF A
THIC LETTER. The type expert, however, will soon disco-
a difference in design which sets it distinctly apart from
sans serifs of similar appearance, for a new idea has been
bodied in this type. It has not been developed from a pro-
ype. It has assumed a similarity to the sans serif letters
ugh its innate qualities. It does not aim to contribute to
eclecticism of type forms by personal interpretation of a
ditional letter.

FINE AND APPLIED ARTS WE HAVE DISTINCT MANIFES-
TIONS OF A CONTEMPORARY STYLE. It does not fill every
ner of the land and has not in former periods. A style is
ays more of an ideal tha a reality. It is always conception

ROUNDERS

Cumberland

8-line No. 133.

CHANGED

8-line No. 136.

CORNERED

8-line No. 207/208

ORGAN RECITAL

8-line No. 176.

GRAND CONCERTS

8-line No. 175.

BERNHARDT

8-line No. 174.

CHANGED

ALL THE ABOVE LETTERS ARE SUPPLIED IN ANY SIZE.

The reference number in front of the diagonal is the two-colour number. The number following the diagonal is the single colour reference number of the same face, which should be referred to when selecting other sizes.

Latest Gowns.

10-line

York Script Dash No 3

Relative

16-line

£1234 Fashion.

8-line

York Script Dash No 2

Graham & Sons Ltd.

6-line

Eva House

12-line

Vegetables

5-line

Bonds

20-line

York Script Dash No 4

"YORK" SCRIPT NO. 1 is made up in founts of 9, 11, 13, 16 and 20 dozen, including Dashes and Angle-ends. It is cut to any size from 5 to 20-line Figures and special spaces can be supplied to order.
Manufactured by ROBT. D. DELITTLE, Vine Street, YORK.

經典的木活字字型

專門提供廣告所使用的木活字字型公司的樣本冊。
展示了許多 19 世紀以降的經典木活字字型。

底利特字型公司 (Delittle)（英國）1950 年代　274×435mm

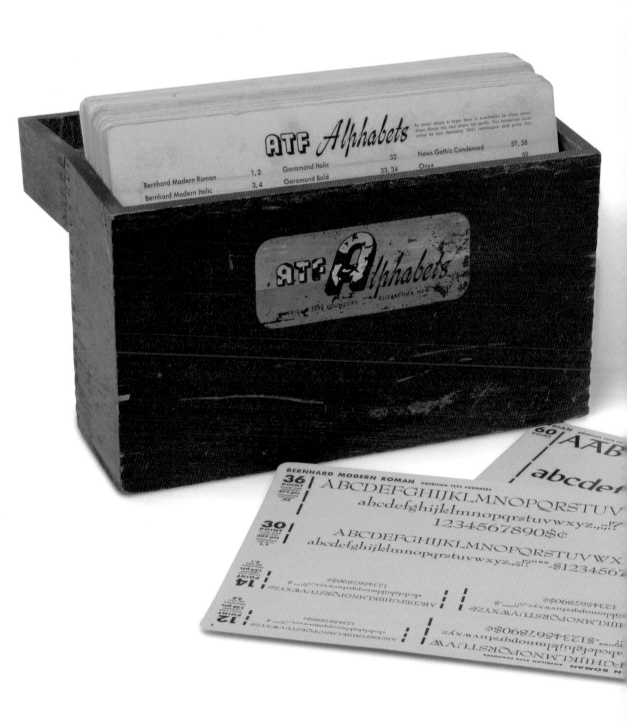

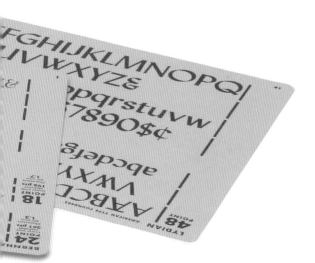

可計算文字級數的卡片

美國聯合字型公司提供給平面設計師，兼具字型
樣本與計算文字級數（copy-fitting）用途的卡片
組。共有 100 張，收錄 57 款字體。

美國聯合字型公司（美國） 1950 年左右 189×266mm

MUSTERSAMMLUNG

VON

J. G. SCHELTER & GIESECKE

LEIPZIG

BRÜDERSTRASSE 26 28.

S G

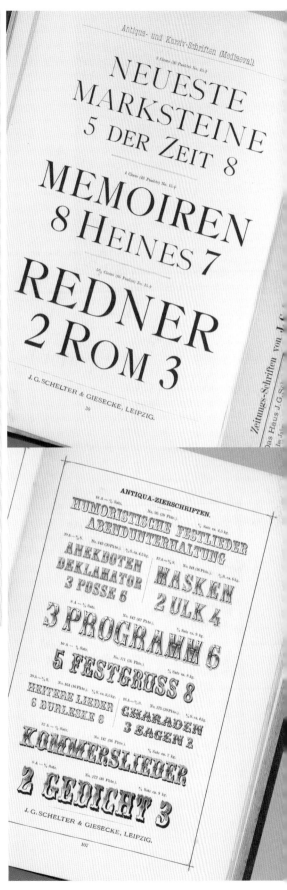

新藝術風格的樣本冊

薛爾特與基澤克鑄字廠 (J. G. Schelter & Giesecke AG)
於 1886 年印製的樣本書。以當時正流行的新藝術風格
(Art Nouveau) 設計並裝幀的豪華樣本書，由於收錄字
體數增加的緣故所以製作成大本規格的書。

薛爾特與基澤克鑄字廠（德國）1886 年　275×186mm

具備專業技術者所排出的文章

書中有附上一些排版的範例，但感覺排版者應該是專業的排版師傅而不是平面設計師。雖然呈現的視覺效果稱不上精緻洗鍊，但文章排版的手上工夫絕對堪稱一流。

　　Advertisers Upright Script 是比起運用在社交文宣上，更適合用於廣告用途的草書體。Cooper Black 是這個鑄字廠中最有名、直到今天仍常被使用的字體。跟古典羅馬體混排是近乎完美的搭配。Morris Romanized Black、Morris Jensonian 等等是將威廉·莫里斯 (William Morris) 所設計的字體進行復刻後的字體。Parsons Examples、Parsons Types and Trimmings 是下伸部 (descender) 與上伸部 (ascender) 都具有誇張長度的字體。

伯恩哈特兄弟與斯賓德勒 (Barnhart Brother & Spindler) 鑄字廠 (美國)　1925 年　285×195mm

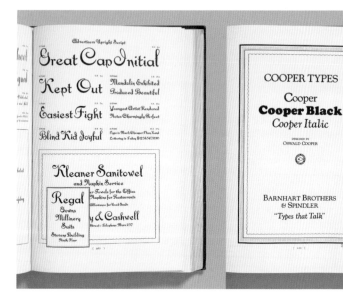

ABCDEFGHIJKLMN
OPQRSTUVWXYZ&

COOPER CAPITALS
ARE "VERY
DISTINGUISHED"

J. L. Frazier
says in
The Inland Printer:
(August, 1924)

"Because of their excellence,
coupled with marked individuality,
the type faces designed by Oswald
Cooper, one of the foremost letter
artists of America, are deservedly
popular. They have attained an un-
usually extensive use in the few years
they have been available to printers
and advertisers, and, in the opinion
of the writer, they are the most out-
standing achievement as yet made
by the B. B. & S. type foundry."

"Cooper—a type face of much
merit · · · strong in character,
thoroughly original. The italic
has many points of charm."
Douglas C. McMurtrie

abcdefghijklm
nopqrstuvwxyz

MR. COOPER himself, says:

"Italic is so much closer to its parent pen form than the
roman that freedom is almost the life of it, and readers eyes do not
resent in italic, so much as in roman, departure from familiar reg-
ularity. I have dared for this reason to give to the italic more of
novelty than I gave the roman · · · · · which I think has some ad-
vantage in these days when italic is used comparatively little for
more emphasis and mostly for variety in display."

Quoted from an interview published in THE INLAND PRINTER

[128]

for **Business**

Cooper type faces are not fanciful conceptions of "artistic temperament," nor
were they created to order of the type foundry as a stunt of "something new." They
were developed for actual jobs in the workrooms of an artist famous as a master at
making the printed pieces of many great merchants and manufacturers typographi-
cally efficacious. Before the types were available, Cooper lettering styles were widely
appreciated and extensively copied in business printing of all sorts.

Cooper types mark a needed departure from the classically artistic but effem-
inate oldstyles—which may be used with the best effect only on oldstyle papers of
soft or rough surface. Cooper type designs also avoid the mechanical stiffness and
monotonous regularity of the modern romans, oldstyle antiques and other standard
types of weight and compactness. Cooper types combine strength with the touch of
charm that only one talented as an artist can give to design.

Cooper typography is always pleasing yet essentially practical. Display lines
and body mass composed in Cooper types have the weight which invites reading on
enamel and other smooth surfaced papers, and which allows for reproduction by
photo engraving and zinc etching processes—quite important considerations to the
printer and advertiser employing modern processes.

**Only the simplest of decoration with the Cooper types—our new
Graduated Wave and Art Design Brass Rules are recommended**

MARSDEN · FIELDING
& COMPANY

A Special Selling of

MARBLES · BRONZES

FROM France, Italy and England, even from Vienna, we have
drawn the Bronzes and Marbles which form our impressive
statuary showing. It includes tiny figurines of gilded bronze,
others of bronze with the features and limbs of inset ivory—tiny
pieces of the most delicate artistry—as well as larger works, more
often in verde or dark bronze, suited for exterior use or for large
halls and important rooms. All these pieces are being specially
displayed this week at very substantial reductions from normal

Also continuing Special Prices on
MODERN FLEMISH OIL PAINTINGS

The Galleries · Second Floor · North Wabash

[129]

Study the Psychology of Type Faces

Remember the Power of Suggestion is the
greatest Force in Advertising—to create
the State of Mind that causes Action to
follow Suggestion — Advertising needs

Types that Talk

What the Critics Say
About Parsons

The page of Parsons type shown in The Printing Art for
February indicated a use of the letter in massed effect for a
book page. This is only one of the uses to which the type can
be put. These long ascenders and descenders enable the
printer to secure effects that are quite artistic. We feel very
sure that the Parsons Series will continue to grow in greater
popularity and usefulness.
Printing Art

Some of the most striking and distinctive printed forms we
have seen during the year were printed from the Parsons type.
For a letterhead, envelope, card, label or other small form, in
which there are not too many lines, this new series provides the
most important advantages of hand lettering—i.e., informality
and distinction, quite valuable qualities in attracting attention.
Printers of quality work have achieved truly remarkable re-
sults with Parsons.
Inland Printer

The Parsons letters have a place in the scheme of things
typographical. Arranged by typographers of artistic taste,
effects are produced at once refreshingly and pleasingly at-
tractive. Parsons Decorators are excellent, and give life and
interest to printed work.
American Printer

The fresh style and tone of a batch of printing [done in
Parsons type] by the Cook Printing Company, Los Angeles,
U.S.A., is noteworthy. An abnormal ascender in the uprights
is made quite a catchy feature, and, used sparingly, the result
is quite successful. The work is distinctive, and of a very
pleasing and original tendency.
British Printer

Commendations of the Parsons Series
have also appeared in the National Printer-Journalist,
Pacific Printer and other publications

Artistic
Popular
Striking
Attractive
Refreshing

Original
Catchy
Pleasing

[156]

PARSONS PUTS THE
PUNCH in
PRINTING

Aside from their unique
decorative value, the long
Ascenders and Descenders
are very effective for
emphasizing words
or parts of words—

PUTS HIGH
IN
Ohio

AND GO IN
Chicago

Kelley WITH THE 'ELL IN

FREE and easy effect
of high artistic tone
is the result Parsons
type will delight you with
when its nice decorative
Swash Initials, Ornaments
and Borders are used in
a tasteful way. The forte
particular is such work as
fine catalogs, newspaper
and magazine ads, cards
and announcements, let-
terheads, booklets. New
business can be secured
by the enterprising ones
who buy early

For a Suit of Clothes you go where
stocks are new, fresh, stylishly cut.
Any reason to assume Print Buyers
do not use just as good judgment?

Business Must Be Served
A letter style of interesting artistic design
will surely serve it better than a hackneyed type
Parsons types and trimmings will help create
that favorably influential atmosphere in which
the advertising message should be received

[157]

最知名的 Caslon 字體排版樣本

最知名的 Caslon Old Face 排版樣本。右上是卡斯隆一世的肖像畫，肖像畫手上拿的是本書
166 頁中的字型樣張。下方是以 Nicolas Cochin 所排出的標籤等等的印刷範本。源自銅版雕
刻風格，是具有高級感的字體，若與花樣一起搭配時所呈現的版面效果會相當華麗。

卡斯隆鑄字廠（英國）1925 年 295×220mm

THE FOLLOWING SPECIMEN PAGES EXHIBIT CASLON LE COCHIN SERIES IN ASSOCIATION WITH NICOLAS COCHIN ROMAN AND ITALIC

ASLONS' Nicolas Cochin and Le Cochin Series exhibited throughout the following pages demonstrate their suitability as body and display types; they have found much favour for booklets, catalogues, magazines etc., and other classes of printing in which distinction is the objective; being named in honour of an accomplished engraver of the period of Louis the Fifteenth, these types recall the finest characteristics and the peculiar charm of the lettering for which the Eighteenth Century stands pre-eminent Cast in nine sizes of roman and eight of italic, Nicolas Cochin is bold and elegant, with an agreeable touch of quaintness in the artistic freedom of its outlines, the height of its ascenders and the strength of its sturdy stems; these fine features give dignity, distinction, and individuality, rendering it invaluable for all the services of display. Le Cochin Roman and Italic is cast in six sizes of roman and five of italic; it at once found favour as a body type, being extensively used in all kinds of advertising matter: newspapers, magazines, programmes, etc. The following pages intend to illustrate its uses in association with the Nicolas Cochin Series. *Le Cochin Italic* possesses in a marked degree distinctive characteristics, and is admirably suited for all classes of work where individuality is required This specimen page is set in fourteen-point Le Cochin Series

FORUM (GOUDY), NO. 27

THIS TYPE FACE WAS DRAWN BY FREDERIC W. GOUDY AND FIRST SHOWN EARLY IN 1912. THE DESIGN IS BASED ON STONE-CUT ROMAN INSCRIPTIONS. AND IN IT MR. GOUDY HAS ATTEMPTED TO PRESENT THE SPIRIT OF THE INSCRIPTIONAL DESIGN RATHER

10 Point — For Hand Composition

ESPECIALLY ADAPTED FOR USE ON TITLE PAGES, FINER COVER DESIGNS AND FOR DIGNIFIED TYPOGRAPHY. A TYPE THAT HAS THE SPIRIT OF THE CLASSICAL ROMAN CHARACTER OF THE FIRST CENTURIES OF CHRISTIAN

12 Point — For Hand Composition

DRAWN AND CUT BY
F. W. GOUDY AND WAS

CHARACTERS IN FONTS

A B C D E F G H I J K L M N
Q R S T U V W X Y Z &
1 2 3 4 5 6 7 8 9 0 ..',

Display — 10 to 48 Point, 41 Characters

GOUDY ATTEM
TO EMBRACE T
SPIRIT OF THE C
STONE CUT FAC
THAT WERE 67

24 Point — For Hand

IS OFTEN US

Hadriano (Goudy), No. 309

IN THE LOUVRE AT PARIS Frederic W. Goudy Saw A Slab of marble on which was cut an inscription in Latin. From a rubbing of three characters, to which he added the remaining letters of the alphabet in the spirit of the original inscription of the first or second century A. D., he designed the capitals of Monotype Hadriano. The lowercase characters were drawn some years after the capitals had been designed. It is generally considered that no type matches the beauty of proportion evident in the capitals of the ancient Roman stone cutter. When we look upon a line printed in classic majuscules we are encouraged to regard as a fact the statement that the glory of the Roman alphabet is in the capitals.

CHARACTERS IN FONTS

A B C D E F G H I J K L M N O P
R S T U V W X Y Z & Æ
a b c d e f g h i j k l m n o p q r s
v w x y z fi fl ff ffi ffl
$ 1 2 3 4 5 6 7 8 9 0 .,·´:;'!?

Display — 12, 18, 24, 30 and 36 Point, 81 Characters

WHEN WE LOOK UPON
Line Set In Classic Capitals V
are encouraged to regard as a f
a statement that the glory of
Roman alphabet is in its capit
Lowercase characters were add
some years after the capitals l
been designed. No type matc

Goudy Text, No. 327

10 Point No. 327J — For Hand Composition

The Best Kind of Originality Is That Which Comes After a sound apprenticeship; that which shall prove to be the blending of a firm conception of all useful precedent and the progressive tendencies of an able mind. For, let a man be as able and original as he may, he cannot afford to discard knowledge of what has gone before or what is now going on in his own

12 Point No. 327J — For Hand Composition

The Best Kind of Originality Is That Which comes after a sound apprenticeship; that which shall prove to be the blending of a firm conception of all useful precedent and the progressive tendencies of an able mind. For, let a man be as able and original as he may, he cannot afford to discard knowledge

14 Point — For Hand Composition

The Best Kind of Originality Is That which comes after sound apprenticeship; that which shall prove to be the blending of a firm

CHARACTERS PER FONT

ABCDEFGHIJKLMNOPQRSTUVWX
abcdefghijklmnopqrstuvwxyz æ fi fl ff ffi ffl
$1234567890.,'':;!?

10 and 12 Point (Cellular Matrices, .030 Drive, for Sorts Casting only) — 80 C
14 to 72 Point — 79 Characters.

18 Point — For Hand Composition

The Better Kind of Originality Is which comes after all sound apprentice $

24 Point — For Hand Composition

Best Wishes and Greetings
your golden wedding day $456

30 Point — For Hand Composition

Floral Designs on Exh

36 Point — For Hand Composition

高迪與赫斯的字型樣本

選自蘭斯頓單字式鑄造排印機公司 (Lanston Monotype Machine Co.)，也稱美國蒙納公司 (American Monotype) 的樣本冊，展示了多款由蒙納公司的資深字體設計師弗雷德里克·高迪 (Frederic Goudy) 和索·赫斯 (Sol Hess) 所設計的字體。

蘭斯頓單字式鑄造排印機公司 (美國)　戰前　280×230mm

Goudy Old Style, No. 394

A FREE FLOWING LETTER Designed By Mr. Frederic W. Goudy, First Shown In 1914, and placed on the Monotype for machine typesetting and typecasting in 1930. Goudy Old Style has an affinity for the classic Italian types, but cannot be said to be an adaptation of any previous letter form. The serifs are sharp and well defined and the fillet curves are generous. Lowercase characters of this series have a tendency to lean

14 Point — For Hand Composition

EFFORTS TO PERFECT A MEANS FOR SETTING SINGLE TYPE BY MACHINE ENGAGED THE ATTENTION OF MANY

ABCDEFGHIJKLMNOPQR STUVWXYZ&Æ
ABCDEFGHIJKLMNOPQRSTUVWXYZ
abcdefghijklmnopqrstuv
x y z fi fl ff ffi ffl æ ct
$1234567890 .,-':;!?¶℞

Display — 14 Point, 109 Characters; 18 Point, 111; 24 Point, 84; 30 Point, 82; 36 Point, 84 Characters

THE RIGHT SERIF ON MOST Characters Is Longer At The Base than the left. Roman capitals and also lowercase letters have $12345

18 Point — For Hand Composition

WELL DEFINED SHARP

Goudy Text Shaded, No. 427

The Printer

Of all the inventions, of all the discoveries in science or art, of all the great results in the wonderful progress of mechanical skill and energy, the printer is the only product of civilization necessary to the existence

HESS NEOBOLD, NO. 363

Fonts Contain 46 Characters — Available in 36 Point only

ABCDEFGHIJKLMNO
PQRSTUVWXYZ&
$1234567890 ..-:;'!?

NEOBOLD IS A PUBLICITY TYPE

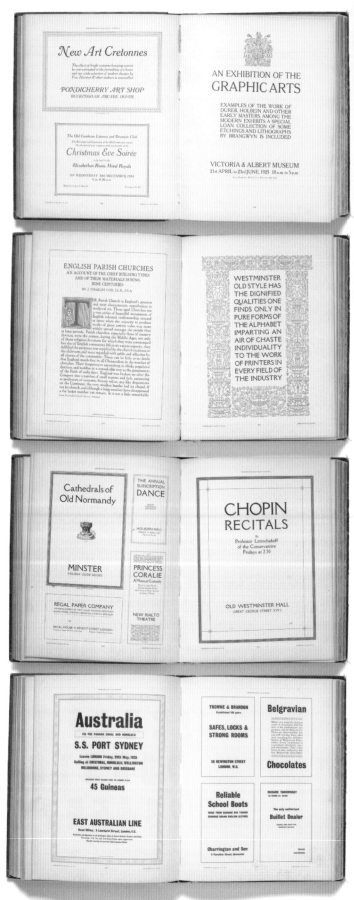

史帝文森・布雷克公司的樣本冊

從右上開始分別是 Winchester Old Style Italic 與 Winchester Old Style、Chippendale 與 Westminster Old Style、Westminster Old Style、Grotesque No.9，每套字體都是這間公司的著名作品。賞析時比起觀察細節，不如從字體本身好好感受一下不同的氣氛。

右頁是 Titling Old Face Open 與 Baskerville Old Face。可以注意到起首文字 T 放在非常偏向中央的奇怪位置，其實是為了讓第二行出現的公司名稱能完整呈現在同一行的緣故。這屬於較為特殊的手法，容易失敗，切勿輕易模仿。

史帝文森・布雷克公司（英國） 1924 年 293×225mm

A HISTORICAL RECORD

THE history of the Letter Foundry of Stephenson, Blake & Co. Limited, is bound up with the earliest days of printing in England, and though the first links of the chain which unites the Tudor Printer-Letter Founders with the Sheffield Foundry may be regarded as rather in the nature of tradition than of history, the record is sufficiently well authenticated to be worthy of preservation.

Whatever opinion may be held as to whether or not William Caxton produced his own punches and matrices and cast his types by means of an adjustable mould, there appears to be little doubt that his pupil Wynkyn de Worde, who worked in London from 1495 to 1534, produced types in this fashion,

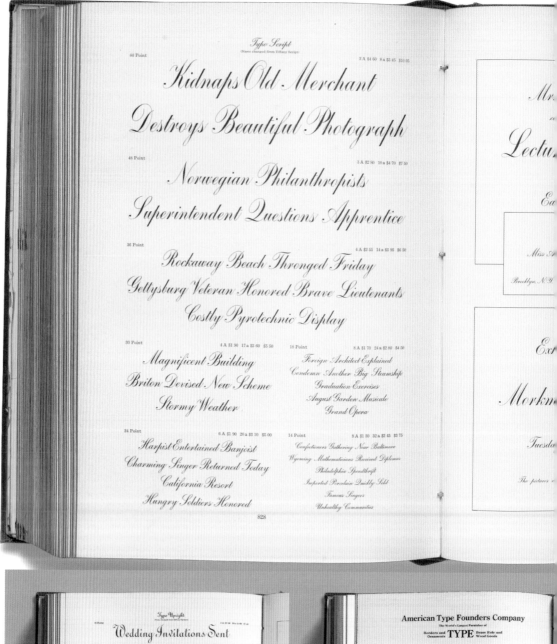
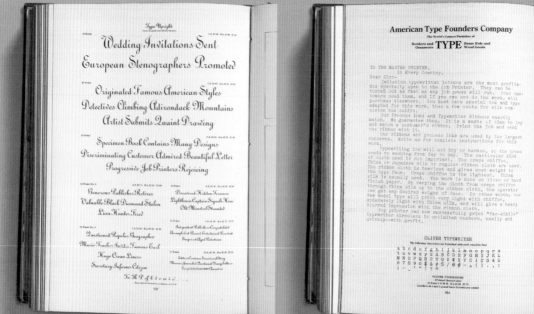

美國聯合字型公司的樣本冊

本頁上方用不同尺寸的 Typo Script 字型發揮不一樣的強弱效果，是很優雅的排版範例。左頁左下方，Typo Upright 字型頁面的最下方所標記的是特別款式的字母樣式，為了達到完美的排版效果一定會使用到這些字母。同頁面右下的 Typewriter face（Oliver Typewriter 打字機專用字型）是將打字機的字型復刻成金屬活字的字型產品。將所有不同廠牌的打字機與其機器內建的字型都復刻齊全，可以用活字排版的方式忠實地呈現打字機打字後的效果。樣本冊中也展現了各種印刷範例以證明其視覺效果。除了文字以外，也擁有各種框線花樣與插畫等活字。

美國聯合字型公司（美國）1912 年　285×195mm

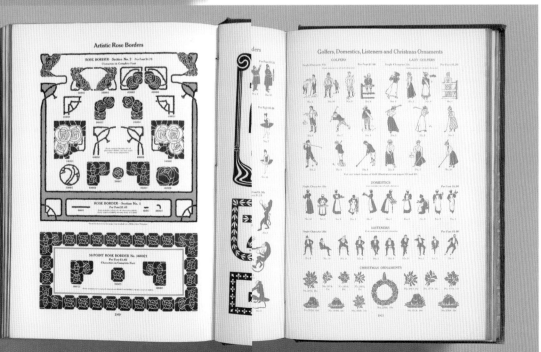

阿姆斯特丹鑄字廠的樣本書

將出自許多知名活字鑄造廠的一些經典字體互相搭配組合。可以好好欣賞一下插圖與文字間的平衡感。

右上：Gravure Open、Select、De Roos Italic。圖案起首文字大寫 P 的設計與空間配置非常巧妙。

中左：Juno、Nobel Inline Capitals。

中右：Egyptian Expanded Bold、Columbia。

下左：Libra。

下右：Gracia、Bodoni Light、Nobel。L 字母的插圖與草書書體所呈現的平衡感非常好。

右頁：Nobel、Nobel Italic。

阿姆斯特丹鑄字廠（荷蘭）1960 年 249×169mm

you'll stand your ground

with new 'Sportlanders'

Certainly it is no exaggeration to say that

crack sportsmen took to them with enthousiasm.

Have you ever tried on a pair of Sportlanders?

If not — go and do so. It's a lucky strike!

Nobel 36 pt and italic 12 pt

<div style="writing vertical">

製作書中所收錄的字型樣本的重要活字鑄造廠

</div>

美國　United States

ATF American Type Founders Inc.

美國聯合字型公司

美國最大的聯合字型公司。為了將彼此旗下的活字互相融通並擴展販賣的通路，聯合了 25 間美國的活字鑄造廠於 1892 年時成立了 ATF。最初所發行的字體樣本書盡可能收錄了旗下每間活字公司的所有字體，所以非常大本且厚實，但漸漸隨著字體販售業績每況愈下，1923 年時開始沒辦法製作出如以往般厚重的樣本。

Typefounders of Chicago / Neon Type Division

芝加哥鑄字聯合公司：霓虹活字公司

霓虹活字公司主要是由較小規模的活字鑄字廠聯合起來設立的公司。

Lanston Monotype Machine Co.

蘭斯頓單字式鑄造排印機公司

由創辦人托爾伯特·蘭斯頓 (Tolbert Lanston) 在美國設立的自動鑄字排版機製造廠。Monotype (單字式) 的鑄字排版機不僅可以排列出文章，由於是一個字一個字的個別鑄造出活字，鑄字後也可以用手工的方式進行排版。

譯注：Monotype (單字式) 意指是以字母為活字的單位，而一次鑄造出一整排鉛字的 Linotype (單行式) 自動鑄字排版機是以行為單位，無法再進行單字拆解與排版。

Barnhart Brothers & Spindler

伯恩哈特兄弟與斯賓德勒鑄字廠

沒有加入 ATF 公司，獨自經營直到 1937 年左右才與 ATF 合併。旗下的 Cooper Old Style 字體與其同款粗字重的 Cooper Black 最出名。與 ATF 合併後，一直在樣本冊中保有一席之地直到最後。

德國　Germany

Ludwig & Mayer GmbH

路德維希與梅耶鑄字廠

1875 年於德國的美茵河畔法蘭克福市創業。第二次世界大戰時雖遭受波及，但戰後又展開了業務，與義大利的活字鑄造廠西蒙奇尼 (Simoncini) 有業務上的合作關係。著名的草書字體 Rhapsodie (1951 年) 正是在這裡最先發表且販售。20 世紀的知名設計師如卡爾格奧爾格·赫費爾 (Karlgeorg Hoefer)、雅各布·利伯 (Jakob Erbar) 等人都有為此鑄字廠提 供他們的字體設計。

D. Stempel AG

斯坦普爾鑄字廠

1895 年創業，1985 年時被萊諾公司收購，1986 年關廠。開廠初期似乎只有製造排版時用的鉛角 (注)，但之後也著手鑄造活字。戰爭前完全被競爭對手鮑爾鑄字廠甩在後頭，但戰後因 Optima、Melior、Helvetica 等字體而開始急速成長。旗下 Garamond 字體的高品質受到廣大好評。

譯注：鉛角 (日：込めもの)：活字排版時用於字間、行間、版面留白處等地方的金屬填充物。

H. Berthold AG

伯特霍爾德鑄字廠

原本是花邊輪廓等的裝飾類製造業者。之後不僅著手製造活字，並致力引進德國制的點制 (point) 標準，在活字印刷歷史上有著重要的貢獻。但由於活字的製造晚了其他公司一步，所以最後只好將販賣的通路轉向俄羅斯。

Klingspor Typefounders

克林斯波爾鑄字廠

以魯道夫·科赫 (Rudolf Koch) 為設計師代表，曾製造了許多具有強烈風格的活字字體。二戰後被斯坦普爾鑄字廠收購。現在成為了一間博物館。

192

J. G. Schelter & Giesecke AG

薛爾特與基澤克鑄字廠

1819 年於德國的萊比錫市創業。1825 年時開始製造且販售大小寫字母齊全的無襯線字體。雖然歷史上公認最早期的無襯線字體是由威廉·卡斯隆六世 (William Caslon VI) 在 1815 年左右製作的活字字體，但由於只有收錄英文的大寫字母，若以完整性而論，薛爾特與基澤克鑄字廠算是最早提供連小寫字母都有收錄的完整無襯線字體的字型公司。除了活字以外也有提供印刷機等的製造與販售。著名的標題用字體 Belwe (1907 年) 也是由此公司最早開始販售的。1946 年之後被德意志民主共和國 (東德) 轉為國營事業。

Bauersche Giesserei

鮑爾鑄字廠

1837 年於德國的美茵河畔法蘭克福市由約翰·克里斯蒂安·鮑爾 (Johann Christian Bauern) 所創業。1900 年代時委託埃米爾·魏斯 (Emil Weiss)、盧西恩·伯恩哈德 (Lucian Bernhard)、魏斯的弟子約翰尼·弗里德倫德爾 (Johnny Friedlaender) 等人進行設計，立下良好的實績。20 世紀時旗下的 Bauer Bodoni 跟保羅·倫納 (Paul Renner) 所設計的 Futura 等字體獲得了巨大的成功。

瑞士　　　　　　　　　Switzerland

Haas'sche Schriftgiesserei AG

哈斯鑄字廠

創立至今將近 400 年的活字公司。旗下發表了 Helvetica 的前身 Neue Haas Grotesk，也在之後持續販售 Helvetica 的字型家族。被法國佩尼奧公司收購後，新設了 Haas France 公司。最終與斯坦普爾鑄字廠合併。

荷蘭　　　　　　　　　Netherlands

Joh. Enschedé & Zonen

恩斯赫德鑄字廠

1703 年於荷蘭的哈勒姆 (Haarlem) 創業。初期以印刷公司打出知名度，提供紙鈔或郵票等的印刷業務。1743 年時收購了一間活字鑄造公司之後，也開始製造活字。為這間公司提供字體設計的 20 世紀知名設計師有布朗·德·杜斯 (Bram de Does)、楊·凡·克林彭 (Jan van Krimpen) 等人。

Typefoundry Amsterdam

阿姆斯特丹鑄字廠

1851 年於荷蘭的阿姆斯特丹創業。也有製造印刷機的活字公司。因為旗下製作許多德·杜斯所設計的活字字型而有名。也曾經於香港設立過分公司。

法國　　　　　　　　　France

Deberny & Peignot

佩尼奧鑄字廠

Univers 字體最初是為了佩尼奧鑄字廠所開發的照相排版機而特別設計的照排字體，之後才被製作成活字字型販售。所以 Univers 整組字排開時會稍稍顯得寬鬆，應該也是由於這個緣故。

Fonderie Olive

奧利夫鑄字廠

1836 於法國的馬賽創業。旗下發售了許多由羅傑·艾庫斯克芬 (Roger Excoffon) 所設計的具有代表性的字體。

義大利　　　　　　　　Italy

Societa Nebiolo

內比歐羅鑄字廠

也有生產印刷相關機器的義大利最大規模的活字公司。也是從戰爭前就最先開創以獨特的編碼制度分類字體的活字公司。雖然有數字編號系統的字體家族以 Univers 最為知名，不過內比歐羅鑄字廠更早就率先將公司旗下的所有字體與其字型家族都賦予了數字編碼。從 1930 年代的樣本冊裡就能看到他們的獨家分類系統。

英國　　　　　　　　　United kingdom

The Monotype Corporation Ltd

蒙納公司

創辦人托爾伯特·蘭斯頓在美國完成單字式鑄造排印機的設計後，前往英國所成立的公司。

H.W. Caslon & Co. Ltd

卡斯隆鑄字廠

於 1700 年初期就創業的鑄字廠。創辦人威廉·卡斯隆 (William Caslon) 原本是在獵槍的槍身上雕刻花樣與文字徽章的接案雕刻家，後來被推薦後轉職為雕刻活字父型的師傅。鑄字廠持續運作經營直到 1937 年時關門。旗下最有名的字體為 Caslon Old Face。

Stephenson Blake & Co Ltd

史帝文森·布雷克公司

創業時收購並繼承了字體世家卡斯隆的部分家族產業，1841 年更名為現在的公司名稱。於 1937 年時收購了所有卡斯隆的家族產業。

Delittle

底利特字型公司
大尺寸的木活字字型公司。

世界の美しい

欧文活字見本帳

世界歐文活字 300 年 經典

350 件絕版工藝珍藏，
令人目眩神迷的歐文字型美學

嘉瑞工房
コレクション

www.kazuipress.com

嘉瑞工房

使用進口金屬活字進行排版的歐文活字印刷公司。原為井上
嘉瑞的私人印刷工作室，由高岡昌生（現任負責人）繼承後
發展成為公司。擁有超過 300 種以上的優秀歐文金屬活字字
體，目前幾乎皆已難以取得。所有字體與其各種尺寸加起來有
1500 套以上的字型，嘉瑞工房妥善運用這些字型，以歐文活
字排版印刷製作各種文具商品。曾獲日本 TYPOGRAPHY
協會的第三屆【佐藤敬之輔獎】企業團體獎。

原著作者：嘉瑞工房
譯者：曾國榕
責任編輯：沈沛緗
封面設計：王志弘
內頁設計：葉忠宜
行銷企畫：陳彩玉、陳玫潾、蔡宛玲、朱紹瑄
出版：臉譜出版
發行人：涂玉雲
總經理：陳逸瑛
編輯總監：劉麗真
城邦文化事業股份有限公司
台北市民生東路二段 141 號 5 樓

發行：英屬蓋曼群島商家庭傳媒股份有限公司城邦分公司
台北市中山區民生東路二段 141 號 11 樓
讀者服務專線：02-25007718；25007719
二十四小時傳真服務：02-25001990；25001991
服務時間：週一至週五上午 09:30－12:00；下午 13:30－17:00
劃撥帳號：19863813 戶名：書虫股份有限公司
讀者服務信箱：service@readingclub.com.tw
城邦網址：www.cite.com.tw
香港發行：城邦（香港）出版集團有限公司
香港灣仔駱克道 193 號東超商業中心 1 樓
電話：852-25086231 或 25086217 傳真：852-25789337
電子信箱：hkcite@biznetvigator.com
新馬發行：城邦（新、馬）出版集團
Cite (M) Sdn. Bhd. (458372U)
41, Jalan Radin Anum, Bandar Baru Sri Petaling, 57000
Kuala Lumpur, Malaysia.
電話：603-90578822 傳真：603-90576622
電子信箱：cite@cite.com.my

一版一刷 2017 年 2 月
ISBN 978-986-235-559-6 城邦書號 FI2021
版權所有‧翻印必究 (Printed in Taiwan)
售價：650 元（本書如有缺頁、破損、倒裝，請寄回更換）

Beautiful Typography from all over the World
世界の美しい欧文活字見本帳
© 2012 Kazui Press
© 2012 Graphic-sha Publishing Co.,Ltd.
This book was first designed and published in Japan in
2012 by Graphic-sha Publishing Co.,Ltd.
This Complex Chinese edition was published in 2017 by
Faces Publications, a division of Cite Publishing Ltd.

＜日本語版制作スタッフ＞
デザイン：篠原康弘 Yasuhiro Shinohara (Soiton)
撮影：村上圭一 Keiichi Murakami
編集：宮後優子 Yuko Miyago
(Graphic-sha Publishing Co., Ltd.)
協力：立野竜一 Ryuichi Tateno, 上田宙 Hiroshi Ueda,
小林章 Akira Kobayashi

國家圖書館出版品預行編目(Cataloging in Publication)資料
世界歐文活字 300 年經典：350 件絕版工藝珍藏，令人目眩
神迷的歐文字型美學／嘉瑞工房著；曾國榕譯 ──一版──
臺北市：臉譜出版：家庭傳媒城邦分公司發行，2017.02
　　面；　公分
譯自：世界の美しい欧文活字見本帳
ISBN 978-986-235-559-6（平裝）
1. 平面設計 2. 字體 3. 活字印刷術
962　　　　　　　　　　　　　　　　　　　　105024088